Carl Dietrich Carls

Ernst Barlach

Pall Mall Press · London

First published in Great Britain in 1969
by Pall Mall Press, Ltd.
5 Cromwell Place, London S.W.7

© 1931 and 1968 Rembrandt Verlag, Berlin

English translation copyright 1969 in New York
by Frederick A. Praeger, Inc., New York

SBN 269 67129 3

Printed in Germany

PREFACE

I saw my first Barlach sculpture, *Shepherd in a Storm*, in 1923. It made an unforgettable impression on me. Shortly afterwards I read his play *The Poor Cousin*. I was as fascinated by it as by his sculpture, and from then on I avidly followed his career. 1924 saw the publication of *The Deluge*; 1926, *Boll*; 1928, his richly illustrated autobiography. More and more I became captivated by the unique gift of this man—a sculptor of incomparable individuality and a fascinating playwright.

In 1930, at the beginning of my theatrical career, I was instrumental in getting *The Deluge* produced in the town of Osnabrück, an enterprising undertaking for a medium-sized municipal theater. We sought to prepare the audience for the play through newspaper articles, by running a special matinee in which we discussed his works, and by exhibiting Barlach sculptures in the lobby. Encouraged by the success of this venture, I went on a country-wide lecture tour, beating the drum for Ernst Barlach with youthful enthusiasm. It was during this tour that I wrote the first draft of this book, which was published by Rembrandt Verlag in 1931, a time when to produce a book on Barlach represented something of a risk. But interest in Barlach continued to grow, and other editions followed, the last in 1935. By then, however, its distribution was encountering almost insuperable obstacles. The Nazi defamation campaign against Barlach was in full swing, and all efforts to support him were being frustrated. In the fall of 1936 the book was officially proscribed and the plates confiscated. Hitler had decreed that Barlach was one of the 'degenerate artists'.

Not until 1950, five years after the end of World War II, and twelve years after Barlach's death, was the book reissued. Assembling

a comprehensive pictorial survey of Barlach's work proved no simple matter—his works were scattered and their whereabouts frequently unknown—but with the help of the publisher, the executors of Barlach's estate, and Hermann F. Reemtsma, who had stood by Barlach in his late difficult years, a comprehensive though by no means complete record could finally be assembled.

I wish to express my gratitude to Mr. Reemtsma, the art patron and donor of the Ernst Barlach House in Hamburg. I first met Mr. Reemtsma shortly after the end of the war and found in him a man with a profound understanding of Barlach's work. Our conversation took a personal and very gratifying turn when, reaching for a book on his shelf, Mr. Reemtsma said that through this he had become interested in Barlach. What he held in his hand was a copy of the first edition of my book. In the summer of 1934, when life under totalitarianism was beginning to become intolerable for Barlach, Reemtsma enabled him to complete the project he was then working on, the *Frieze of the Listeners*. Reemtsma later gave his entire Barlach collection to a public foundation.

Today Barlach's work needs neither justification nor endorsement. It has survived, is accepted by both East and West, has found a suitable home in Güstrow and in the Barlach House in Hamburg, and its fame is spreading throughout the world. Everything this artist created is illuminated by his uncompromising honesty and true humanity.

I hope that this new, expanded, revised edition of my book will be acceptable to all those seeking a comprehensive survey of Barlach's oeuvre.

Berlin C. D. C.
August 25, 1968

Man's fate—his vulnerability, his feeling of hovering, lost and naked, between heaven and earth, his joys and sorrows—is the dominant theme in Ernst Barlach's work. He suffered and was involved. He rejected the purely decorative in art, the playful abstractions, and anything that failed to take the human into account. His creative impulse had its roots in the representation of suffering and joy.

After a long, painful struggle and numerous disappointments, Barlach gained supreme mastery of a variety of media and produced sculptures, graphics, and literary works of incomparable cohesion and individuality. Without doubt, Ernst Barlach is one of the most remarkable and individualistic personalities in modern European art. He has been called an Expressionist, but that says little about him. He was essentially an individualist who had developed a style that was completely his own, highly expressive and majestic, completely underivative, without a trace of eccentricity.

He was unique in that he was uncompromising in the pursuit of an art in which form and content are in complete harmony. His was the achievement not only of a consummate artist but of a human being who, remaining true to himself, unstintingly gave of his best, a man who explored the farthest reaches of his talent.

Barlach remained true to himself also in his relationship with the region of his birth to which he returned at the age of forty, when he settled in the small town of Mecklenburg. There he found both the

peace and the themes he needed for his work. 'Here in Güstrow,' he wrote in a letter, 'there exists a somewhat backward but healthy primitivism. Country life lends the smallest thing a noble shape.'

In his autobiography Barlach tells how as a child he began to sense things which could be neither seen nor heard, and how suddenly the woods in which he played appeared in a completely new light. This was the first of many similar discoveries he made between his ninth and twelfth years: 'It was like the blinking of a familiar eye through the crevice of the verdant, beech-leaf canopy.'

This powerful image was to reappear, transformed and made into the symbol of all experience, in the play *The Deluge*, when one of Noah's sons says of God: 'He hides behind everything, and everywhere there are narrow cracks through which He glows, radiates and shimmers. Very narrow, fine cracks, so narrow that one can never find them again if one looks away.'

This typifies Barlach and reveals much about the roots of his art. These early sensations, this sudden discovery of his surroundings, of his creative imagination, were to remain with him throughout his adult life. They are evidence of an exceptional sensitivity, a steady growth of his ability to find that other reality, the other truth.

Barlach, taking stock of the roots and forces responsible for his growth as an artist, said that these early experiences helped to shape his entire work. From the very outset 'things behind reality' played a special role; an inner compulsion drove him to search for the hidden meaning behind the outer appearance of things, for the true image behind the mask. This search accounts for his relationship with the human form. As a sculptor he was not satisfied with visual appeal and texture, with the interplay of relaxed or moving limbs, with the tension of muscles or with skin. For him the human body was not only that which was visible. He searched in it for the hidden element.

8

'My mother tongue,' Barlach said, 'is the human body or the *milieu*, the object, through which or in which man lives, suffers, enjoys himself, feels, thinks. I can't get away from that.' With this statement, made in 1911, he sought to set himself apart from abstract art. But at the same time he indicated that he drew a dividing line on the other side as well. When Barlach speaks of the nakedness of man he does not mean the state of undress but spiritual nakedness. He even saw nudity as a garment. Therefore, apart from some early studies, he made no nudes. Man, he argued humorously, came into the world naked, but then clothes were put on him; animals have their own pelt; man was given clothing, and God doubtless knew the reason why. And Barlach also knew why he left the human body, which he understood as well as any other sculptor, wrapped in clothing. Only the clothed shape, the sensed rather than the obvious, was able to express the inner turmoil, the psychic twilight of the human figure as he felt it, and only thus was he able to achieve the unique transparency of his figures, which resemble Gothic sculptures insofar as their limbs are covered but can occasionally be glimpsed through their severe clothing, with the entire figure thus illuminated from within.

Barlach saw the human form, which for him remained firmly linked with suffering and joy, as a vessel holding the greatest secret, which he sought to uncover. Reality remained his anchorage, but he never copied it; rather he attempted to depict it allegorically. The vision he had was the representation of humanity in turmoil and weighed down by fate, a representation in the sense of a 'participation which goes so far in its understanding that it takes the place of the depicted.' But the road towards that goal was a long one. Barlach was almost thirty-seven years old before he finally found his form, the great and simple form which expressed what was in his mind.

Ernst Barlach was born on January 2, 1870, in Wedel on the Lower Elbe. He spent most of his youth in Schönberg and Ratzeburg, not far from Lübeck, in close communion with the North German landscape and its people, whom he came to know while accompanying his father, a country doctor, on his calls to the local peasants and the wealthy landowners.

Barlach's forbears had lived in this north-western corner of Germany for centuries. The name Barlach presumably derives from the Lower Saxon town of Burlage. It can be traced back to about 1650, and was then variously written as Burlach or Barlach.

The Barlachs were a gifted family. One of his ancestors had been a member of the Berlin Art Academy, and many others, among them his father, drew, painted, and wrote.

Barlach's mother was the daughter of a customs official. She neither painted, drew, nor wrote, but she was, according to her son, open to new experiences and possessed a remarkable memory.

Ernst Barlach inherited his mother's receptivity and his father's creativity. Both his parents were products of the North German land. All his ancestors had been inhabitants of the plain, had lived under the same low, overcast sky, had battled the wind which swept in from the sea. He, too, bore the marks of this harsh, broad landscape.

In view of the family's artistic bent it was not surprising that Ernst Barlach began to draw, carve, and write verse at an early age.

However, when at the age of eighteen he was confronted with the choice of a career he was at a loss what to do. His father had died and left him only a small inheritance, and his guardian was unwilling to give his approval to so risky a career as that of an artist. But as luck would have it, the son of a local choir-master was an art teacher in Hamburg. Barlach's guardian thought teaching a respectable profession. So in 1888 Barlach left for Hamburg to train as an art teacher.

His first Hamburg teacher thought him completely without talent, and that he would never be able to do anything worth-while in art. He advised him to give it up. But Barlach refused to follow his advice. On the contrary, he decided to take up sculpture in addition to his other subjects.

He began by copying plaster casts, but his new teacher believed in letting his students work independently from their own sketches. Barlach threw himself into his work; new vistas were opening up, new areas in which he could work happily and wholeheartedly. He began to sense what it was that he had to do, though without finding the right way immediately. But after a long interruption due to illness, he returned to his work with the realization 'that one has to decide on a single and the most important thing,' an insight which was to shape his future.

Before him lay a long and difficult road. His was a ceaseless effort to find a personal approach, a search which was to take him more than fifteen years. The art of his day was not able to offer him much guidance. How could he, Barlach, who had always regarded the phenomenon man as a mystery, be attracted to run-of-the-mill naturalism? He also felt uneasy with classicism; it failed to satisfy his search for intensified expression. He did everything that was asked of him in Hamburg and later at the Dresden Academy, but he derived little benefit from it.

His Dresden teacher, Robert Diez, encouraged him to sketch the man on the street, sound advice which Barlach found to his liking. From that day on he was never without a pocket sketch-pad, and he jotted down everything he saw. Yet he never thought for a moment that the faithful rendering of reality was the final goal. He wanted something more without quite knowing what. And even though Diez was a sensitive and responsive teacher, he could not help him in this. In 1894, Barlach produced his final work at the Academy, *The Cabbage Picker* (1894), the figure of a stooping woman walking across the field, her right arm extended, picking the crop, her left arm holding some cabbages. This sculpture, alive and graceful, earned him a silver medal and showed that he had learned technical skill during his Dresden years.

A year later Barlach went to Paris, no doubt hoping that Paris would help him find himself. His friend, Carl Garbers, a sculptor, his senior in years as well as experience, encouraged him to make this trip. Garbers had won a grant for a design for sculptures for the Hamburg Town Hall. Using the remainder of his parental inheritance, Barlach joined Garbers in Paris. However, his hope of finding himself there remained unfulfilled. The Paris chapter of his autobiography interestingly enough is entitled 'Whither Sails the Boat?' Although Barlach liked living in Paris and did not lack friends among the young painters, sculptors, and writers there, he received no inspiration from the new French art movement. A well-meaning older painter persuaded him to enrol in the Academie Julien, but the endless drawings of nudes bored him; however when sketching on the street 'the pencil began to jump in my hand impatiently.'

Barlach experienced Paris in his own way, exploring the city on foot: 'I soon felt at home among the streets, squares, river banks, and beautifully conceived open spaces . . . The Louvre consumed and held

19

me fast for days, weeks, months on end. I walked around in it like a resident ghost haunting a house, as part of it, belonging, accustomed to it like a rat to its hole.'

It is rather odd that Barlach let himself be swallowed up so completely by the Louvre, and because he did, he missed much of the work of his contemporaries. Later he could not remember whether he had seen even a single Daumier, and he was only barely aware of Rodin. He himself explained this by saying that enthusiastic though he seemed to be about the work of other artists, he did not really look for support, advice, or models, and he also doubted whether the modern masters could have been of help to him then. Later Barlach did admit that his exposure to French Impressionism did prove useful after all, because it taught him to avoid the obvious. However, at the time it had little impact. He drew and saw much, forever observing cf. 18 bottom the people in the streets. His Paris sketchbook is the product of an almost manic industry. In addition, he did a number of charming, 18 top scurrilously humorous drawings such as *The Centaur Chiron* and *The* 17 *Siren* (1895). He also tried his hand at painting; his *Self-portrait with the Goatee* (1896) is a good example of this phase. However, he came to the conclusion that he was no painter and promptly gave away all his painting equipment. It was during this period that he began work on a novel in which two symbolic characters explore Paris. Apparently it was a very convoluted piece of writing, and he himself later dismissed it as unsatisfactory, though it remains of interest as his first venture into literature.

When Garbers heard that Barlach was thinking of becoming a writer, he felt compelled to put a stop to this incomprehensible aberration. As far as he was concerned Barlach was a sculptor and nothing more. Writing was a waste of time. Meanwhile he himself had become quite successful and was looking for an assistant to help

him with a rush commission—a sculpture for the Hamburg Rats-keller. Barlach, pleased at the opportunity to replenish his diminishing funds, accepted Garbers' offer. The two worked day and night to give the good burghers of Hamburg 'a jolly wine-taster, coy, bibulous, and upright,' as Barlach noted ironically. This may not have been his type of work, but it represented the tough reality of commissions to which his friend Garbers, always the practical man, now introduced him.

In the spring of 1896, Barlach returned to Germany, his money gone and his health impaired. He suffered from a cardiac condition. In the Thuringian woods, nursed by his mother, he regained his strength. The following year Garbers again summoned him to Paris to help him with yet another commission. This second Paris trip also did not bring him what he hoped for. Barlach had to admit to himself that the net result of his Paris experience was not a very satisfactory one: 'I remained exactly the same, learned very little, and forgot nothing at all.'

Back in Hamburg, Barlach formed in 1898 a working partnership with Garbers which lasted several years. Together they designed a relief for the roof of the Town Hall of Altona, a contemporary allegorical work—a man and woman in a boat on the high seas, safely guided by a winged female figure. A picture of the two young artists and their work appeared in a paper under the caption: 'The sculptor Carl Garbers with his assistant Barlach next to his new work.'

Barlach seemed quite pleased with this working arrangement, even in the role of assistant. It gave him enough time to continue his own work; he wrote, drew, and even contributed some drawings to the
cf. 21 *Jugend*, a Munich periodical featuring the works of young artists.

Then came his first really big success, which, however, soon turned into an equally great disappointment. He and Garbers had won the first prize in a competition for the design of the Hamburg market square. The problem they had to solve was to create a suitable setting for the monument of William I, which Barlach described as 'an equestrian statue with an antediluvian horse, lame and long-necked, and a veritable simpleton of an emperor. I think he's praying, but I'm not sure.' Yet despite the ridiculous statue, the two young men were overjoyed to have won the opportunity to execute a 'work of sculptural magnitude,' as Barlach called their design. Meanwhile, their plan, which the prize-awarding jury had called a 'cohesive design of overwhelming simplicity,' had secretly been shown to old

Johannes Schilling, the sculptor responsible for the equestrian statue. Schilling thereupon took over the entire project, watered it down, and got rid of the two young innovators, even though Garbers was one of his former pupils. The loss of this great chance was a blow. They felt cheated, but their protests were in vain. Garbers never quite got over this disappointment; Barlach packed his bags and went to Berlin. Later he said he was rather glad that the project never materialized. 'The work would have taken up much of my time,' he told his friend Friedrich Schult. 'This way I found myself much sooner and also freed myself from Garbers.'

He and Garbers had been a rather ill-matched team: Garbers, then in his middle thirties, was active, venturesome, and aggressive, always with an eye on the main chance, while Barlach, six years his junior, was rather introverted, still not quite sure of what he wanted, and rather unhappy about devoting time to business matters which could be better spent working. That Garbers had made him his partner when his small inheritance was almost exhausted had been an unexpected stroke of good fortune, and he was grateful to his friend for giving him a chance to work. But in the long run, he soon came to realize, the relationship of dependency which had developed was not without its pitfalls. He therefore felt a vast sense of relief when it came to an end.

When Barlach left for Berlin he had a commission which offered him temporary financial security—designing a tomb for a prominent Hamburg family. A diary notation of 1901 tells about his plans for this work: 'Standing guard at the door to the tomb is a female figure personifying the human feeling of painful remembrance. In posture and gesture she should give the impression of listening to something inside the tomb, be impervious to all external interruption, and should evoke a feeling of deep devotion. Mourning

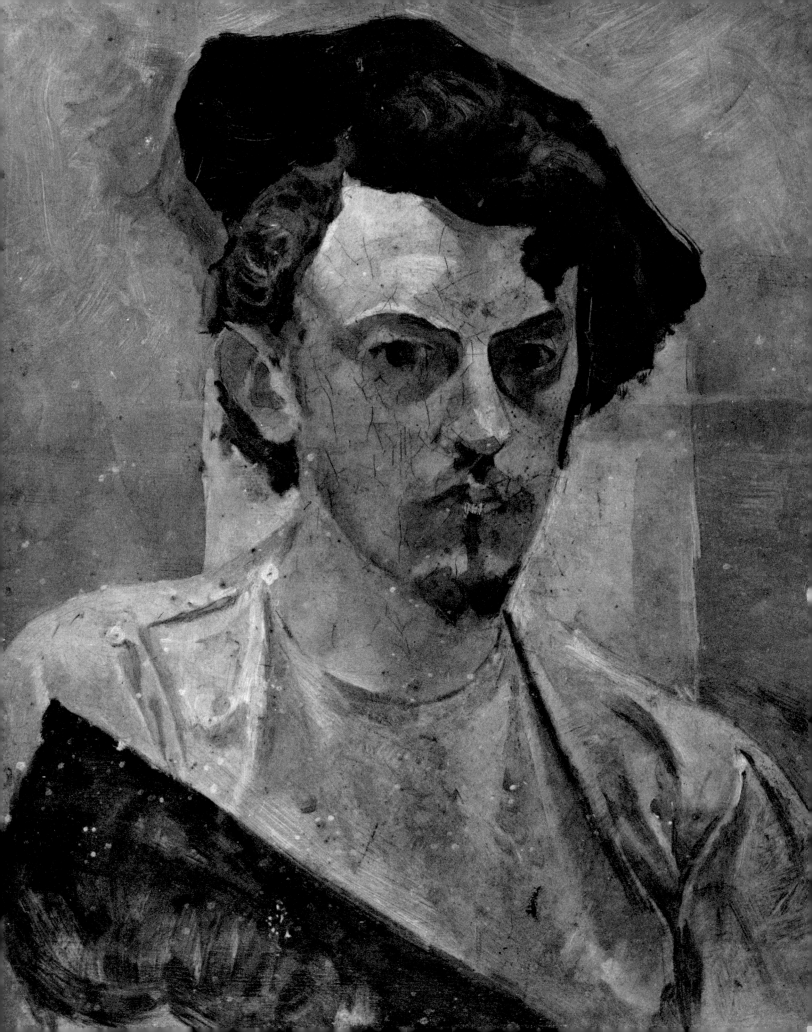

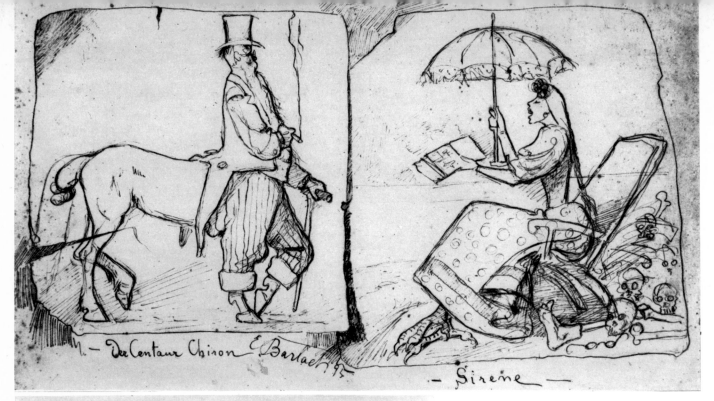

— Der Centaur Chiron E. Barlach

— Sirene —

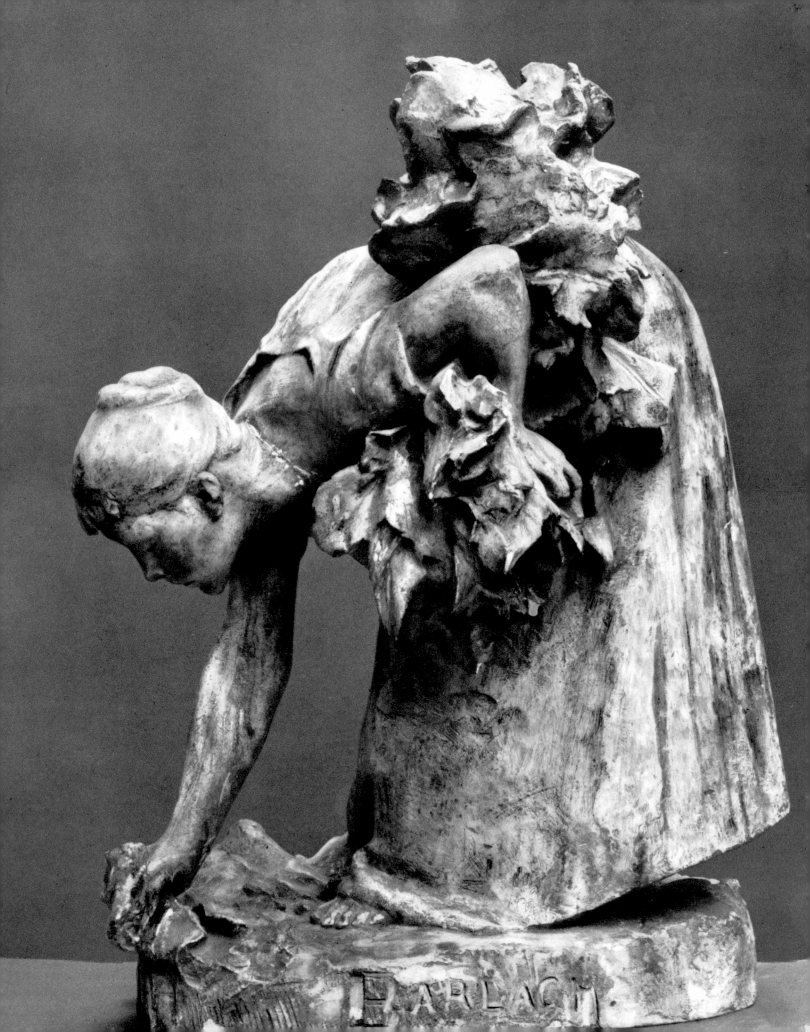

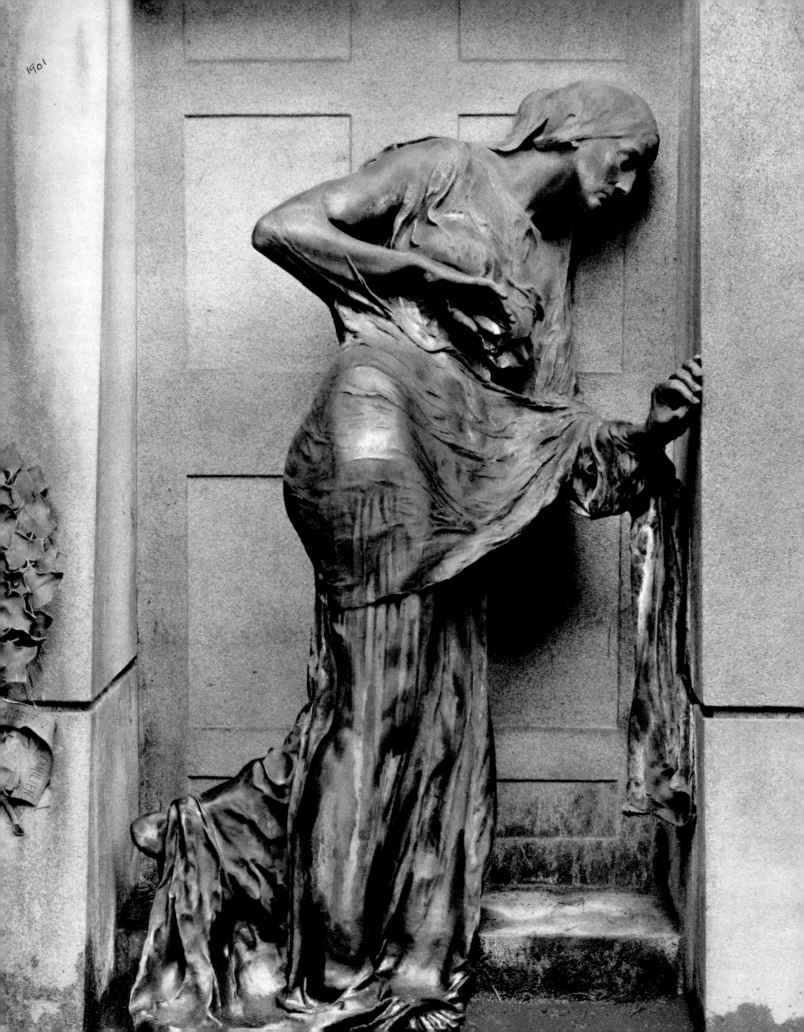

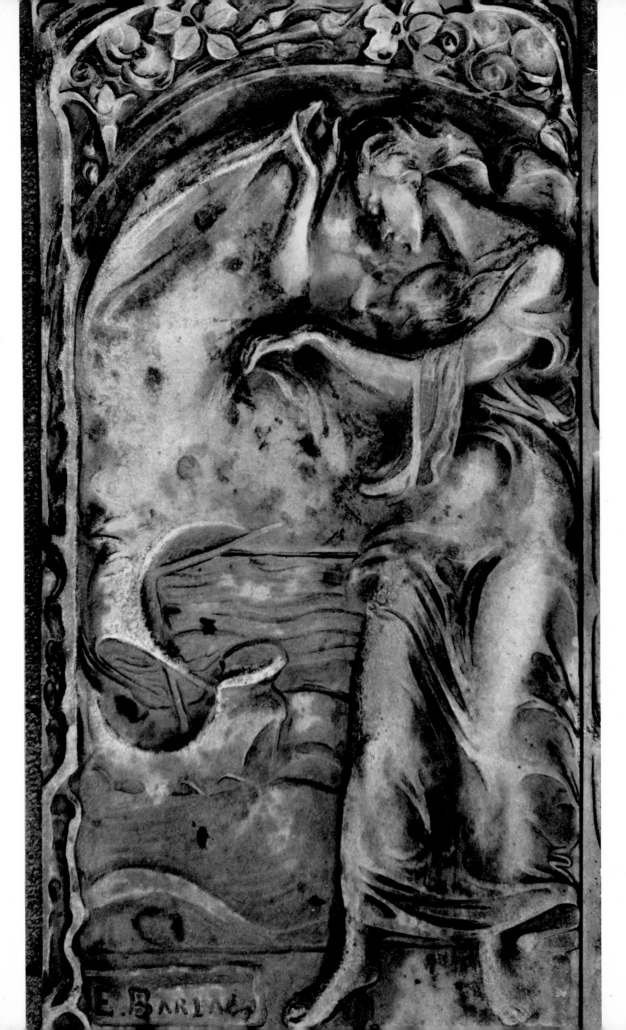

1902

23

24

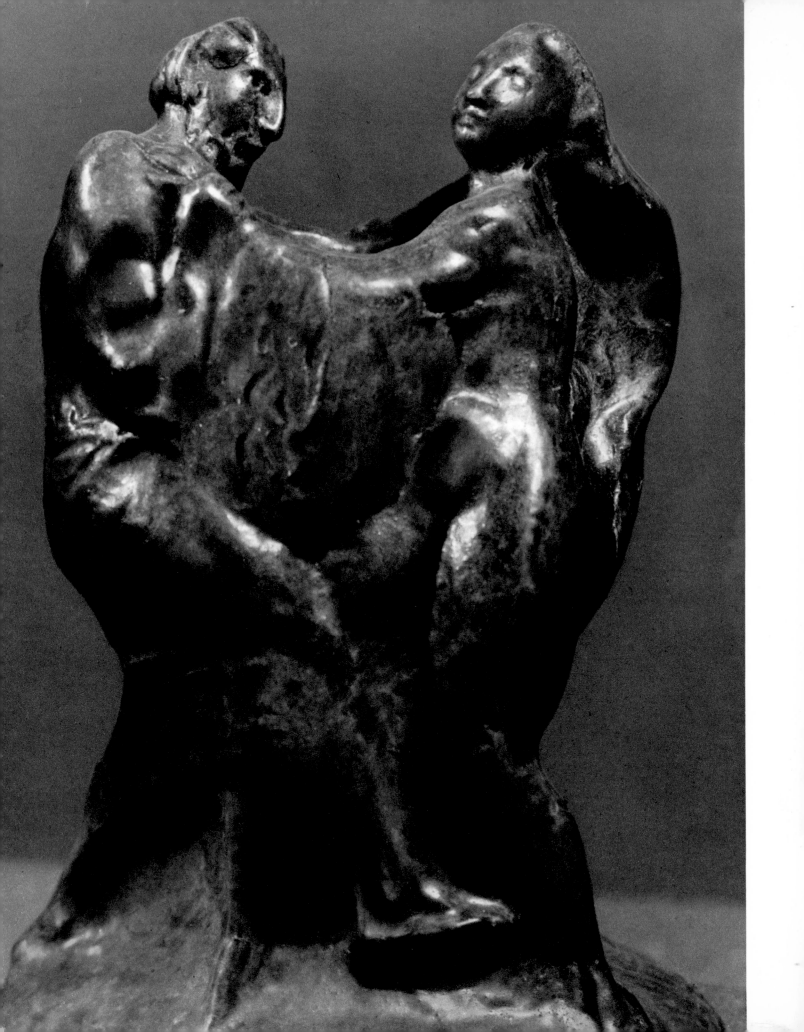

1903

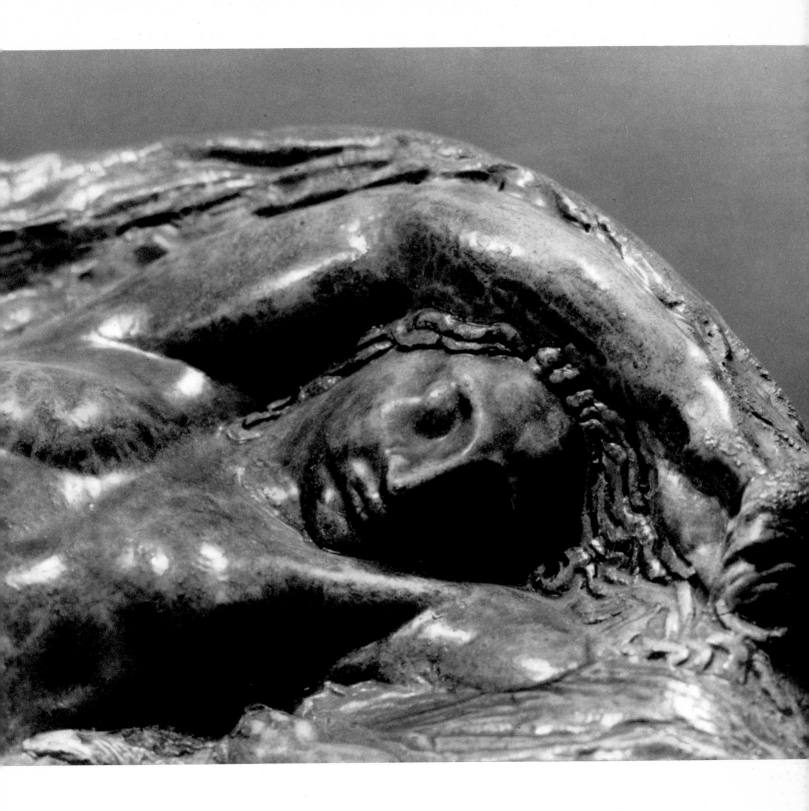

1904

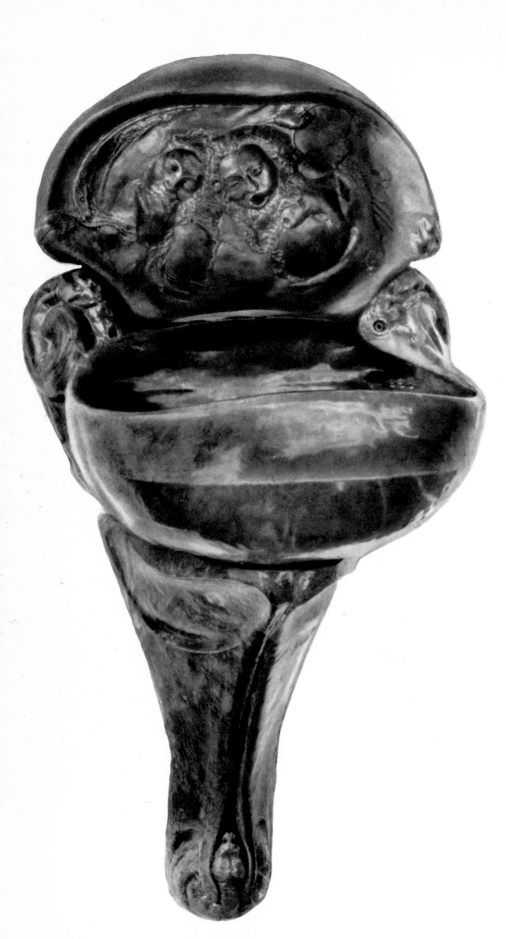

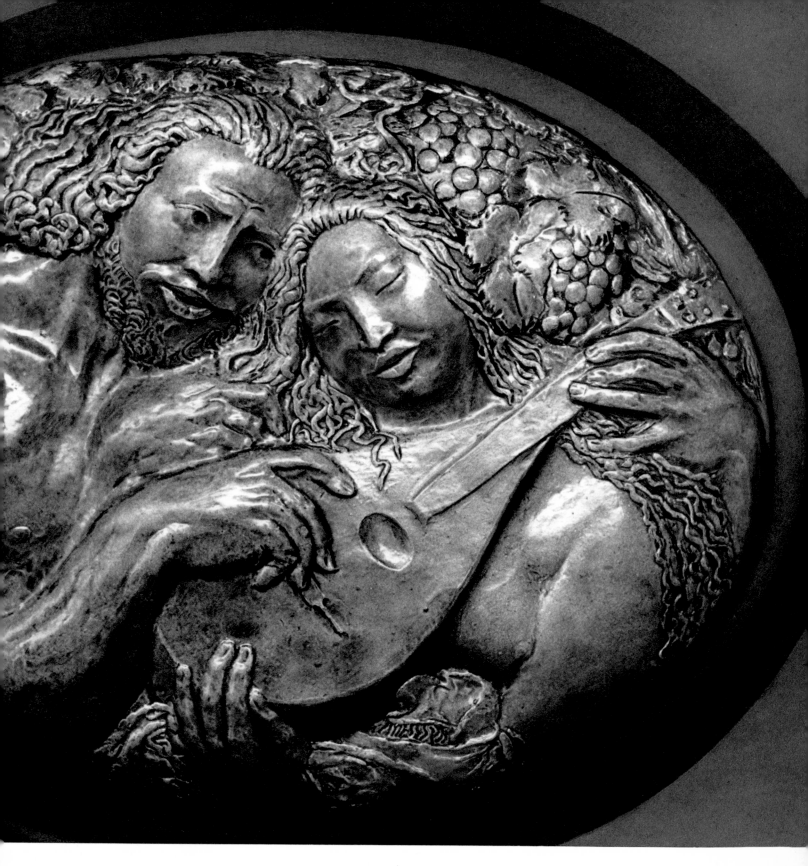

1904

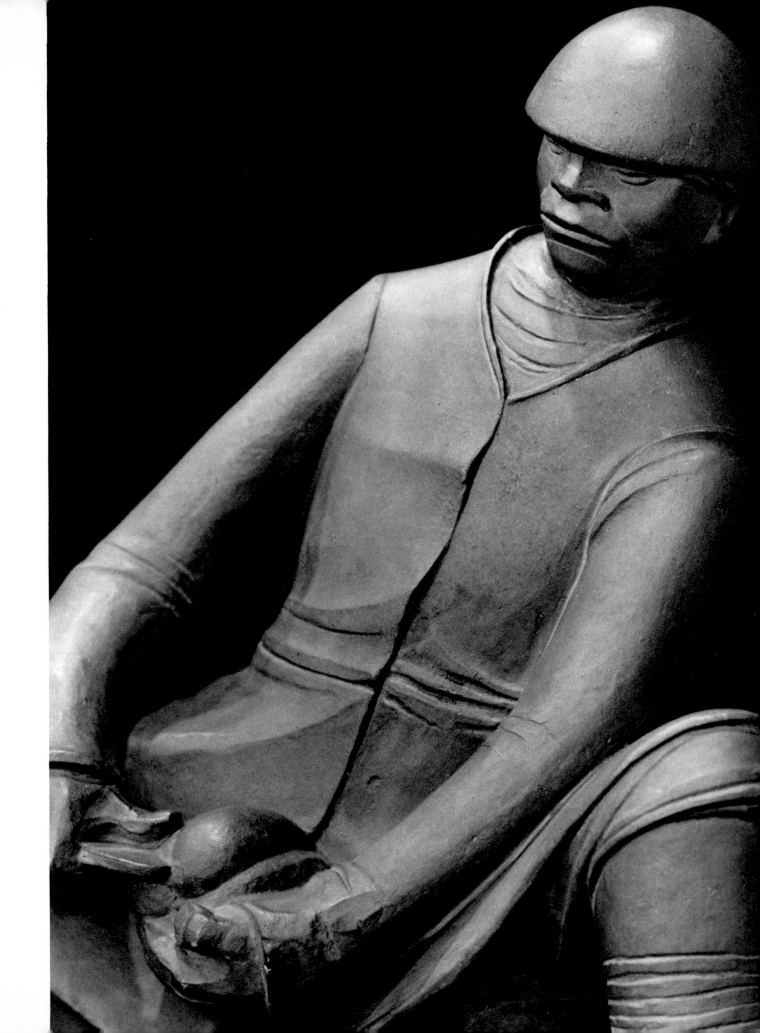

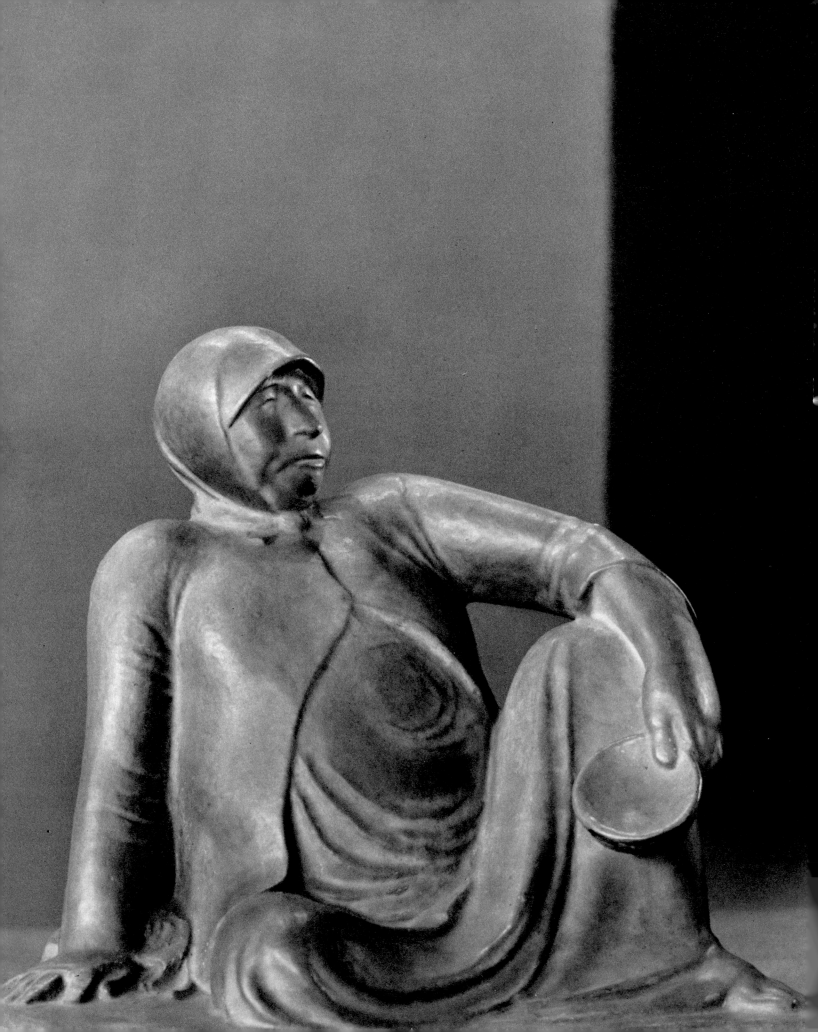

34

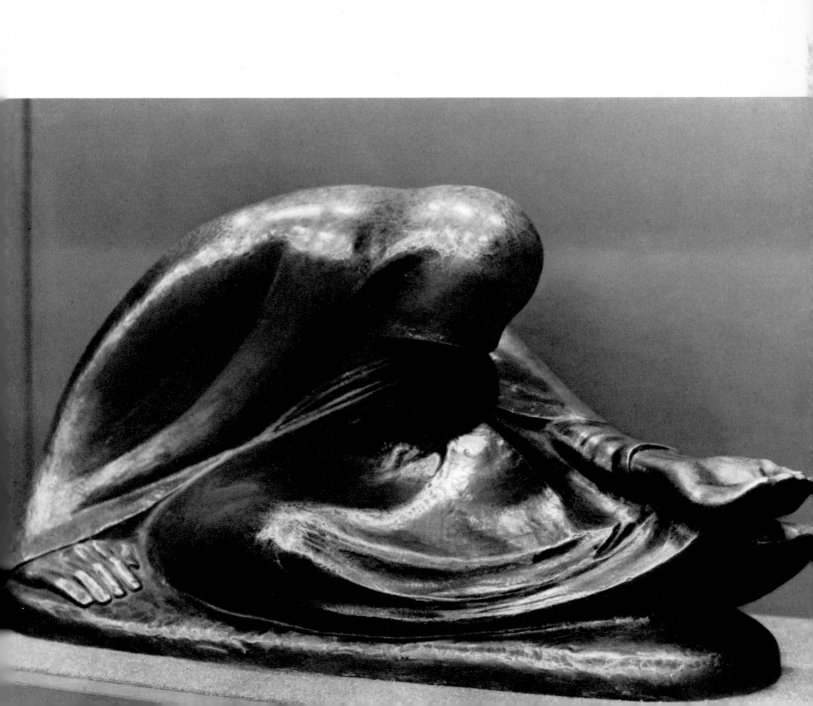

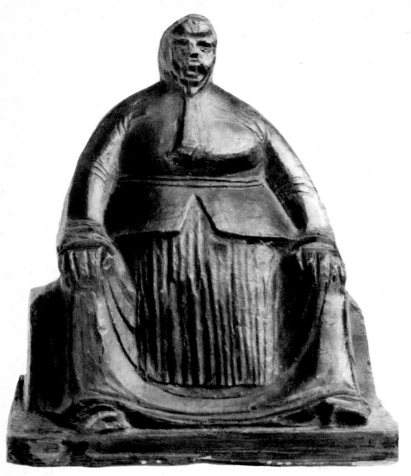

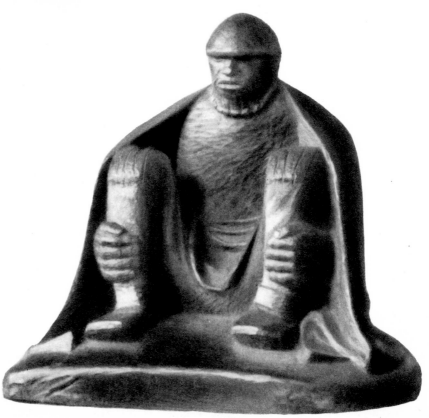

36

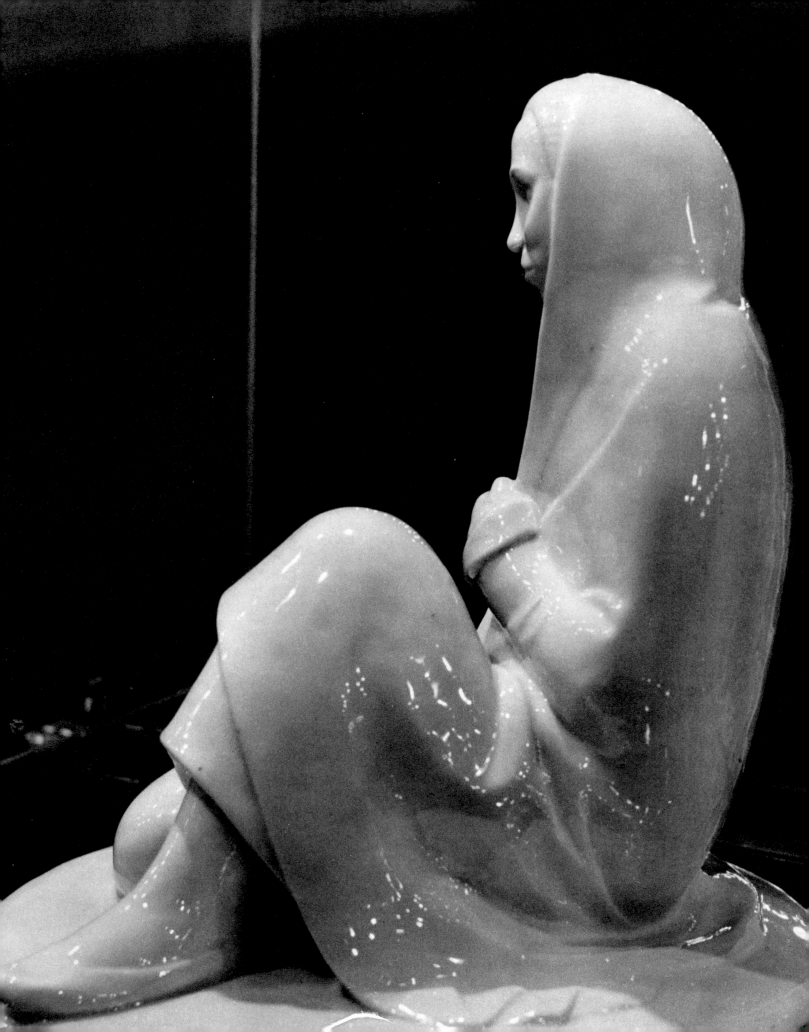

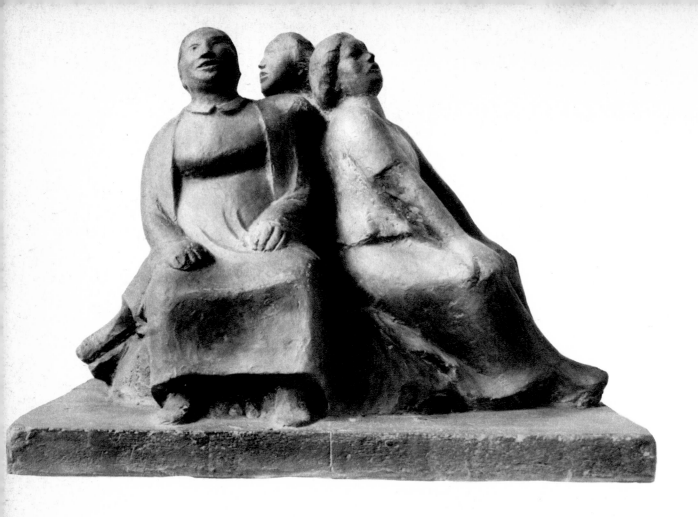

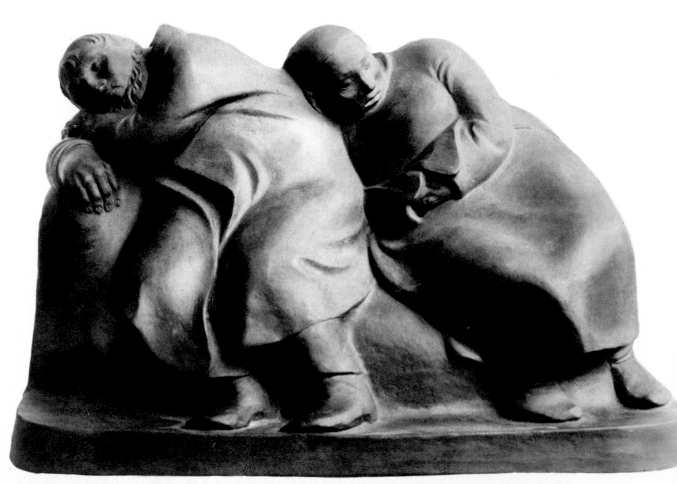

38

must lend the movements restraint and calm. Even a small angel, whose music should be like the rustling of the surrounding woods, has to put down his bow in the face of the solemnity of the setting.' Of course Barlach was concerned most of all with satisfying his important client, but the manner in which he adapted the prevalent *art nouveau* style shows that he possessed a remarkable formal vocabulary. This is borne out particularly by the two bronze reliefs on the tomb, *Lament* and *Woman Beckoning*.

22, 23

His sketches and drawings of that period reveal even more clearly the direction in which he was developing. Where in the past he had needed ten lines, he now made do with three. He himself wrote about this greater clarity, this discovery of the simple form and precise expression thus: 'At one time amid innocent wanderings hither and yon there occurred a turning-away from the thoughtless acceptance of every accidental form . . . I began, timidly enough, to omit everything that did not contribute to the emphasis of a not clearly known or desired effect: I was no longer simply tolerant, or the servant of the visible existence. I had the audacity to want to organize it, though often enough I became bogged down and instead of organizing was unable to do anything more than indulge in a decorative roll and surge.'

Barlach's painful maturing process, his ceaseless quest for the appropriately simple form, could not protect him against the 'decorative roll and surge,' particularly since he, in order to earn a living, had to fall in with the current taste. He more or less conformed to the *art nouveau* style, but it was only a transitional stage. Ultimately he freed himself of the decorative tendency of his *art nouveau* period. He realized that it was an obstacle in his sculptural work. That was why he was able to say later in life: 'I can bid good-bye to everything I did before the age of thirty-six with a light heart.'

Even though Barlach exhibited in a number of group shows in Berlin, he learned how difficult it was for a young sculptor to become known. He also did well in a competition for a Goethe monument in Strasbourg. The design he submitted showed the young Goethe, legs casually crossed, leaning back on a cane, looking up at the stars. We find here a hint of the concept which was to turn up ten years later in one of his loveliest wood sculptures, *The Astrologer*.

On the whole this first Berlin interlude, which lasted two years, was of little profit to Barlach. He was glad to return to Hamburg in the fall of 1901, when he and Garbers were asked to do a *Neptune* 25 sculpture for the building of the Hamburg-America Line, as consolation and compensation, so to speak, for the failure of the market-square project. Later Barlach, looking at the twenty-foot-high copper Neptune with trident and crown, standing on a shell drawn by four horses on top of the office building, dismissed it out of hand as a 'thrown-together object of grotesque incoherence.' Yet to us today it would seem that the expressive heads of the horses do constitute a thoroughly acceptable sculptural solution.

After this 'last mindless sortie,' as he himself, having grown sceptical over the advisability of such gigantic undertakings, sarcastically labeled this project, he left Hamburg for the city of his birth, Wedel, no doubt in an attempt to come to terms with himself, and to get away from the turmoil of life in the big city. He furnished a temporary studio, drew, wrote, and modeled, did whatever he felt like doing, and when the indoors became too confining took long walks along the Lower Elbe, his 'big room' as he used to call this corner of the world which he loved so much.

'How often,' he wrote in the novel fragment *Seespeck*, 'did he stroll in the sunshine across the heath or walk aimlessly across the bare fields . . . The white smoke of the burning potato vines seemed to him

like the longing to scatter his questions to the four winds, and the full moon hung like a large yellow seal on the forbidding sky.' *Seespeck* is Barlach himself, as he then lived and worked, withdrawn, a dreamer nourished by the landscape in which he feels at home.

Barlach's financial situation was precarious, his only source of income being a variety of small commissions, from headstones to portrait plaques. He was optimistic about some designs he had made for the ceramist Richard Mutz, who was trying his hand at new shapes and glazes based on Japanese models. Of course Barlach had to pay obeisance to contemporary taste, for only mass-produced items could possibly be profitable, yet he nonetheless managed to develop a highly personal, somewhat baroque style, and together with Mutz he succeeded in imparting a new and appealing quality to the traditional material. A reclining *Cleopatra* (1904), a relief named *Wine, Women and Song* (1904), and the highly original *Wall-Fountain* (1904) are among the fourteen designs he made for Mutz. Particularly interesting is a dancing *Faun and Nymph* (1903), a work whose imaginative shape hints at the sculptural power of the later Barlach.

But all this could not keep body and soul together. The ceramics failed to bring the expected profits, and in the fall of 1904, Barlach was forced to try his luck as a teacher in the school of ceramics at Höhr. He was most reluctant to do so, for he was neither a teacher nor was he sufficiently skilled in the arts and crafts; after only six months he left Höhr and decided to try his luck in Berlin once again.

This second Berlin interlude, which, apart from brief interruptions, lasted five years from 1905 to 1910, brought him both sorrow and misery and artistic recognition. He knew that everything was at stake and that he would have to mobilize all his energy if he was to make a place for himself. He was convinced that sculpture was his medium, and he hoped to be able to produce 'a work of complete

and, if need be, pitiless matter-of-factness.' But when he looked at his *Refugees Resting* in the Berlin Exhibition of 1906, a small bronze which he had thought good, it suddenly seemed to him to be only another half-measure and he became fed up with the whole business. He tells how after this disappointment he crawled into a dark corner of the Café Bauer, discouraged and exhausted. 'I am not misunderstood,' he wrote in his diary, 'but overestimated—after this!'

Since this bronze was later melted down, we cannot tell whether his harsh judgment was valid. But be that as it may, we know that he encountered more and more economic and personal difficulties, and that, sitting in his poor lodgings consisting of two rooms 'dark and long like a pair of coffins,' he reached a low point and thought of himself as 'almost hopeless.' 'In my discouraged state I was often practically unable to get out of bed. I would have liked to crawl back into bed by ten o'clock; I was going downhill.' But suddenly the unexpected happened, the big step forward, the by now unexpected artistic break-through. It began when his brother Niko, who had emigrated to America, visited him in Berlin and invited him to accompany him on a trip through Russia, to Kharkov, where another brother, Hans, was working as an engineer. It was to be a family reunion, nothing more, but for Ernst Barlach it proved to be one of the most important events of his life, the turning point in his artistic development.

'Even while we were driving through Warsaw to the other railroad station across the Vistula,' Barlach wrote in his autobiography, 'I was shaken by the happiness of the joyful awakening of one who had not yet forgotten the pain of slowly dying. I saw that the ready-to-harvest field was waiting for me. I thought: look, this is the same outside as inside, this is all immeasurably real . . . and despite fever and endless fraternal strife, I, like the plague, devoured all visions

44

of city and steppe with one all-consuming hunger, in the glow of another fever, an infection not through climate, but born of an incurable addiction which had consumed all my defenses. Nothing alien or dismaying, everything seemed to me like a long-familiar story, open, exposed, unresistingly offered to me at my pleasure.'

The trip lasted less than two months, from August 2 to September 27, 1906, but what Barlach experienced during this brief period stirred and shook him up and gave him new life, fresh courage, and self-confidence. He began to draw like a man obsessed, overwhelmed by the infinity of the steppes, by the insignificance of man in the vast expanse of this landscape. He took hold of what was offered to him, impressions of landscape, figures, and faces, and took down what he could in hundreds of sketches. In his *Journey Through the Steppes*, a brief travel book, he speaks of 'two kinds of infinity, the calm one in harmony with eternity,' and an 'infinity of the monumental craving for the development of an innate creativity.' This gives a clear hint of what moved Barlach most in this vast landscape, in which the human element, if one wanted to depict it, could assert itself only as a 'crystallized, clearly defined form'. He found and could grasp that which he had sought for so long: the prototype of the human condition instead of a mere reproduction, the human figure amid the forces of nature and fate to which it is exposed and against which it has to assert itself.

cf. 30 top left
30 top right

What Barlach experienced in Russia was in fact nothing less than the confirmation of himself. The Russian people, wedded to the soil and exposed to the infinity of space, embodied most strongly the uncertainty of human life between heaven and earth, the human condition in this world. Rainer Maria Rilke, who some years earlier had also traveled through Russia, had reacted in a similar fashion. He, too, was deeply moved by the Russian peasants, 'lonesome men, each

one carrying a world within himself, each one steeped in his humility without fear of abasing himself.'

The primitive life of these people, their physical closeness to the soil, lent every crouching or reclining figure, every peasant in the field, every roadside beggar, every market woman, every dancing pair, an almost sculptural quality, encompassing piety as well as rude anger, full of inner tension, mysterious yet completely real. That is how one had to work, Barlach felt, omitting everything incidental and giving the essential in figures which are as complete 'outside as inside, inside as outside,' without ever losing sight of the infinite.

On this journey through the steppes Barlach's hitherto unstilled longing, his insatiable hunger for sculptural expression, was satisfied. But his intoxication with the steppes was no mere romanticism, not simply an enthusiastic reaction to a legendary Mother Russia. Barlach was not blind to the bleak reality and abominable social conditions. He saw the misery around him, and he had no illusions. Beggars everywhere made a business of their poverty, lamenting and theatrical, not unlike the characters of Gay's *Beggar's Opera*. Barlach saw all this clearly, soberly, and unsentimentally: 'The fat beggar-woman whom I have been watching closely since my arrival,' he wrote in his diary, '. . . walks around as she must have done in better days, in rags but fat . . . The beggar with the artifical leg changes his post frequently. He leans against a lamp-post or a wall, standing firmly on his good leg, the artificial one propped on a cane. It dangles and is profitable. With slimy obsequiousness he points to it as if it were a famous sight, with a taunting smile, and he does not ask and certainly does not beg . . . Others pray, above all the many blind beggars who all day long tirelessly bow their foreheads to the ground and with sepulchral voices appeal to one's generosity. . . . One passes

by and either gives or does not give — and if one has heard the song of the beggars for a few weeks, this low, whining business-tone of publicized misery, one becomes disgusted with the entire lot of them, whether they are at fault or innocent victims.'

But regardless of his feelings at the time, these beggars continued to occupy his thoughts: 'That is what we humans are, basically all beggars and problematical beings,' he wrote many years later. 'Therefore I had to create what I saw, and naturally I developed a spiritual kinship with the suffering, simple, hoping, searching, and hence vice-ridden beings given to drink, song, and music.'

Barlach returned to Berlin bursting with creative energy. Of course, he still had to work long and hard before he was able to do really finished sculptures instead of half-finished models, but now he was able to come close to what he had in his mind's eye. Working feverishly he did a series of sculptures that were umistakably his own—beggars, peasants, and shepherds—unlike anything ever done before, not mere mirror images and certainly not figures from folklore, but sculptured prototypes, expressive, severe, and highly personal.

Much speculation has surrounded Barlach's Russian journey, during which he so suddenly and surprisingly found himself, yet the explanation is obvious. After years of trial and error, he stood ready, at the age of thirty-six, to master the human form. He was like a dammed-up stream ready to burst forth. True, in his Wedel days he had gained fresh insights, but the familiar setting of his native plain was apparently not enough; he needed a more forceful catalyst, a still greater expanse of space, and an encounter with a still simpler way of life to bring him to a clear and more profound understanding of the human form. That is why these peasant figures of the Russian steppe would not let him rest until he recorded them as they were, free from all extraneous decoration.

In the spring of 1907 he exhibited two terracottas at the Berlin Secession, the *Blind Beggar* and the *Russian Beggar-Woman with Cup*. Here we meet her again, the fat beggar-woman of his diary. When he compared the finished sculpture with the original pencil sketch, Barlach arrived at a conclusion which may have come as a surprise even to him: 'I have changed nothing of what I saw. I saw it like that because I saw simultaneously the vile, the comic, and —let me say it unabashedly—the divine.' cf. 32

These two *Russian Beggars* won the applause of art lovers and experts whose judgment Barlach respected. He was particularly pleased by the praise of August Gaul, the well-known animal sculptor. It was Gaul who introduced him to Paul Cassirer, a venturesome art dealer and publisher whose generosity during the next twenty years played a vital role in Barlach's life.

In his reminiscences, the art historian Karl Scheffler, who followed Barlach's development closely, tells of those years of early success: 'On first meeting him one immediately felt that here was an outsider and a unique man. Even though he was still groping and did not know how to master the wealth of his sculptural-poetic vision, he still impressed one as a well-rounded personality. He was destined to suffer, for there was something of the addict about him; the source of his power was one-sided, but it flowed with enormous rapidity. He had none of that pallid coyness which so frequently characterizes the romanticist. Also, he did not run away from life.'

He lived modestly and, as Scheffler pointed out, very differently from other Berlin artists, who led a solid bourgeois existence, going to parties and looking for business. Barlach had no social graces. He tended to withdraw, hermit-like, and success did not change him.

His behavior when a woman whom he thought he ought not to marry bore him a son was also not ordinary. He did not try to evade

responsibility for the child and make a financial arrangement with the mother, as many others might have done. On the contrary, he fought a bitter court battle for custody of the child. 'I have the pleasure,' he wrote in a letter of 1907, 'to be suing the mother of my boy for him. The law does not recognize the father of an illegitimate child as a relative; however, it has left open the possibility to have it declared legitimate, even against the wishes of the mother.' After winning his suit he looked after the little boy by himself, until his mother, who was living in Güstrow, took him. Scheffler describes this new, almost forty-year-old father, thus: 'One winter day I ran into Barlach on the street. He was carrying his boy on his right arm, and in his left hand he held a newly-purchased kerosene lamp. He looked like an emigrant, and in fact that is what he was all his life. The only thing that was missing was for the lamp to be lit in broad daylight and the walking simile would have been complete.'

It should come as no surprise that this emigrant who was never completely at home in the bourgeois world had his peculiarities. He was, Scheffler said, completely unpredictable; everything about him seemed spasmodic and abrupt: 'He rarely spoke at length, but could be very descriptive in few words. And many of his words and expressions were of his very own coinage.'

After his return from Russia Barlach also began his first play, *Dead Day*. The idea grew out of a personal experience, his battle for his son, which left him with the feeling that even though he had acted according to his convictions he had nonetheless been a party to a tragedy by taking the son from the mother and the mother from the son.

Dead Day is set in a mythical twilight world in which domestic spirits are on intimate terms with human beings. A young man wishes to leave home and follow his father, who has gone out into the world and never returned. The mother does not want her son to leave. She sees the outside world only as temptation, not as a challenge, and tries to stifle her son's desire to set forth. But he has been stirred up by the words of a blind old man, a mysterious agitator and emissary from afar. When he remains deaf to his mother's pleas and imprecations she resorts to a radical measure: she blocks his escape by killing the horse on which he had planned to ride away. It had been his one hope of escape. The mother through her selfishness destroys her son's future, and both of them die because of it.

Replying to attempts at psychoanalytic interpretations that he had written a play about a mixture of maternal and sexual love, Barlach quite emphatically denied having had anything of that kind in mind. *Dead Day* was an attempt to put everything he wanted to say in his sculptures into words as well, as if the shapes formed by the artist's hand had expanded, stretched their heavy limbs, and

begun to master the art of speech. Though what they had to say was written on their faces, still here they sound a new note, a peculiar sort of restlessness, an immense longing. This, his first dramatic work, contains one element which was to recur in all his later plays — the conflict between the soul and the body in which it is imprisoned. 'Everyone has inherited that which is best in him from an invisible father,' he says at the end of *Dead Day*. 'What is strange is that man does not wish to acknowledge that God is his father.'

For a long time Barlach vacillated between the visual arts and writing, undecided as to which offered him the better chance of self-expression, when he suddenly reached the most unexpected decision of doing both—sculpting *and* writing. Both sprang from the same source and contained the same elements, only in different forms. He did not mix the two art forms and did not seek to remove the line that divided them. He never lost sight of their individual laws. He did not let literary ideas infiltrate his sculptures, nor are his plays the recorded voices of his plastic figures, and, most important, he was not one of those theatrical versifiers who nursed some nebulous ideas about 'total art'. However, there is no denying that there exist connecting lines between his sculptures, drawings, and writings. Everything he did bears the mark of an unusually strong personality whose astonishing gifts were channeled to present the image of man and his world in one focal point, in an existential experience.

In 1907-1908 Barlach made his first wood sculptures, the *Sitting* 36 top
Woman, *Sitting Shepherd* and *Shepherd in a Storm*. Why did he 36 bottom, 57
suddenly change his medium? Perhaps at first it was only a desire
to give his work its final form himself, without others making casts
and models. But apparently he soon began to feel that this new
material was a boom to him, and he began to work in wood with
unparalleled energy. Barlach himself described his initial experiences
in a letter written to Artur Eloesser, the art critic of the *Vossische
Zeitung*: 'You probably know that in 1907, untutored, I began with
wood. The so-called wood sculptors, ornamental carvers of buildings
or furniture, artisans, still possess something like a tradition; their
tools have been handed down from the past and they know how to
use them. They work from hourly wages or by the piece or yard; they
are uncommonly skilled people and they laughed themselves sick
over my methods. One of them gave me tools. I, completely ignorant,
promptly cut myself. Still, I did not have to discard even one piece
of work as a failure, even though curious things often happened.
Thus for a while I started by sawing, and I must say that the freshly
sawn woods often looked quite good. Had I stopped right there
and exhibited them, who knows what kind of excitement I might
have created. But I searched for perfection and had the satisfaction
of seeing some of my things which were merely clumsy accepted as
something special. On the whole I made things pretty difficult
for myself . . . For years I prepared the wood with an axe, and right

up until 1927 I sharpened the various tools with a kitchen whet-stone.'

Together with the early wood sculptures, which ushered in not only new methods of work but still greater formal concentration, he created a series of ceramics, porcelains, and bronzes, all based on themes of his Russian sketchbooks, among them *The Melon-Eater*, *Sitting Girl* (1908), *Reclining Peasant*, *Russian Lovers*, and the almost stylized *Russian Beggar-Woman* (1907), a seated, huddled figure, head bowed low, propped on her right hand, the open left hand extended, the whole a single touching gesture of entreaty.

cf. 31

37

35, 40

Thenceforth Barlach preferred to extract his figures out of the unyielding block of wood. He knew only too well what he was taking on, but he was firmly convinced that he had found the ideal material. As it turned out he was right. Six superb wood sculptures were the harvest of these fruitful years: two *Astrologers* (one standing, 1909, and one sitting), *The Carouser*, *Troubled Woman* (1910), *The Money Counter*, and *Wild Norse Warrior*, all the product of a ten-month stay in Florence in 1909.

65 bottom left

58, 59

This Italian journey, his last trip abroad, led to a final re-examination of his chosen road. 'Italy did not overwhelm me,' he concluded. 'I came detached and left detached. It would have overwhelmed me had I been a painter, but luckily I was not a painter.' He was captivated by the beauty of the Tuscan landscape, which he discovered in the company of his friend Theodor Däubler. He admired its architecture, was impressed by the frescoes in the Baptistry of Florence, and was moved by the Etruscans, but he remained unchanged. He was not intoxicated by the South because he belonged to the North. The wood sculptures he did in Florence are clear evidence of that. Subconsciously he had long before drawn a dividing line which nothing would induce him to cross.

'On a bleak December morning I again found myself on the Potsdamer Platz (Berlin), strangely sobered,' Barlach writes of his return from Italy. 'I felt chilled by the coldness of the place and the hour, but in its breath I sensed a challenge and a promise.' Soon he again felt that this was the right place for him, traveling back and forth between Berlin and Güstrow, where his mother and son were living and he missed neither the sun nor the light of the South. On the contrary, he felt at ease with the fog and the spirits of the North. The wind blowing across the plain was his friend. He would take hold of his coat and pull it round himself to keep out the wind. Here garments draped themselves differently from in the South; here the limbs were rough and the movements sudden and surprising. Restless longing, not regal serenity and harmony, was the keynote. His soul responded to it . . . He had remained unchanged and so had the landscape. He was happy that this was so.

Barlach's decision in 1910 to move from Berlin to Güstrow was dictated by his concern for his son and his mother. Yet this would not have been reason enough had he not felt that Güstrow was his home. He needed an environment which would not distract him from the work he had to do. Paul Cassirer had freed him from financial worries. He gave Cassirer everything he did in return for regular advances, a most generous arrangement doubly welcome to Barlach because it gave him complete artistic freedom and allowed him to live and work where and how he liked. 'Cassirer spoiled me,' he said after Cassirer's death, and in fact no young artist could have been treated more generously by a dealer. Yet, Barlach, 'a non-Berliner from the top of his head to the soles of his shoes,' as he himself said, could never get rid of the feeling that in Berlin he was being ground down by the art business, even though it was in Berlin that he had found his sculptural form. He therefore remained bound

to that city which had brought him not only recognition and economic security but was also, at least indirectly, responsible for the growing influence of his work beyond the borders of Germany. Yet at the time Barlach was glad to get out from under the 'Berlin goad' and to settle down peacefully, reunited with his family. Now he could devote himself to the development of his many ideas. Mecklenburg offered him the themes he needed. 'I would like to know,' he argued rightly, 'how I could have found them in Berlin. If not among the proletarians, certainly not among the bourgeoisie.' A new period of creativity was opening up for the forty-year-old Barlach. He no longer felt rootless; his feeling of belonging gave him greater sureness and greater mastery. He soon felt so much at home in Güstrow that he compared himself to the old Chinaman who, having to leave home for a few days fits himself out as for a long journey and takes tearful leave of everyone, only to return in three days.

In a letter written during those early Güstrow years, he half amusedly and half contemplatively says that he has been called a 'Low German sculptor,' undoubtedly because of his Mecklenburg themes, and 'probably because Low German is a naively powerful, rough language, appropriate to everything human and untutored. I would like to express sculpturally the elemental quality inherent in the Low German people, with which I have been familiar since my earliest youth.' He was a sculptor with a North German accent if you like, but the local character was not an end in itself but a means; not the goal but the point of departure. In his North German as well as his Russian figures, he was always concerned with the essential nature of the subject he was sculpting. This is made quite obvious in the sculptures of his early Güstrow years—*Resting Wanderer, Sleeping Vagabonds* (1912), *Three Singing Women* (1911), *Lonely Man* (1911), *The Stroller* (1912), and *Panic Terror* (1912).

38 bottom, 38 top
62, 64
65 top left, 67

55

Barlach's intimate relationship with his themes is brought out by a conversation he had with Friedrich Schult about his *Stroller*: 'Yes, he was a local man who got in between Güstrow and Rostock,' he told Schult. 'He sat opposite me, his massive body so motionless that our knees touched. Sketching him right there was out of the question, so all I could do was observe him so closely that I could memorize him.'

In making his wood sculptures, which now constituted the major part of his work, he usually began by making small plaster casts which did not lend themselves particularly well to detail. He knew that the detail would come about almost spontaneously when he worked on the final wood, for every medium has its own laws. He did not believe in fixing every detail in the preliminary design. This he thought put a brake on the imagination and impaired the chance of utilizing all the possibilities inherent in a specific material. On the whole, his approach was unconventional. He did not, for example, believe that the block of wood a sculptor used had to be all of one piece. He refused to become dependent on a single piece of wood and would glue his blocks together as required. He knew the shape he wanted, he said, and that was what mattered.

Barlach did more than ninety wood sculptures. He remained fascinated by wood for almost twenty years, achieving such supreme command of the material that at times it is almost impossible to tell where his work ends and the material takes over. In his sculptures the grain combines with the marks of his chisel, the structure of the material with the figure, to form a new, living, monumental entity. No other modern sculptor has equaled his work in wood, which is considered the very core of his total work. This does not mean, however, that Barlach's mastery of other materials was less complete. There are the unique early ceramics and porcelains, as for ex-

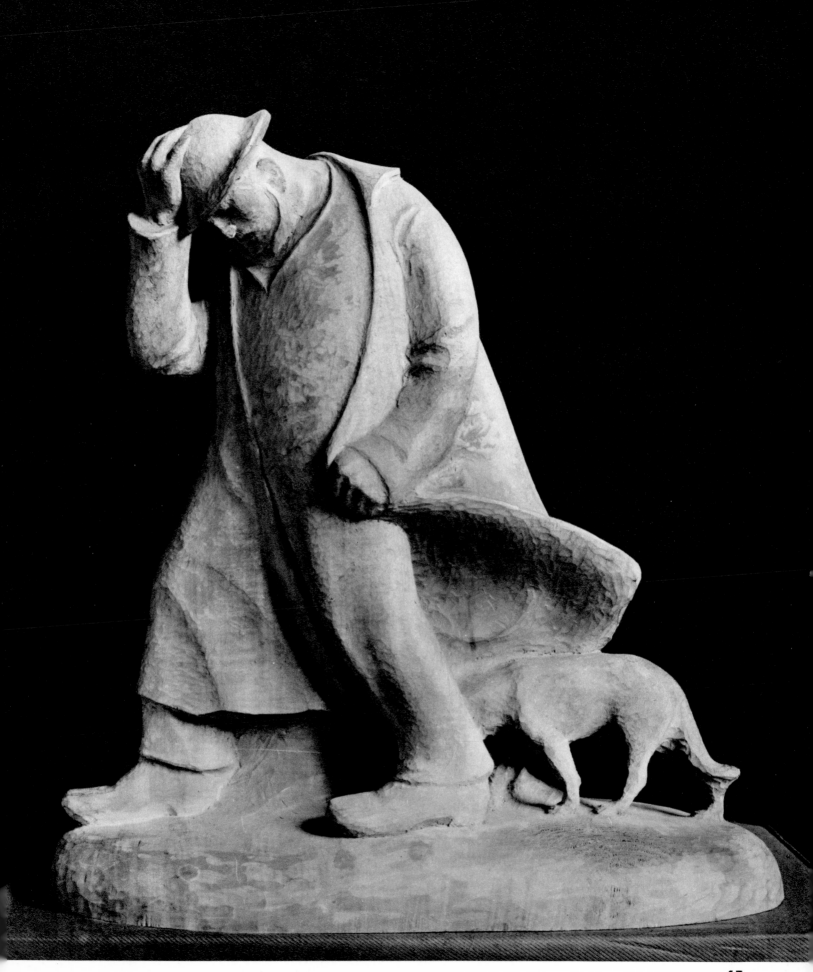

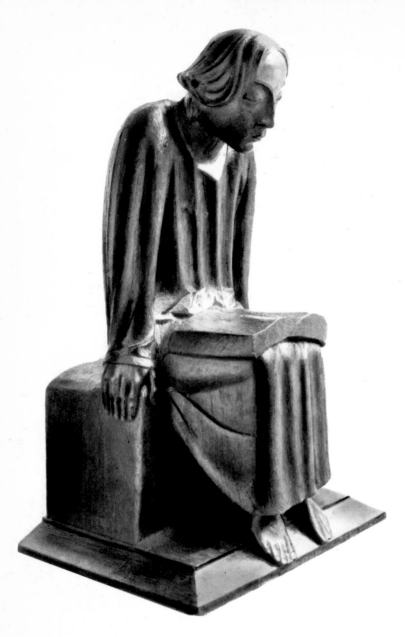

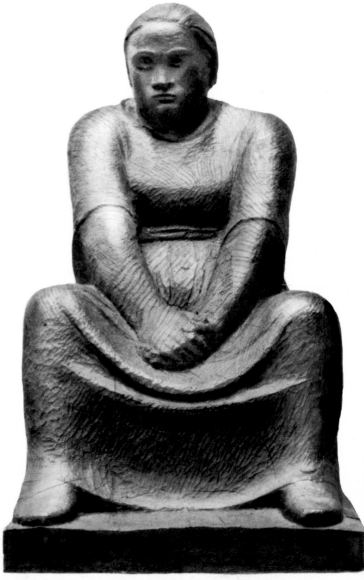

58

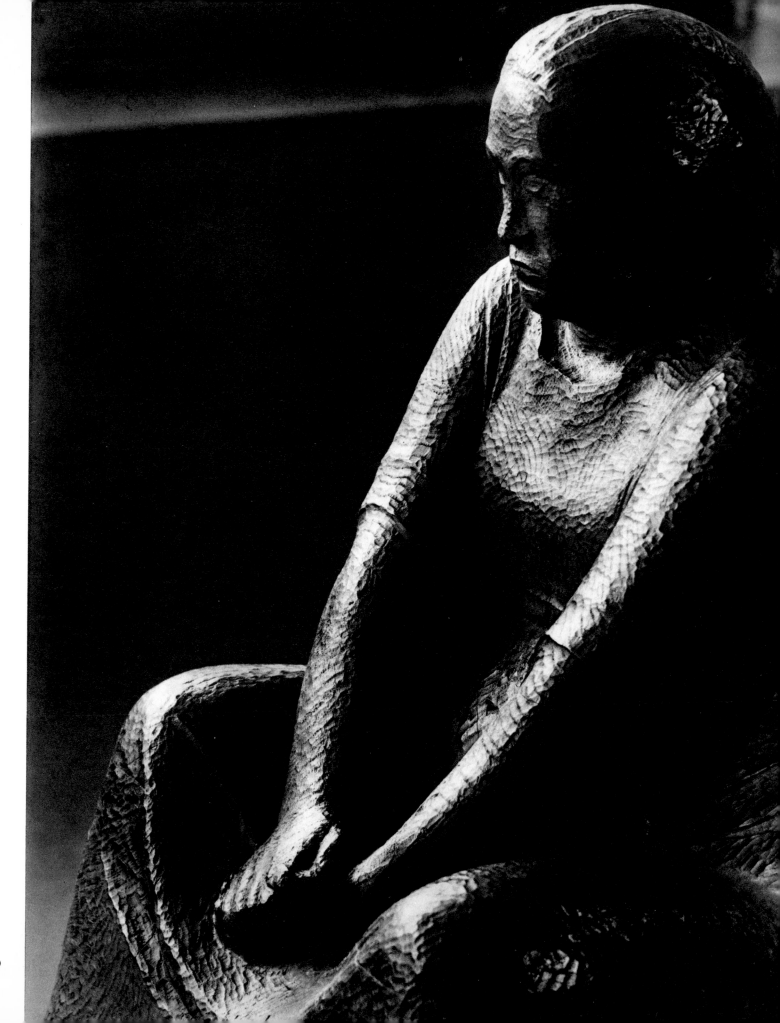

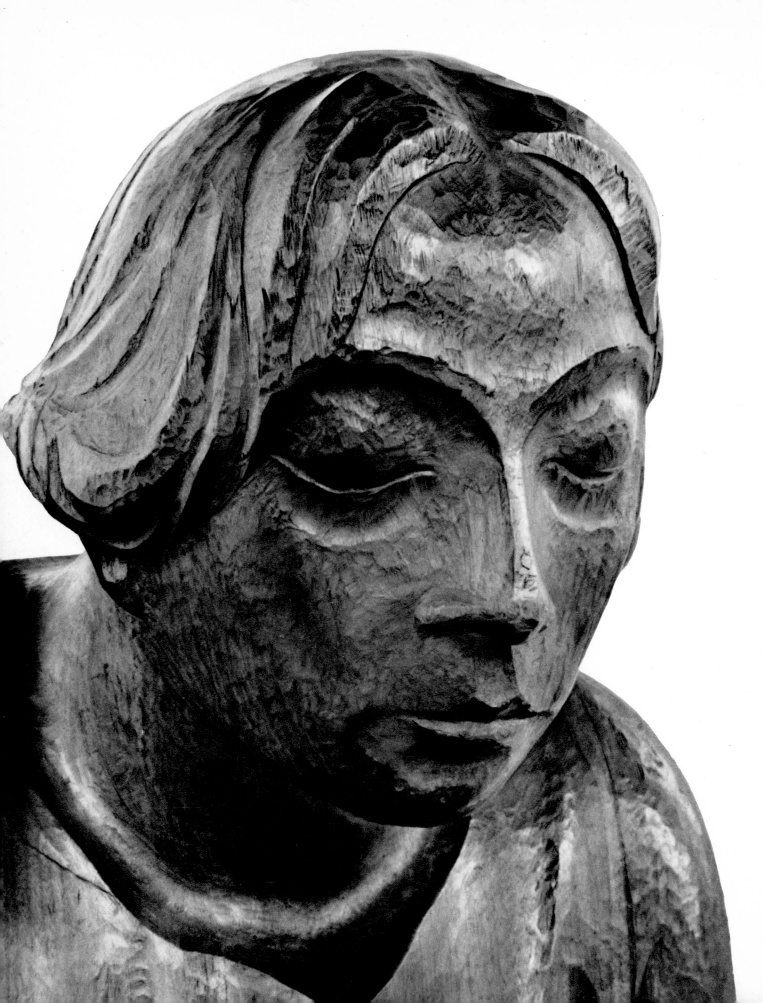

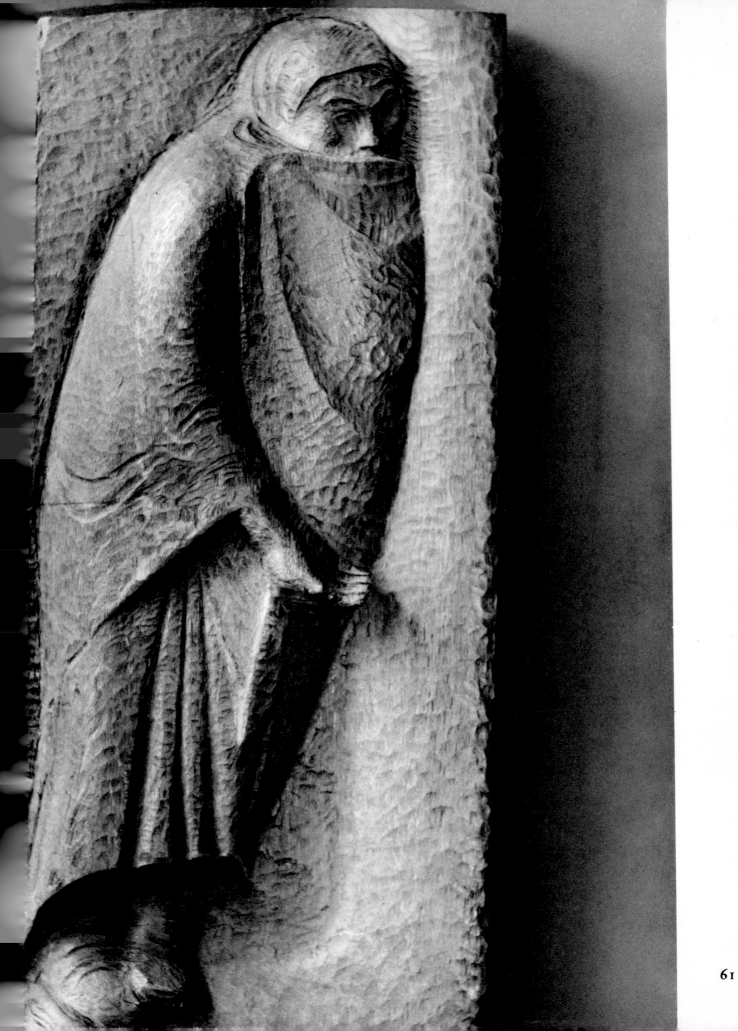

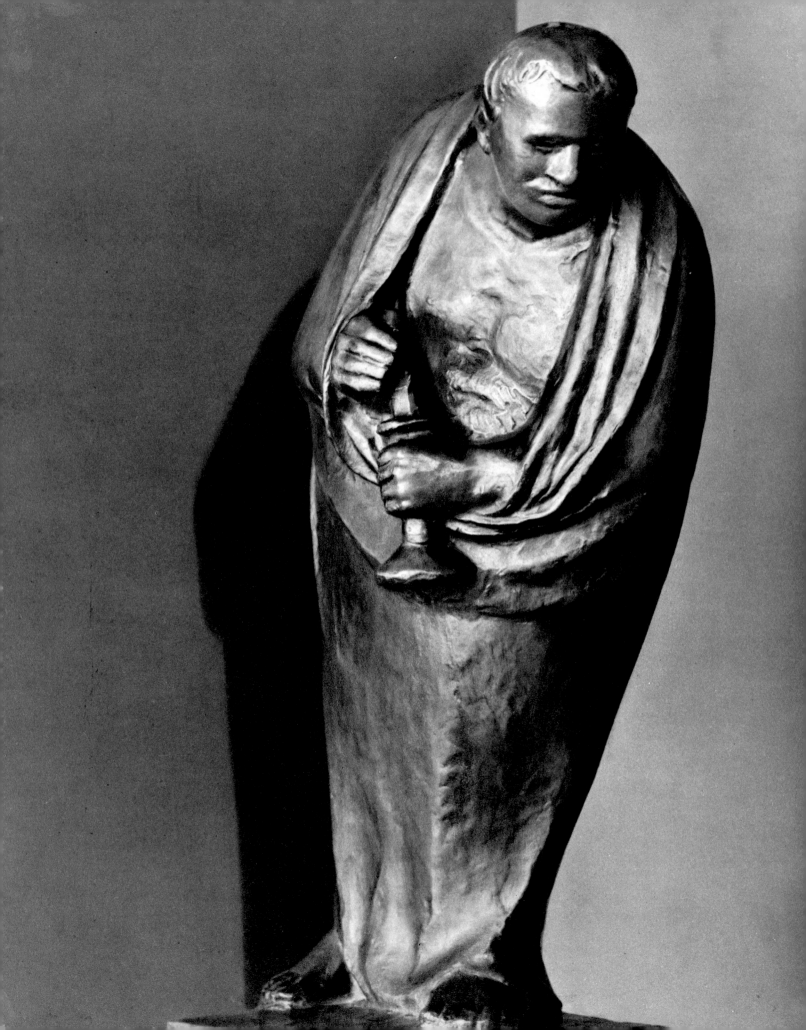

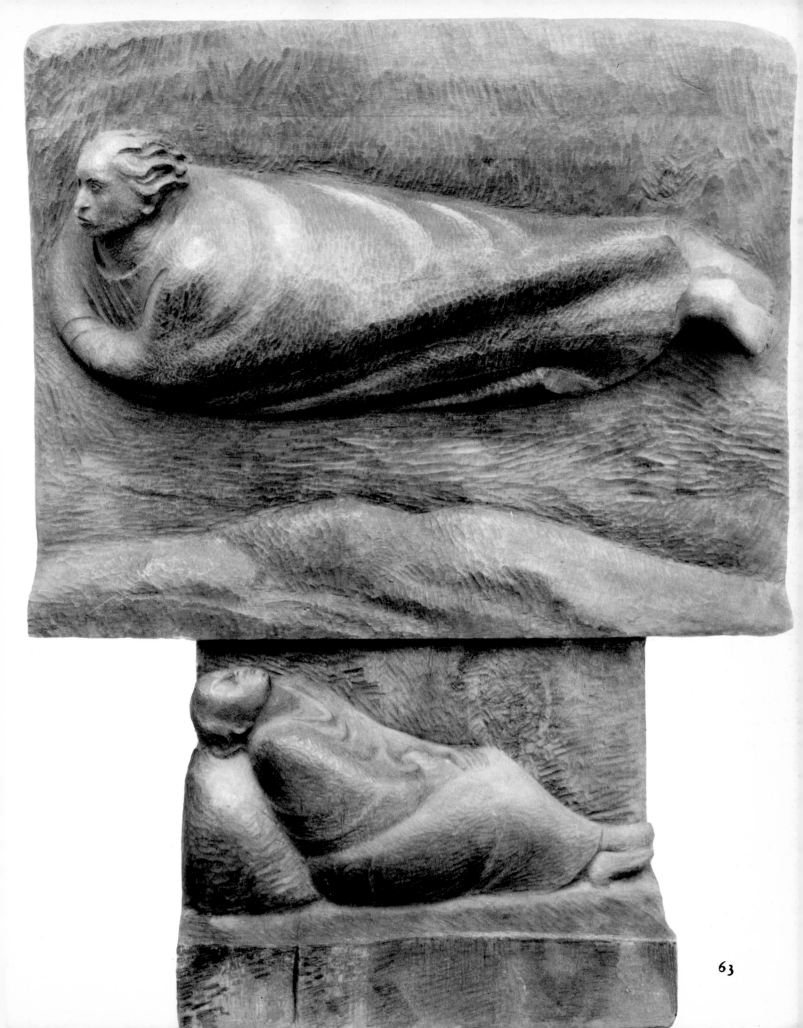

63

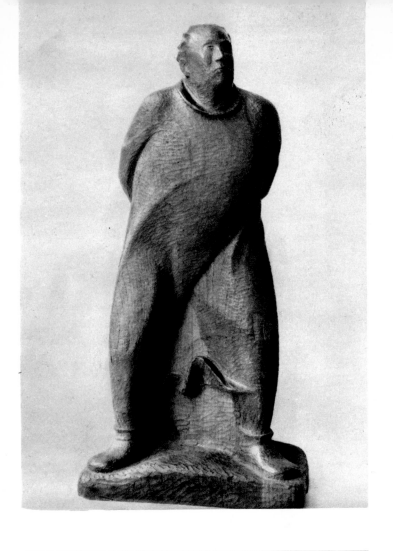
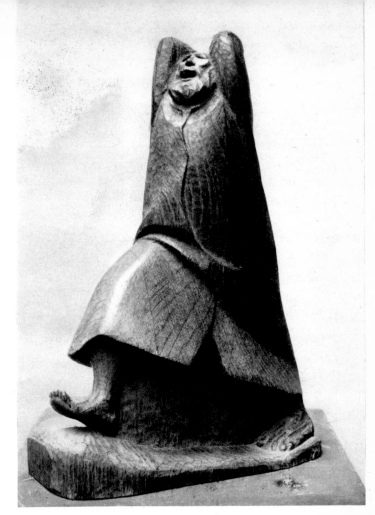
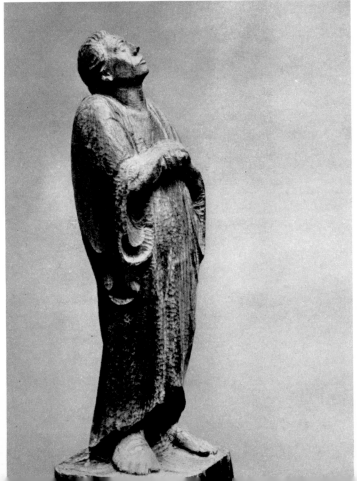
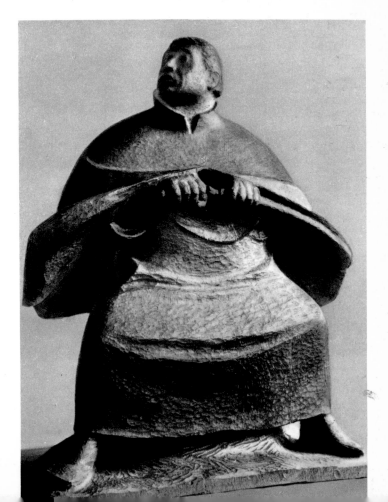

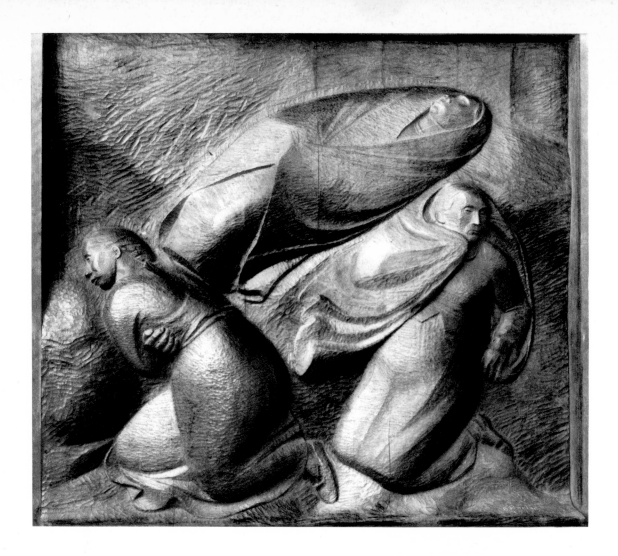

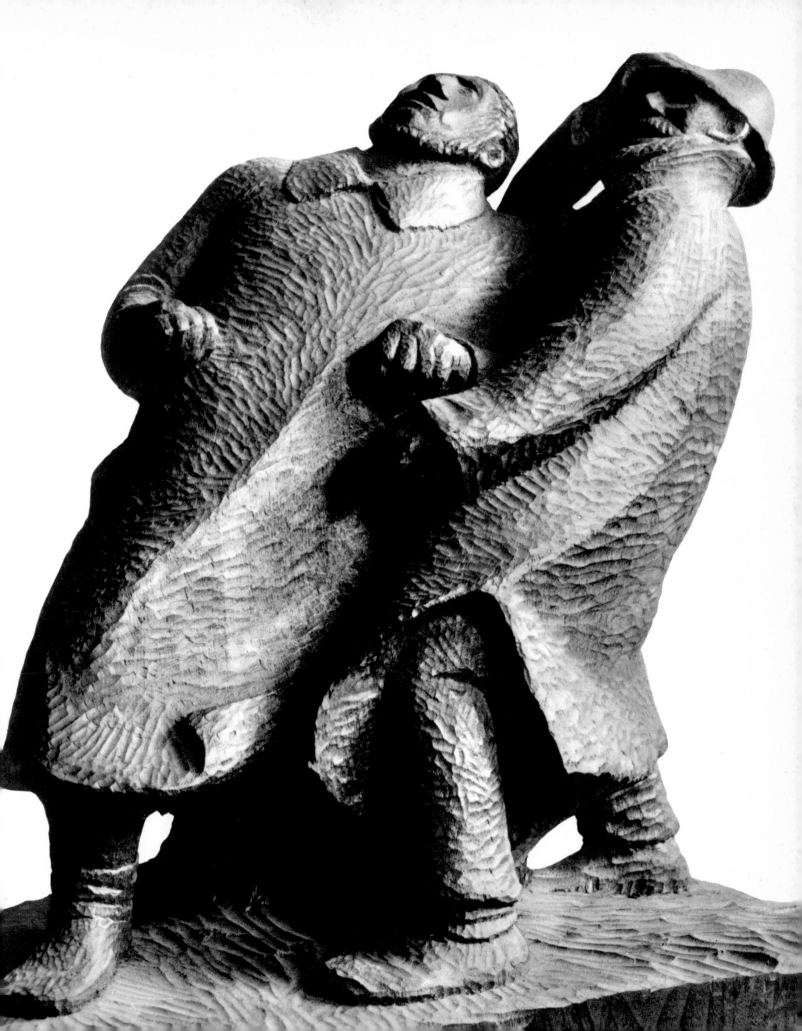

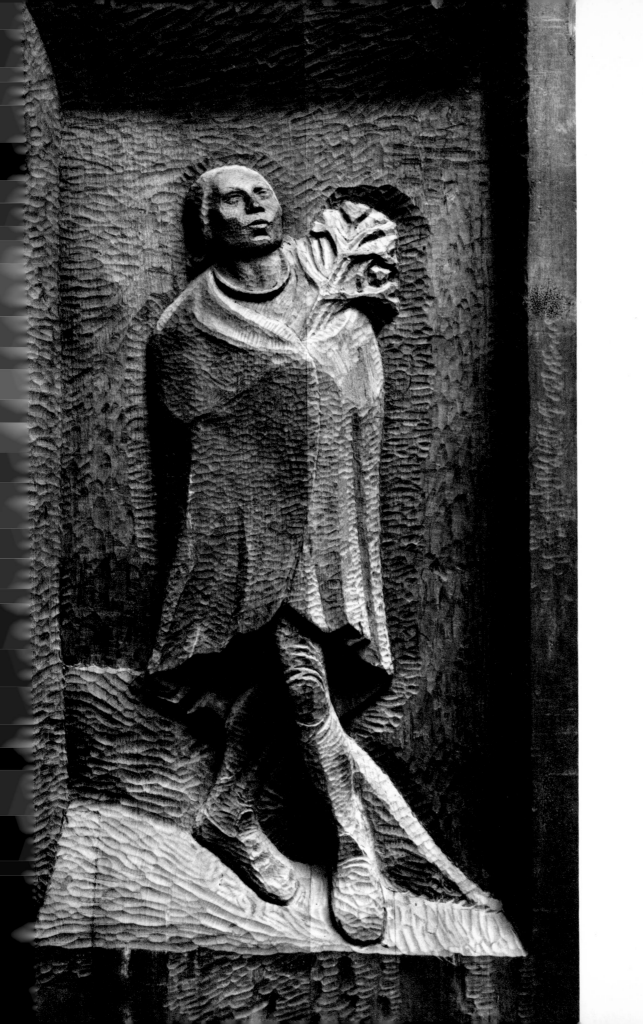

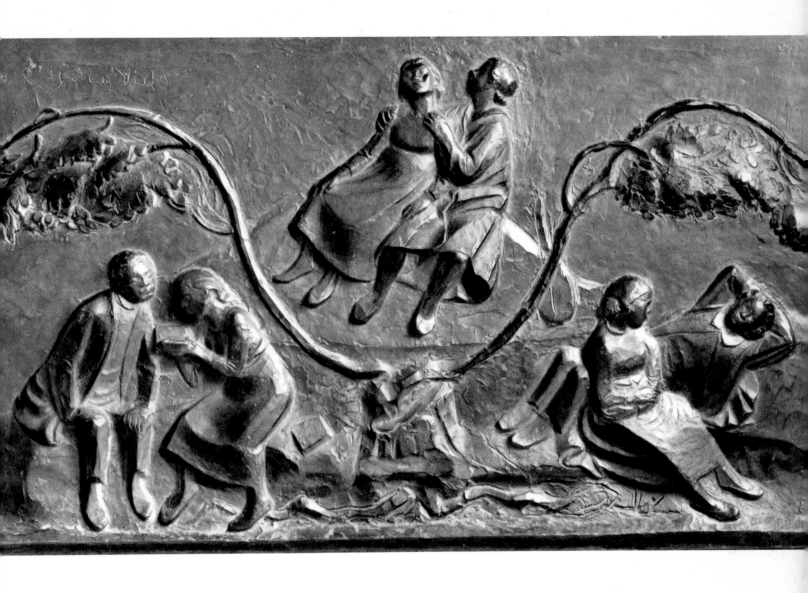

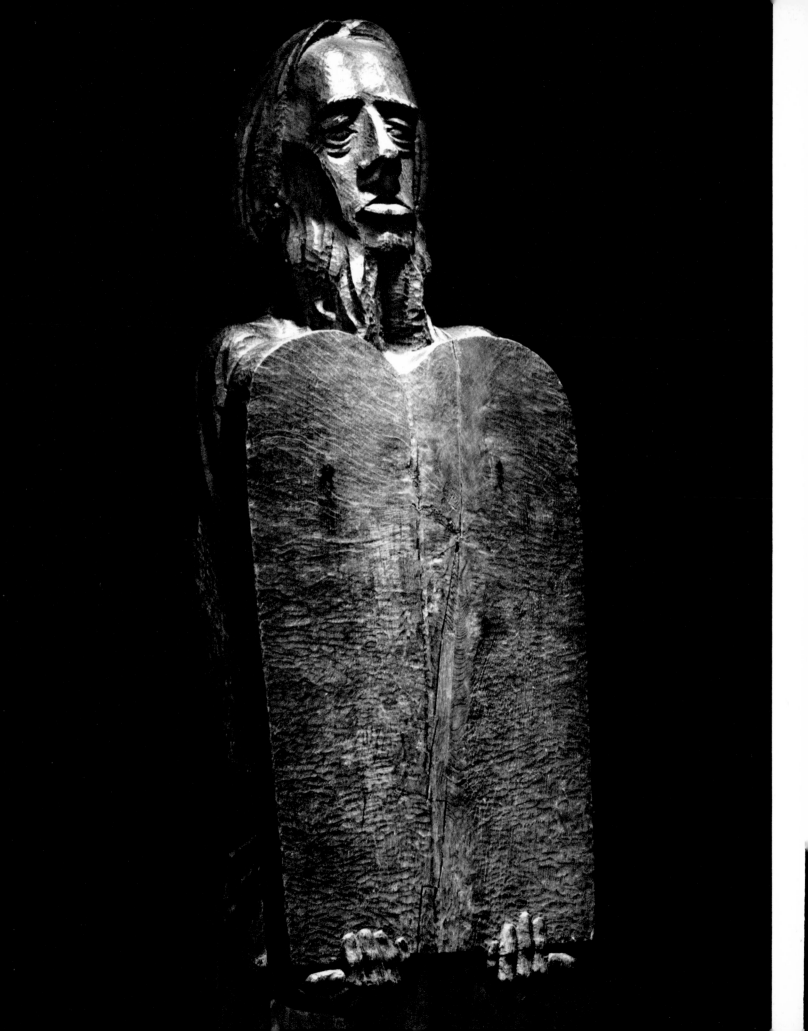

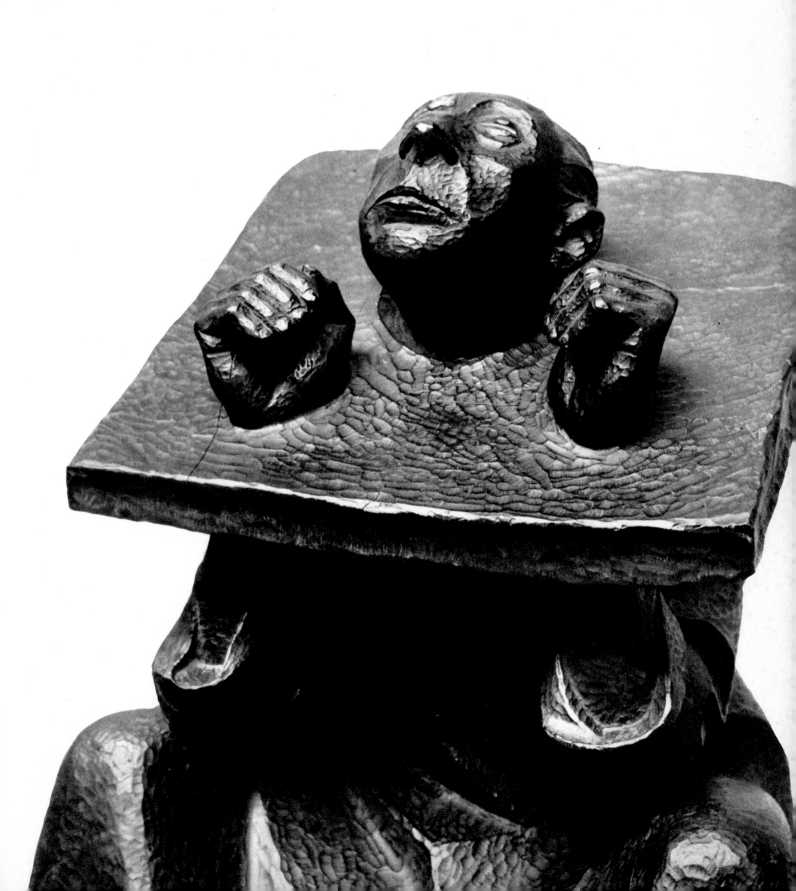

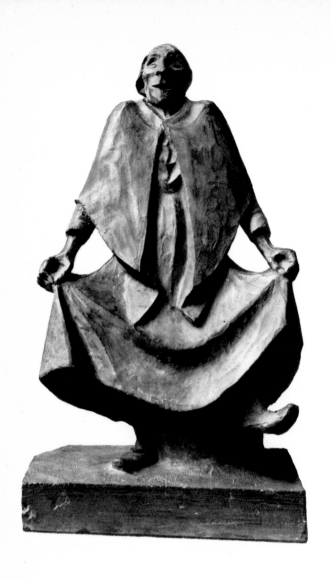

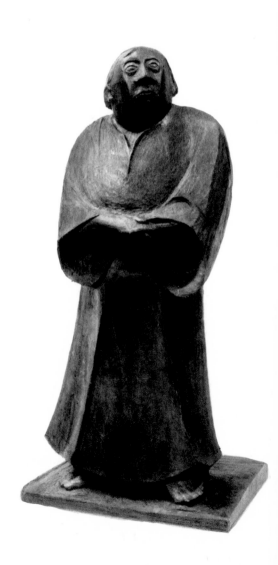

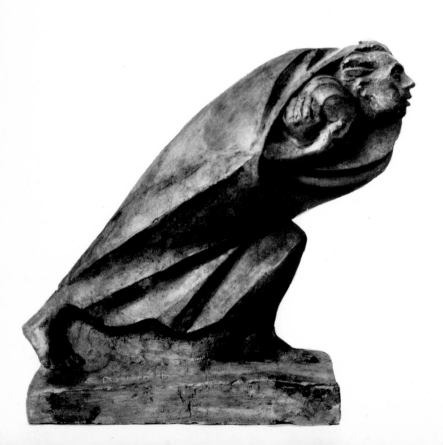

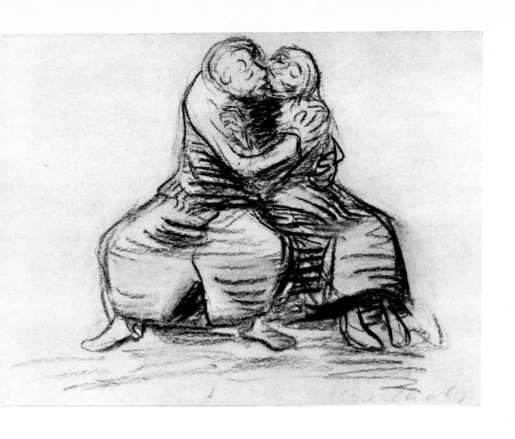

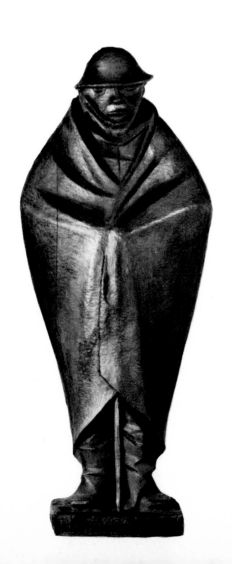

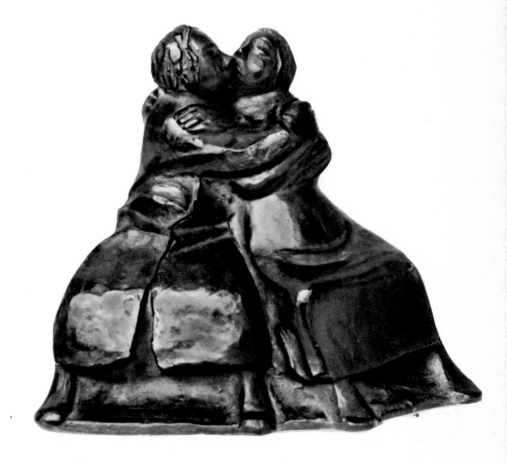

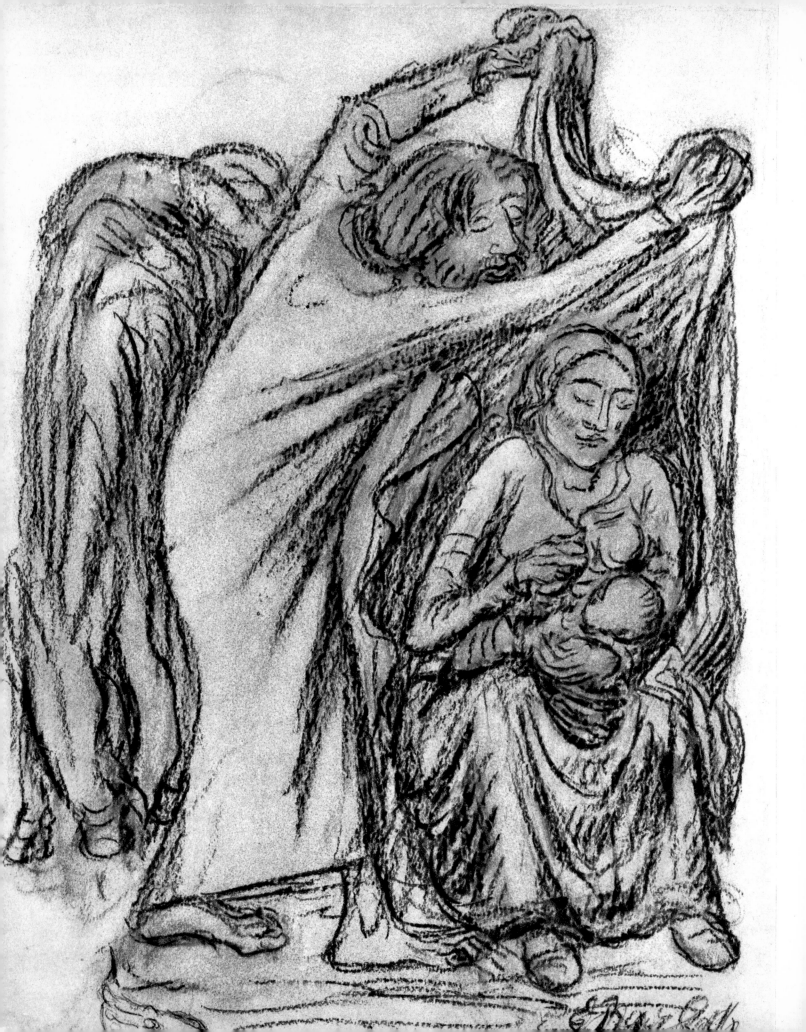

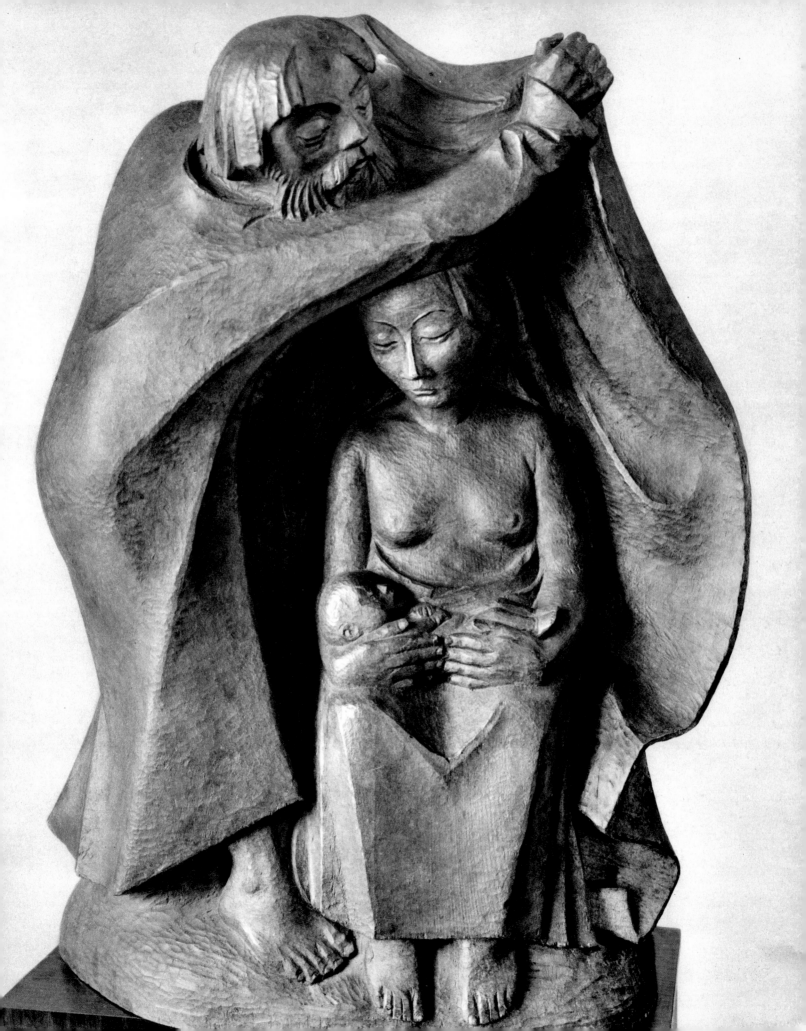

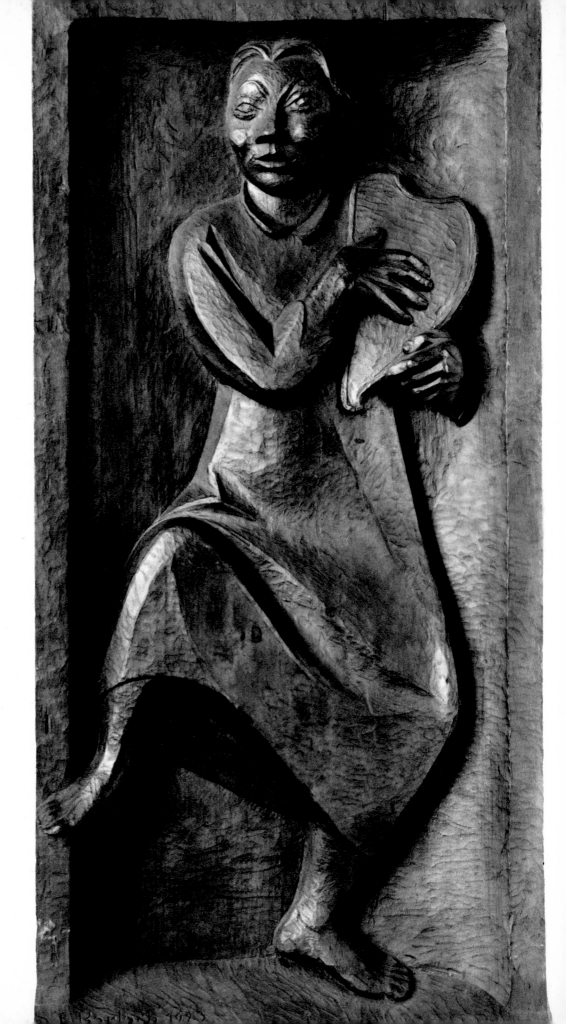

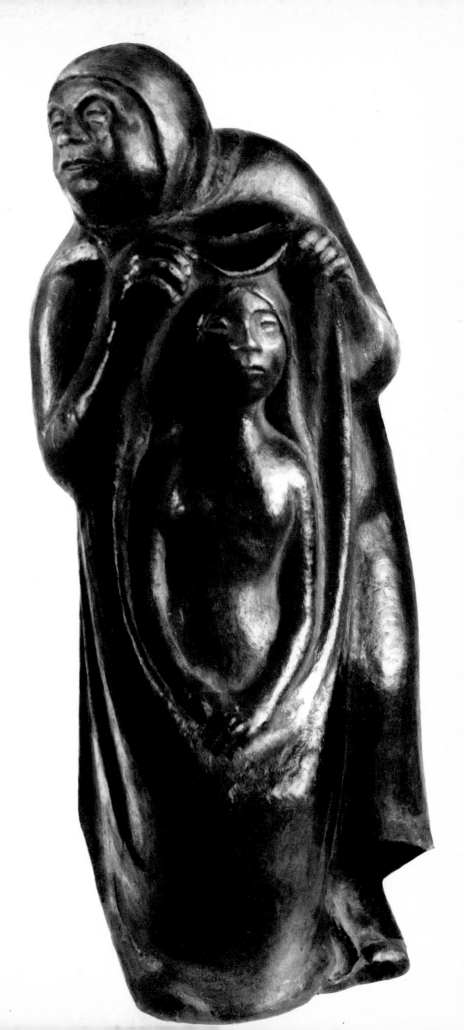

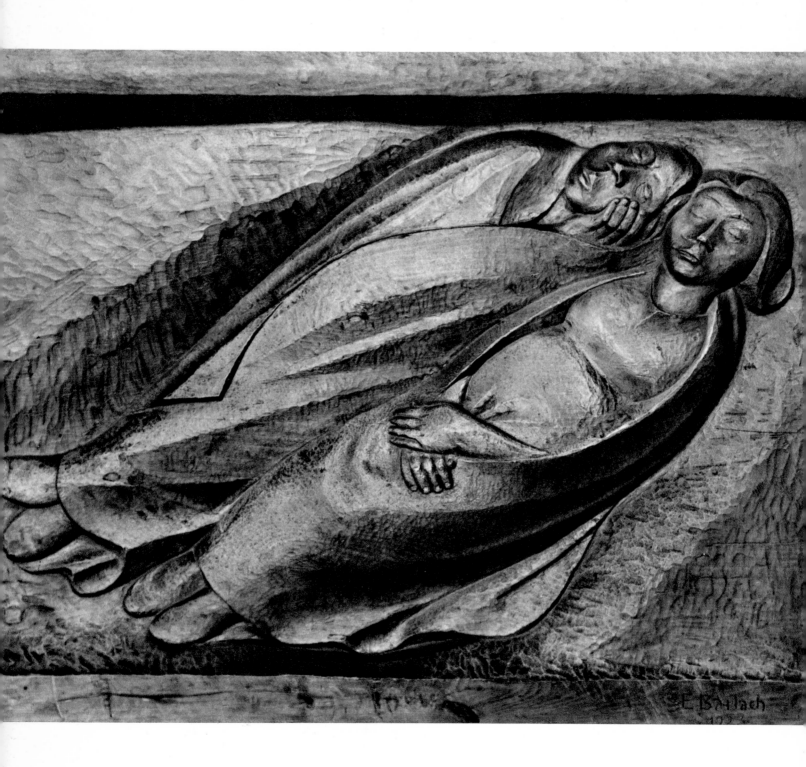

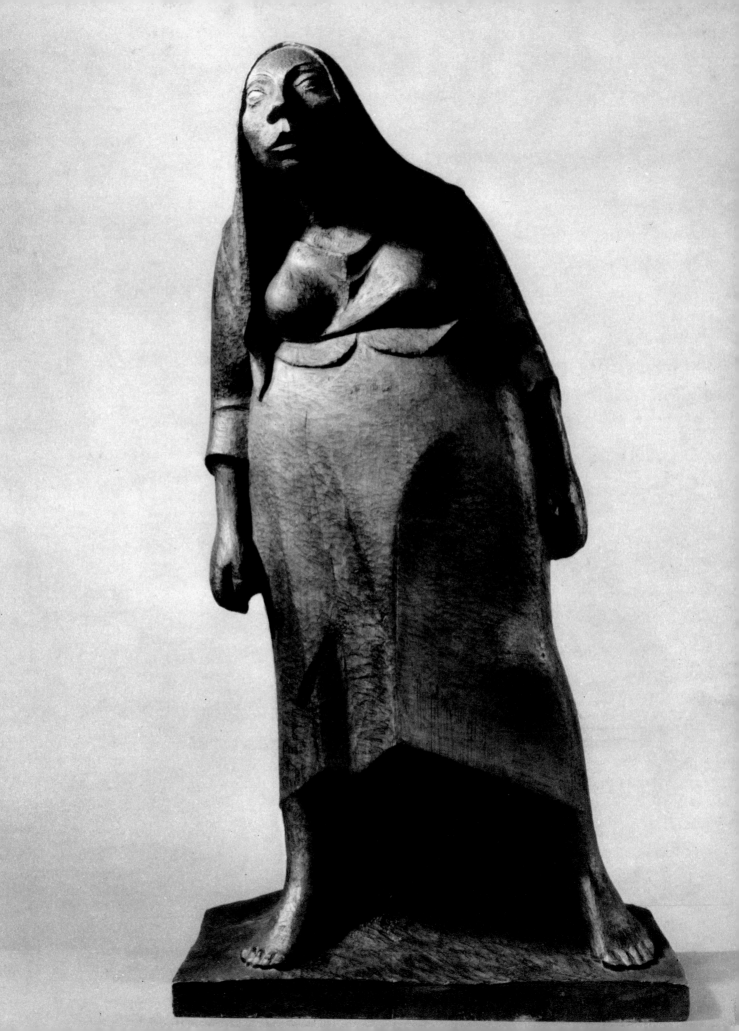

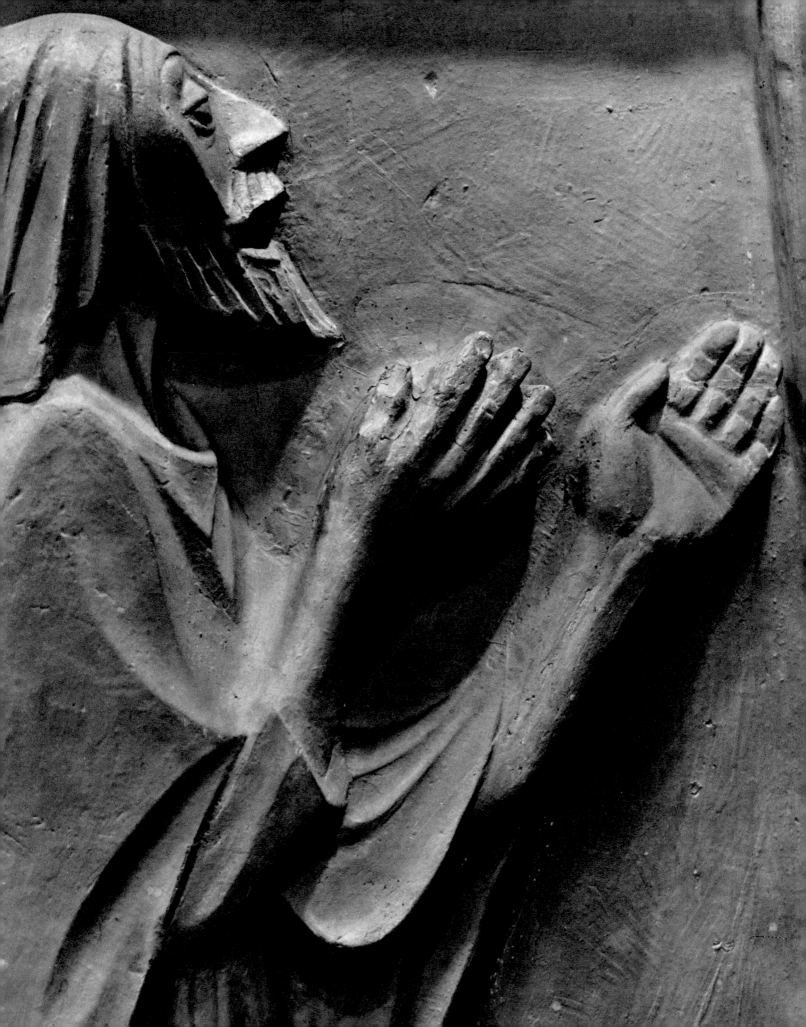

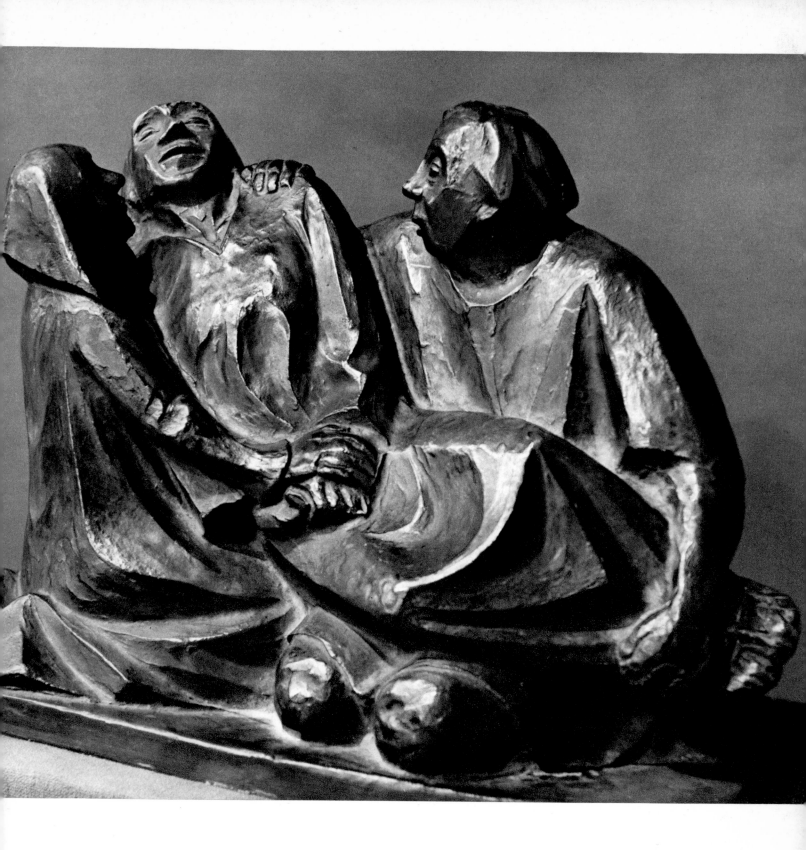

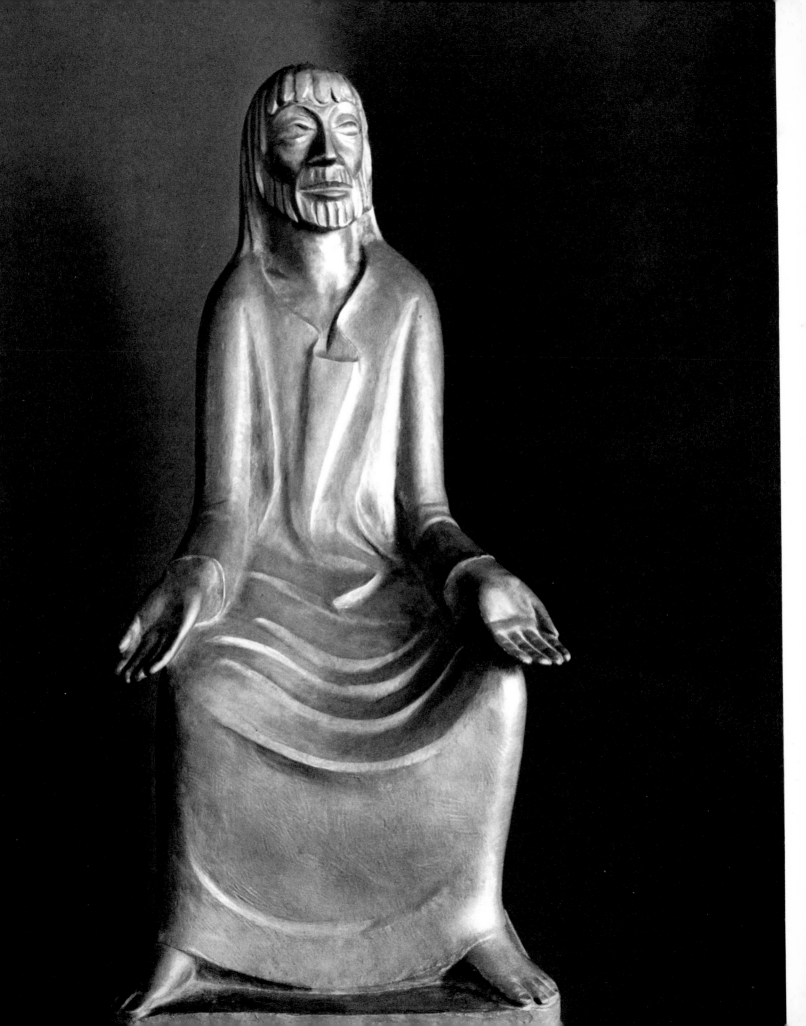

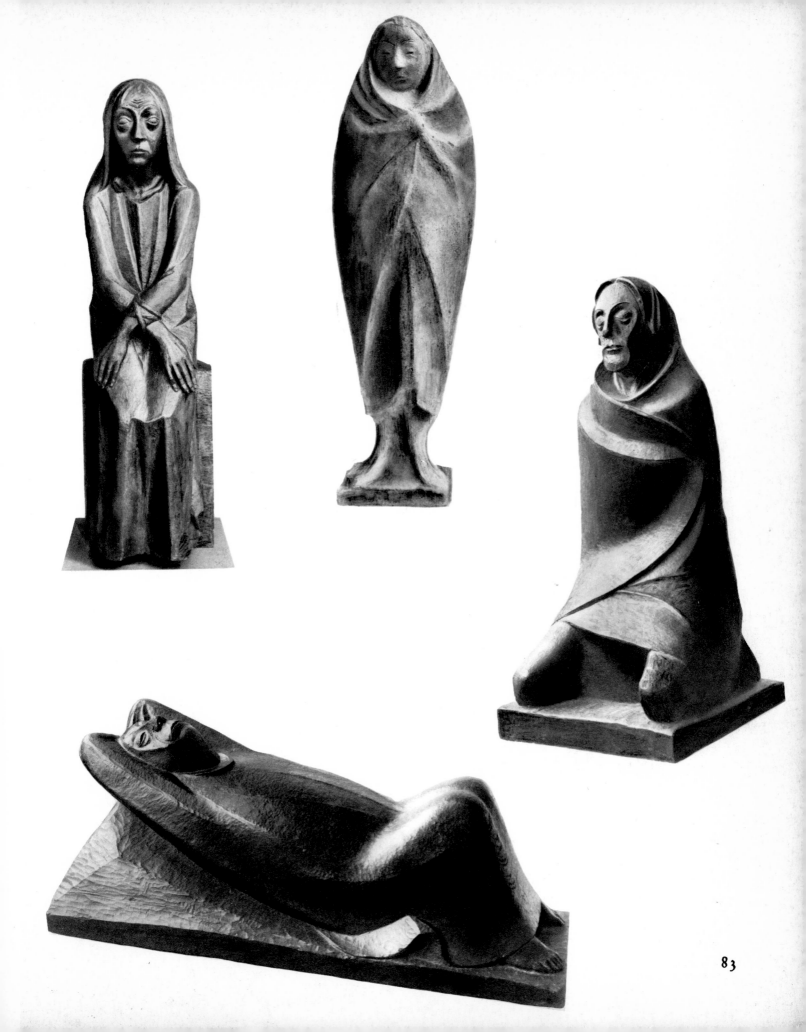

83

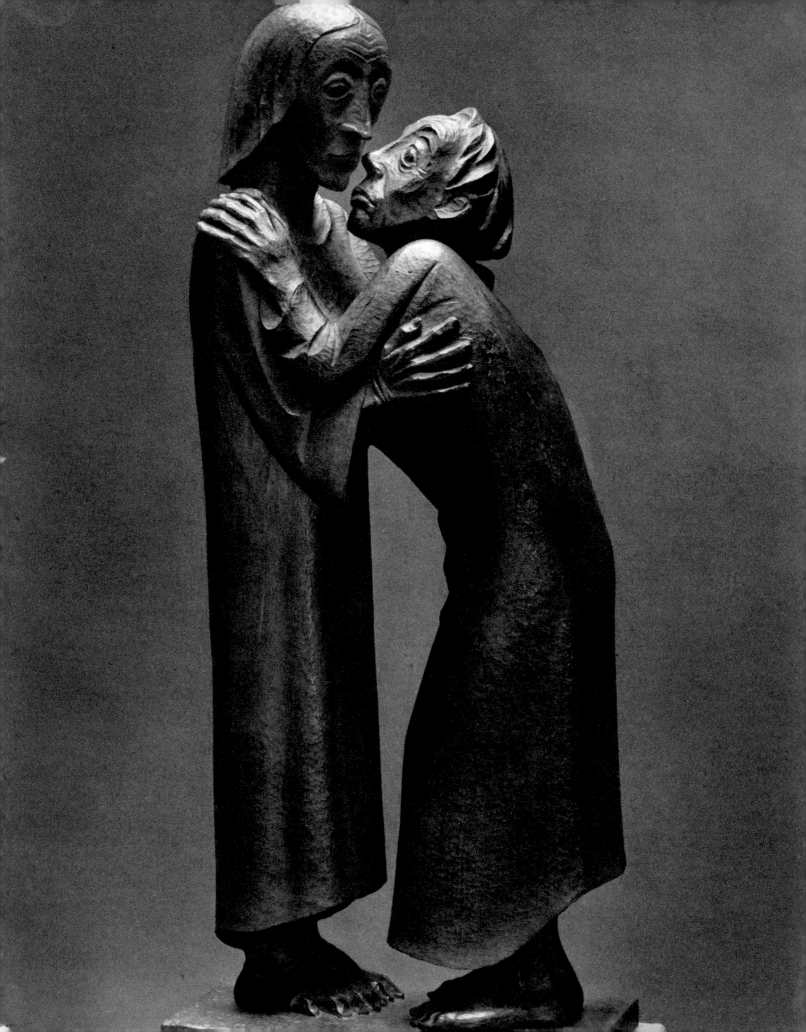

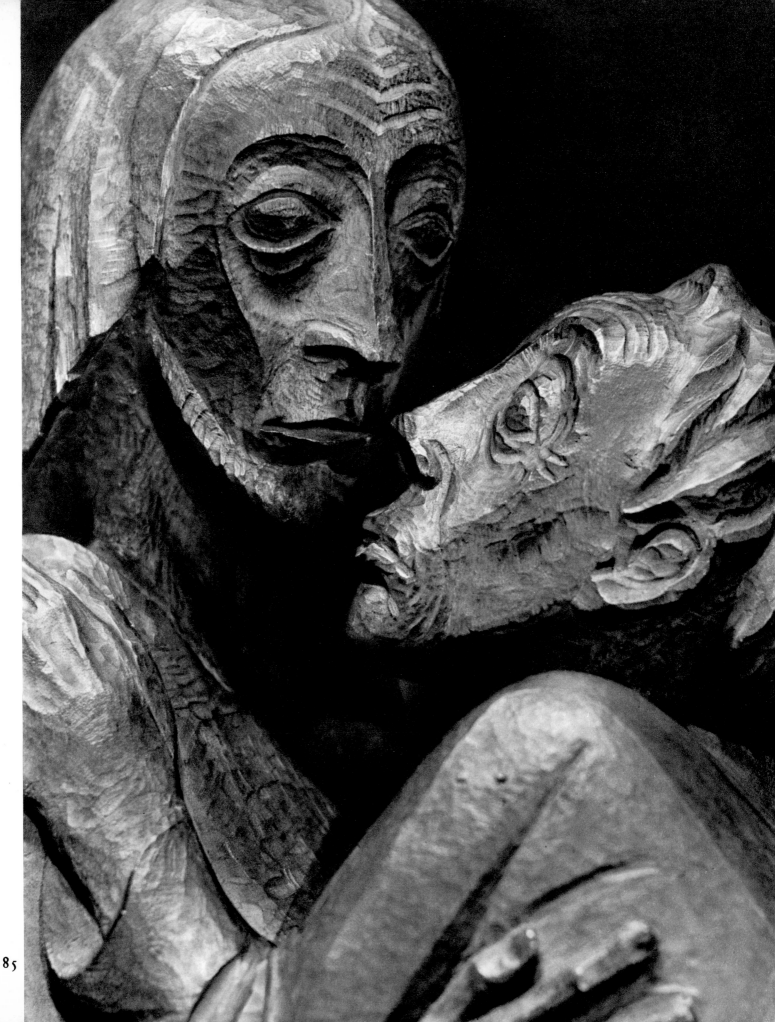

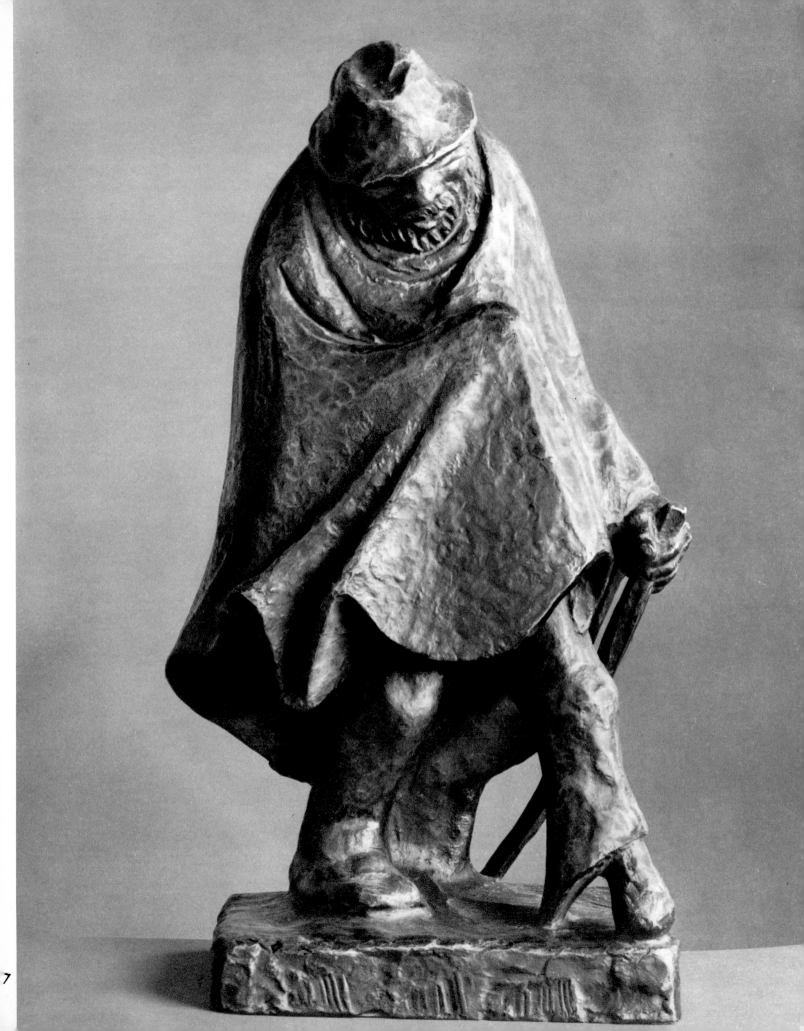

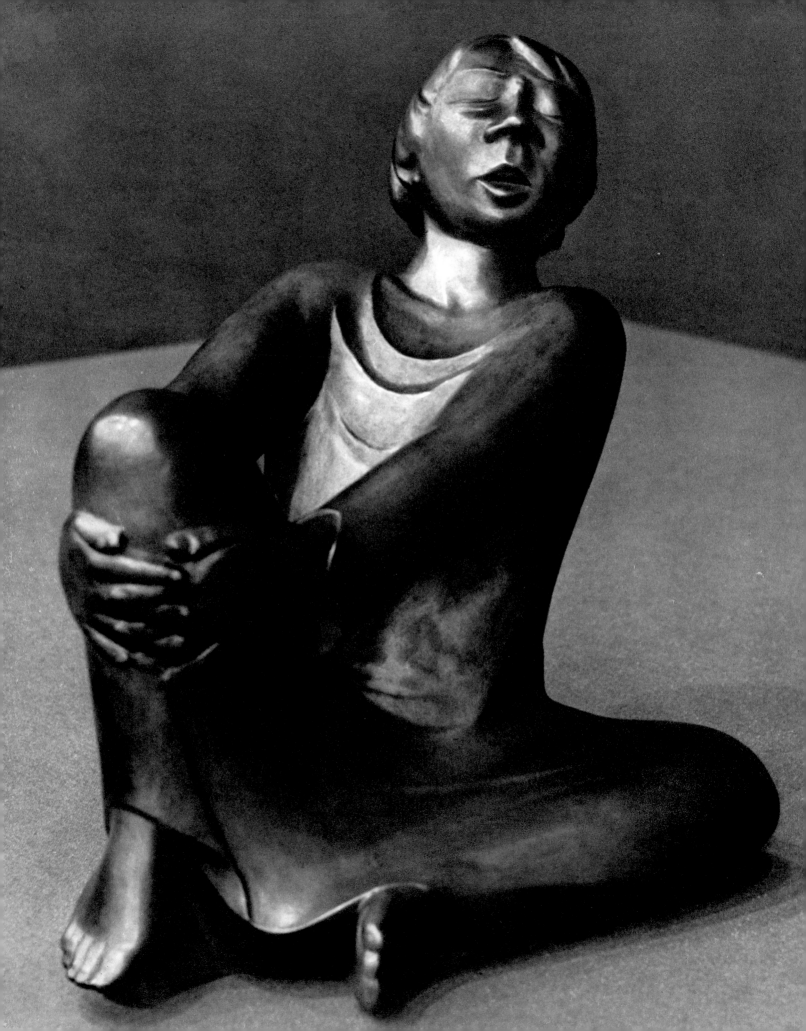

ample the *Walking Woman* (*Russian Nun*) (1909), and around 1930
he did another ceramic sculpture, the *Community of Saints*, a series
of over life-size figures for the façade of St. Katharine's Church in
Lübeck. A little earlier he had done two large bronzes, the *Güstrow
Memorial* (1927) with the famous suspended angel, and the *Warrior
of the Spirit* (1928) for the University Church in Kiel. There followed
a series of smaller bronzes, executed at the suggestion of the art dealer
Alfred Flechtheim, who thought that some of the designs Barlach
had shelved because he did not think them right for wood were cer-
tain to work out in metal. How Barlach himself felt about this can
be seen from one of his letters to Flechtheim. 'I had,' he wrote, 'com-
mitted myself so completely to wood that the execution of works
in bronze seemed to me almost cheap... The first larger work in
bronze, the cathedral angel in Güstrow, seemed to confirm that my
style was also suited to metal. How right I was in this I do not know,
but pleasure and conviction were aroused, and the change of material
seemed more and more desirable. Of course I have designs which seem
to me appropriate only for wood, but I have some daring ideas in
which the immediate result is so important as to rule out the possibility
of succeeding with the slow and painful process of working in wood.'

It would be vain to attempt to reduce Barlach's bronzes to one
common denominator, since Flechtheim's selection was more or less
accidental. It includes figures which had also been executed in wood
and which still seem better in that medium, while works like *The
Kiss* (1921), *The Procuress* (1920), *Praying Man*, *Ecstatic Woman*,
and *The Collector* lend themselves particularly well to bronze, which
can transmit a feeling of improvisation and capture the freshness
of the original design. Here, simply by substituting one material for
another, something emerged which Barlach had relegated to some
hidden corner when he worked in wood.

39
114
105, 106
112, 113
73 bottom right
77

Three works which undoubtedly could have achieved their effectiveness only in bronze deserve special mention. *The Death* (1925) 81 is a group sculpture showing a dying man and two kneeling figures, a man and a woman, saddened and lost, the dead man in their arms, which is as concentrated and powerful as his wood sculptures, yet more moving and concise. Undoubtedly the best known and most memorable of his bronzes is *The Singing Man* (1928), a seated youth 88 in a loose, flowing garment, his raised right knee clasped in his hands, leaning back, transfigured, eyes closed—completely given over to song. The position and stance of *The Reader* (1936) express an inner 193, 194 emotion, a mental concentration as tangible as it is animated. His eyes are riveted on the book which he holds in his hands. He is completely drowned in it; he cannot lose its hold; he no longer sees or hears anything else. *The Reader* and *The Singing Man* are closely related; both are superb examples of expressiveness and ideal utilization of material.

Any attempt at interpretation, any effort to do justice to Barlach's many-faceted personality, will have to take into account his own hints, even though at first glance it would seem as if at times they were not devoid of contradiction. For example, in 1911 Barlach had stated that he saw in his *Russian Beggar-Woman* a mixture of the repulsive, the comic, and the divine. However, that is not what he had said in 1907, when he had written a mocking verse about her and the Russian misery. How did he really feel about this and the other Russian beggars when he created them, he who said that he had to be able to share suffering, had to be involved and concerned in order to become engaged? Did the reinterpretation in the sense of the 'human situation in its nakedness between heaven and earth' come only later? It is unlikely. He doubtless had both in mind from the very beginning, else the encounter with these figures would not have touched him so deeply. Barlach had a good sense of humor. He was always able to see things from two sides and occasionally liked to poke fun at his own figures.

An anecdote from 1918, recorded by Friedrich Schult in his recollections of Barlach, makes clear that he liked to play games with people who asked pompous questions. A woman looking at one of his sculptures asked, 'Mr. Barlach, what did you have in mind when you made this?' Barlach answered, 'That's not a proper question. If I'd had anything in mind I wouldn't have had to make the thing at all.' But the lady was persistent and asked again: 'But what does it

represent, Mr. Barlach?' Barlach replied: 'The externalization of an inner process.'

Well, this curt rejoinder was only half true, for Barlach undoubtedly had a great deal in mind, even though he denied it. In a diary entry of 1906, he wrote, 'The plastic view of nature sees time and eternity simultaneously. It sees in the soil the skeleton of the earth rather than the many fine hairs sown across its skin that blur its clarity; it sees in the air the breath of space, and only later or perhaps not at all, the many whirlpools of thousands of colors and tones; sees trees and bushes as individual shapes, as children of the soil rather than as a variety of things as seen through the camera.'

Barlach's sculpture, which with these reservations he called the 'externalization of an inner process,' easily lends itself to interpretation. The most striking aspect of the figures from his various periods is their strong formal contrasts. On the one hand there is the motionless, symmetric, heavy massiveness of his *Sitting Shepherd* of 1907, and on the other, the dramatic outline, the vehemence of motion of *The Fugitive* and *The Avenger*, two wood sculptures of 1920. The contrasts between these figures characterize the range of Barlach's sculptural work. However, in some of his other works the sharply contrasting elements of these compositions are combined and supplement one another. *The Troubled Woman* (1910) possesses the symmetry of the *Sitting Shepherd*, though less severe, and despite the massiveness expresses an inner life which was not present in his earlier works. More animated and yet still very compact is the *Stroller* (1912), which like *Shepherd in a Storm* (1908) is an example of Barlach's ability to set his figures amid wind and weather. His sculptures, except for the *Frieze of the Listeners* (1930-35) and some other works of his maturity, are marked by solidity and massiveness. All of them seem wedded to the soil, seem to grow out of it, often

36 bottom

72 bottom left

58 bottom right

65 top left

57

177

92

still half-rooted in it. This closeness to the earth, the earthbound heaviness, is one pole to which all of Barlach's sculptures are related.

And the other? That lies beyond the realm accessible either to the eye or the mind; it is accessible only to sensibility, to feeling. These figures which are so close to the soil possess a secret second face, and often it seems as if a part of them were outside reality. This secret double life of Barlach's figures is the result of a peculiar restlessness which again and again breaks through their form.

The Carouser seems to be rebelling against the heaviness of body and limb. With powerful movement, the drunken man leans far back, grasps his knee firmly in his hands, and looks up boldly, as if hoping to find the fulfillment of his dreams up above. *The Lonely Man* (1911), leaning forward and widening towards the top, seems out of balance. The stretched-out neck, the downcast eyes, the entire stance and movement, express an unsteady searching, a disturbance and aimlessness—a forgotten man roaming restlessly through the world. It is the same loneliness which frightens the *Freezing Girl*, abandoned to the mercies of a cold world. Her expression is one of fear; she huddles, freezing, her feet icy, her hands groping to protect and hide her face. This single movement, the gesture of pulling her wrap close, transmits all the pain and restlessness of this creature. Still more controlled, more internalized, is the restlessness of the *Pregnant Girl* (1924). There is only a hint of movement. The wrap she wears falls straight down, without any drape, except for a detail near her face. Here within a small area Barlach has concentrated all accents. One hand pulls the wrap tautly across her shoulders, a movement which is repeated in a single fold at the hem of the dress. But a fold draped around the face like a rippling pool focuses all attention on the face. The downcast eyes, the raised brows, the firmly closed mouth, all these indicate a complete shutting out of the surroundings,

62

83 middle top

an intensive preoccupation with self. What this figure, one of the gentlest and most sensitive of Barlach's wood sculptures, expresses is the restlessness of deep hope and constant expectancy.

The restlessness of *The Fugitive*, on the other hand, is a completely 72 bottom left externalized, breathless fear. He storms forward with long strides, an extremely harassed man. The nature of his persecution is not stated; everything about this figure, which resembles a taut bow, is directed solely toward a representation of the profound experience of flight. The head is stretched forward, the eyes stare into space, the hands grasp his coat. The sharp lines above the knee and the heavy folds into which the figure is divided underscore its heedless flight. Here Barlach makes conscious use of symbolism and of the possibilities inherent in spatial composition, yet despite all expressiveness and power, the total effect is almost decorative. This figure, which looks as though it might have been part of a relief, is not one of Barlach's most balanced sculptures, but it displays a tendency occasionally found in his work.

Panic Terror (1912), two male figures seemingly overwhelmed by 67 unexpected catastrophe, appears less exaggerated. Their step is measured, they throw their bodies back, looking upwards—an image of dismay greatly strengthened by the parallel movement of the two bodies pressed closely together. With an instinctively defensive gesture they try to ward off the danger threatening them. It might be a natural catastrophe, a heavy wind or thunderstorm, perhaps, or it might be something irrational, an apparition or a vision. The figure of *The Ecstatic* (1916) goes a step beyond the agitation of 65 top right these two men. That which fills them with terror fills him with rage. His inner turmoil breaks through with enormous force. His long stride puts a single, large diagonal fold into his dress and determines the proportion of the entire figure. Its strong dynamics, from the diagonal base pyramid created by the vehement stride, continues through

the conic torso to the arms, which are thrown over the head with the same violence, while the mouth is open, about to shout. Only an all-encompassing inner agitation could account for this sort of ecstatic reaction. He calls out to God, feels his nearness, and fights Him in painful, wild delirium; joy, pain, hope, and despair are the close companions of ecstasy.

72 top *Dancing Woman* (1920), a figure that would be quite at home at a witches' ball, turns the obsession with ecstasy into the grotesque. Her stiff limbs move in a rhythm both comic and eerie. This figure, inspired by a village character who, uninvited, attended all local weddings and entertained the guests with jokes and dances, dances without inhibitions; a hopping movement animates her body, from her hands, which hold the hem of her skirt, to the hunched shoulders, the slit eyes, the low forehead, and the folds of the dress. She seems to turn into a spectral vision before one's eyes, a mandrake-root phantom in the dim light of a forest in which the outlines of fantastically shaped trees take on human form.

65 bottom left Finally there is *The Astrologer* (1909), one of Barlach's most moving early woods. An archetypal experience, a glimpse of the universe, here takes shape simply and impressively. With face raised to the heavens and body bent back, this man stands under the evening sky, completely enveloped in the gentle rhythmic motion of the lines and surfaces surrounding him, the personification of awe-struck concentration. He looks out into the infinity of space, aware of his own diminutive size, a mortal being, yet a mortal able to glimpse into eternity. Out of this awareness grows his restlessness, his compulsion to think and to question. Why else would he be driven to try and read the stars? This solidly-built man, feet planted firmly on the ground, is also close to the soil, but part of him quite obviously belongs to a higher sphere.

Almost all of Barlach's works convey this feeling of closeness to the soil and inner turmoil. This quality, this belonging to two worlds, this eternal, somewhat clumsy dance of the suffering, despairing and hopeful, the lonely and waiting, the driven and persecuted, the over-whelmed and obsessed, the upright and ambitious, the fighters and seekers, is present in all his works. All of Barlach's creations share a basic emotion, whether their theme is the Russian steppes or Mecklen-burg or an imaginary landscape—namely the awareness that man is made of clay and will return to the earth, but that he contains a seed that wants to grow, a restlessness which always remains with him.

This restlessness, this wish to transcend the self, undoubtedly has religious roots. Although he certainly did not adhere to any specific religious belief, he did want to assert a universal faith. At any rate, he said that he would not dispute those who held that his sculptures expressed a search for the answer to the whence and whither of man. This whence and whither is the great theme of his work. Where does man come from? Certainly not from the ape, says Barlach. 'I do not think of myself as descending from the past, from the rear, but from up front, from above,' he said in one of his letters. He was quite serious about the 'higher origin' of man, insofar as he felt that man was only 'half of something else,' an exile, the poor cousin of a higher being. His plays state this conviction even more clearly, but it is also part and parcel of his sculptures.

65 bottom
right

63, 66 top

In November 1917, in the middle of World War I, Paul Cassirer opened the first big Barlach exhibit in Berlin. He showed about two dozen wood sculptures, from the *Sitting Shepherd* to the just completed *Freezing Girl*. In addition, the exhibition included numerous drawings, lithographs, and plaster casts. In leafing through the catalog of this show, which included the *Stroller, Troubled Woman, Sleeping Vagabonds, The Village Fiddler, Old Woman with Cane, Three Singing Women, The Swordsman* (1911), *The Ecstatic, The Desert Preacher, Panic, The Carouser, The Solitary, Portrait of Theodor Däubler* (1916) and the reliefs *The Vision* (1912), *The Deserted* (1913), and *Hunger*, one feels that one is witness to a significant artistic launching far removed from all war and its accompanying turmoil. Today these works are widely scattered, the valued possessions of collectors throughout the world. But at the time they were not very salable. Nonetheless, Paul Cassirer was pleased with his show. He had no regrets. The grateful Barlach put it thus: 'He took my lambs out to pasture, he cared for my freezing firstborn.'

In his diary Barlach reveals how torn he was at that time. He had just completed *Hunger* when the war broke out, and he saw women at the railroad station taking leave of their husbands. 'They carry the heaviest burden,' he noted on August 3, 1914. 'My wood sculpture, even though it was done before all this happened, is a picture of the future: they wander across fields and steal turnips to stave off their hunger.'

Yet despite his premonition of catastrophe, he let himself be carried away by the general enthusiasm. As a good patriot he wanted to be part of things and to be called up. When he failed to be enlisted he went to work in a children's home and later volunteered for the medical service. In December 1916, he was finally conscripted into the infantry. However, his war service lasted only three months. Without his knowledge, August Gaul, Max Liebermann, and Max Slevogt had sent an appeal to the War Ministry asking for his discharge. The Ministry was apparently sufficiently art-orientated to grant the appeal. Barlach was somewhat surprised to find himself discharged so soon, but rather pleased to get back to his work and complete something he had begun in 1915: a large chimney relief, a triptych with a rectangular center panel with two side panels—two male high-reliefs 68 *The Lover* and *The Poet*. The center panel shows three couples, 69 one tired and exhausted, the second reading and lost in thought, the third looking up into infinity. All three couples are grouped around a tree stump whose two new branches form a leafy roof over two of the pairs. The idyllic calm and gentleness of this relief is not at all typical of Barlach.

An idyll in the midst of war? Of course, it was a commissioned work, but still that was not the only reason for his approach. In a letter to Reinhard Piper, written by Barlach while working on the frieze, he said: 'One learns to accept the war, but only for brief spells, then it catches up with you with giant steps, more terrible than before. But one learns to know peace, at least I do. Against this background life takes on dignity . . . Things I used to take for granted now become important . . . Silence becomes meaningful without interpreting it and reading a meaning into it.'

It is typical of Barlach that he was reluctant to contribute to the periodical *Kriegszeit*, which Cassirer and Alfred Gold had begun to

publish in August, 1914. When first asked to contribute, Barlach made this curt notation in his diary: 'Certainly not, Mr. Gold!' But finally he did, despite his distaste for 'would-be soldiers,' though not quite so regularly as Gaul and Liebermann. In the eighteen months in which his friend and patron was an enthusiastic supporter of the war, Barlach contributed twelve lithographs, among them such sad, disturbing 126 bottom right works as *Evacuation* (1915) and *At the Eastern Border*, not exactly 126 top right works overflowing with war enthusiasm. The twelfth, *Mass Grave* (1915), never appeared; apparently it was suppressed.

In April 1916, Cassirer returned from military service a firm opponent of the war. He dropped the *Kriegszeit* and launched a new journal, *Bildermann*, which he put under the editorial direction of a man who had never before edited a journal, the well-known pianist and music teacher Leo Kestenberg, a confirmed pacifist. He hoped to reach the people and the working-class subscribers of the people's theater movement, but in vain; even though well-known socialists were among the contributors and each issue featured lithographs by artists like Liebermann, Slevogt, Gaul, Zille, Kokoschka, and Kollwitz *Bildermann* ceased publication after eight months and only eighteen issues. It is surprising that the censor tolerated it even that long. For example, Barlach's cover for the issue of October 20, 1916, entitled *Anno Domini MCMXVI Post Christum Natum*, shows the Devil 126 bottom left leading Christ up a mountain and pointing to the vast expanse of the world and its riches—graves as far as the eye could see, and in the background Golgatha with three empty crosses. Barlach's diary spells out what the Devil tells Christ as he shows him the view: 'Your dear Christians are devilishly clever.' But the picture did not require any caption; its message was clear enough. Barlach contributed a total cf. 127 of eight drawings to *Bildermann*; a ninth he had done never appeared. On October 23, 1916, he wrote in his diary: 'The death

mask is removed and the messenger, the archangel who was hidden behind it, speaks of the coming peace.' The drawing was to have this caption: 'Death will no longer be, nor sorrow, nor shouting, nor pain . . .' A plea, a prayer, the plea of a man who was not only tired of war but hated it. 'If only millions of people would wake up after the war with a hangover,' he wrote in a letter in 1916 in which he said that the war was Europe's greatest shame. 'Just as a public personage who is hysterical and inferior is quickly found out and thereafter treated according to his worth and merit, so will Europe be treated.' Prophetic words these, a foreboding of what most Europeans realized forty years later, after yet another world war, namely, that all of Europe was basically defective. He hoped that Germany and the rest of Europe would develop a healthy mistrust of 'all these firm convictions about what was primarily and supremely important for people,' would undertake a complete revaluation, embark on a change of course which in his opinion called for a renunciation of nationalism and trade imperialism.

cf. 132 bottom left

How heavily the terrible events of his time rested on him can be gleaned from a letter of November 2, 1918, to his cousin Karl Barlach damning war and its weapons. He admitted that he had failed to speak out publicly, but that now he knew where he stood and felt compelled to come out for what he believed in. Upon seeing his first woodcuts, grim reminders of poverty and misery, black-and-white apocalypses, Käthe Kollwitz wrote in her diary: 'I saw something that bowled me over . . . Barlach has found his way.'

For a long time he was unable to deal with any themes other than those relating to the war and postwar years, with violence and the victims of violence, with suffering. His sculptures of those years include the tortured *Man in the Stocks* (1918), the suffering *Shackled Witch* (1926), the wood-relief *Tortured Humanity*, the kneeling,

71, 83 top left

desperate figure of *The Horror*, two images of pursuer and pursued, *The Avenger* and *The Fugitive*, and a picture of two helpless beings helping each other, *The Blind and the Lame*. This must have been what Barlach had in mind when he wrote: 'There is much more to man than he suspects . . . I believe one ought to be optimistic, but in the end everything boils down to the deeds of the heart.'

At this time he was elected to the Prussian Academy of Art, a sign that although he lived far from Berlin, its artistic elite considered him as part of it. He was also offered two professorships, one in Dresden and the other in Berlin, but he turned down both. His art and writing occupied him too fully to allow him to take on any additional work. Also he had been away from Dresden for many years, and his feelings about Berlin were ambiguous. He visited it occasionally, only to rush back to Güstrow as quickly as possible. Yet Berlin remained a 'magnetic, gigantic secret,' he wrote in his diary, 'which attracts and repels me with wild moodiness.' After his mother's death, he even considered moving to Berlin. His mother had committed suicide in a mental home which she had entered voluntarily. Her death was a great blow to Barlach. He was now alone with his son, and his friends urged him to get away from Güstrow. About a year after his mother's death, August Gaul died, and his studio stood empty. Cassirer tried everything in his power to get it for Barlach, and he almost succeeded. In fact, Barlach had already ordered his things to be moved there, but at the last moment some housing official refused to approve a residence permit which had already been granted by another office. Barlach remained in Güstrow. He seemed content at being able to work in his accustomed setting, although the stable which had served as his studio for more than ten years was not nearly as well equipped as Gaul's Berlin studio. 'You are right in saying,' he wrote to a worried friend, 'that my situation at the moment seems intolerable, but . . .

if one hears the workings of the machinery of fate, as I do, one listens and lets things happen as they will . . . Here in Güstrow I am on a sort of lonely island and try to be as comfortable as circumstances permit. It must be all right, because something gets done. The complete concentration on my work is relaxing . . . and the uniformity of the days is merely external and goes well with my present state of mind . . . One does not suffer if one pushes the ego aside for the sake of a deserving cause.'

Barlach was even more outspoken about his need for privacy and the price he was willing to pay for it in a letter written to Reinhard Piper in 1924. 'In the fall I had to spend a number of weeks in Berlin, and again it meant swimming through the whirlpool. Strange that these quite clever and intellectually astute people there fail to see that I am a square peg in the life of Berlin, a piece of superfluity, a personified protest. I don't talk much about it, but they ought to see what's what. The result is that my miserable tenement here, my badly furnished room, my petit bourgeois household, is becoming the straw to which I cling desperately. That is how I have lived and worked, up to my present age of fifty-five. How can I now let Berlin remold me? God forbid! Living here is a kind of luxury, and I need the luxury of the modestly poor which is—what? Freedom! One has everything in Berlin but freedom, and freedom happens to be my greatest need.'

One must look at Barlach's life against this background. His work was the only thing that really mattered, and when he talked of freedom he meant above all the solitude and peace he needed in order to be in full command of himself and his energy, constantly changing from one medium to another, from sculpture to graphic work to writing. He never would have been able to muster this degree of concentration had he been part of the intellectual life of Berlin, for he was not very strong. In Güstrow, however, he was able to isolate himself. In

return he gladly accepted the fact that his life there was at times, as he himself admitted, 'thoroughly uncomfortable.' But what mattered was that he could work without disturbance, and that was all he really cared about.

Around 1925, Barlach's reputation as both sculptor and playwright began to spread. He received a literary award and in one year his plays were performed at eleven theaters. The Munich Academy of Art made him an honorary member, the Berlin National Gallery acquired his relief *The Deserted*, and twenty of his wood sculptures were bought by private collectors in Berlin, Hamburg, and Breslau. In February 1926, Cassirer held the second Barlach exhibition with thirty-seven old and new wood sculptures, from the *Troubled Woman* and *Reclining Wanderer* to *The Waiting One* (1924), *The Ecstatic*, *The Dreamer* (1925), *Shackled Witch*, *Rest on the Flight* (1924), and *The Reunion* (1926). Barlach had some fears about this show, a collection of works spanning more than fifteen years. His worry that some of them might have become obsolete proved unfounded. 'I worried needlessly,' he wrote to his brother Hans. 'Everything has stood up well.'

The exhibition included a number of sculptures which Barlach liked particularly—the *Shackled Witch* and *The Ecstatic*, *The Reunion* (Christ and the Apostle Thomas), and *The Dreamer*. What is it that this dreamer dreams? Is it the same dream as that of the sleeping woman in the wood relief *The Vision* (1912)? There is a similarity; she could be the prototype of *The Dreamer*, and her dream touches on a theme which recurs in Barlach's drawings as well as in his sculptures—the floating figure. 'In my dreams I often fly,' he told his friend Friedrich Schult, 'either close to the ground, like a swimmer in shallow water, or climbing up steeply above the treetops.' One is reminded of that

72 bottom right
83 bottom, 75
84, 85

63

when one looks at this relief, hewn out of two wooden planks leaning against each other, the heavy weight of the larger one on the smaller. This is Barlach's first pictorial rendering of his dream of soaring above the earth. Large and relaxed, the male figure floats in the air, with billowing dress, hair flying, and strong features, protecting the sleeping woman. However loose the connection between these two figures, their underlying idea, the passage of a dreamlike apparition above a sleeping human soul, is persuasive. Two spheres meet and want to become one, but only manage to get close enough to create a mysterious, elemental tension. Cassirer's early hopes for Barlach were more than realized in 1926, in what undoubtedly was the biggest exhibition of his wood sculptures. But Cassirer himself was no longer there to see it. He had committed suicide shortly before the opening.

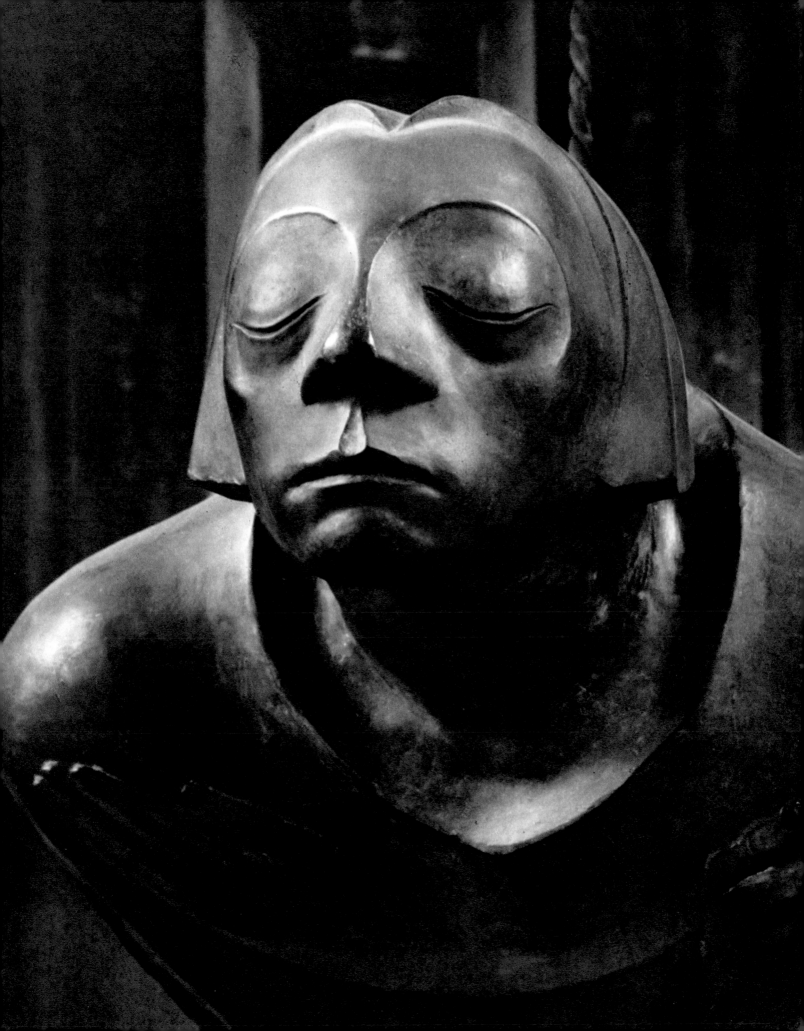

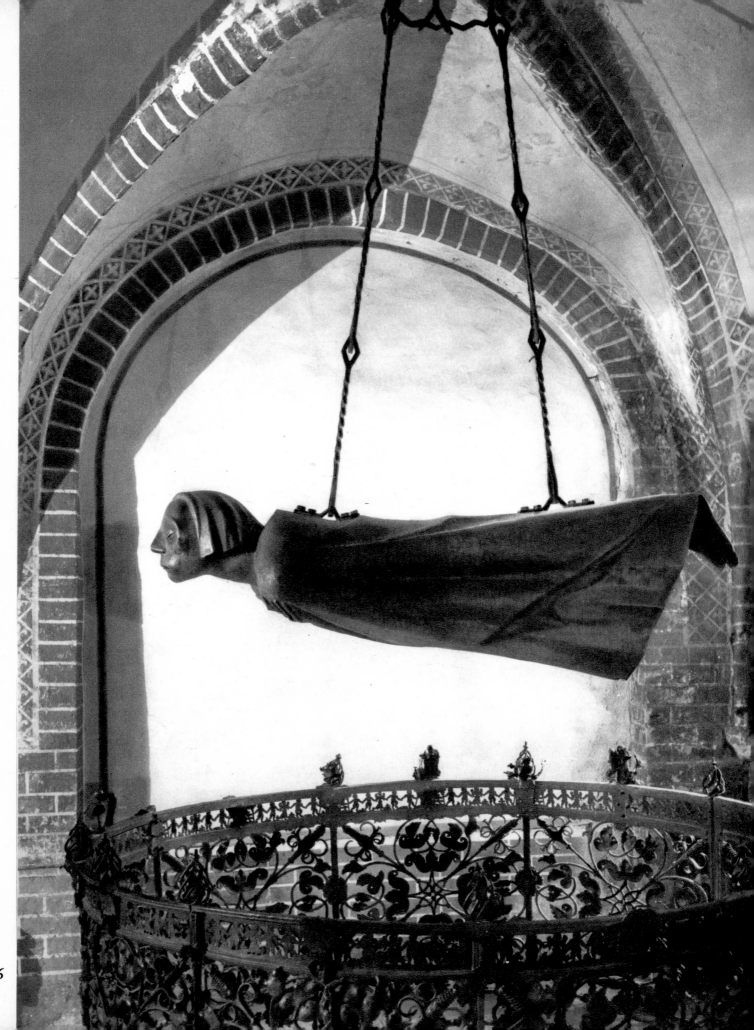

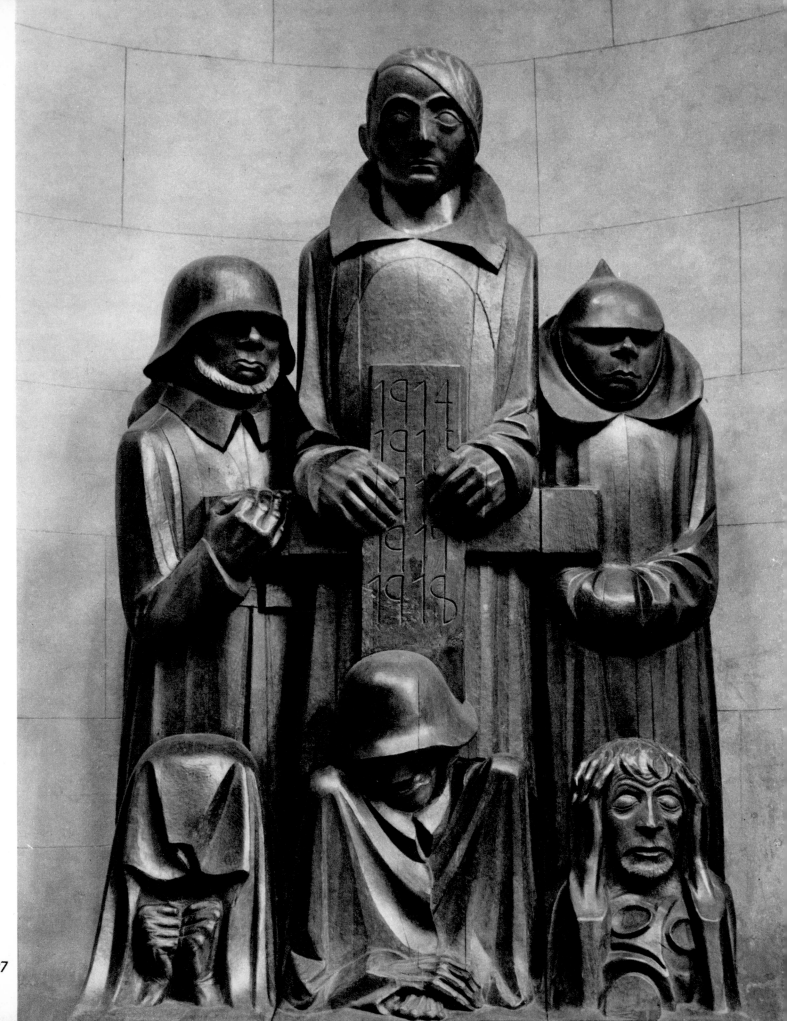

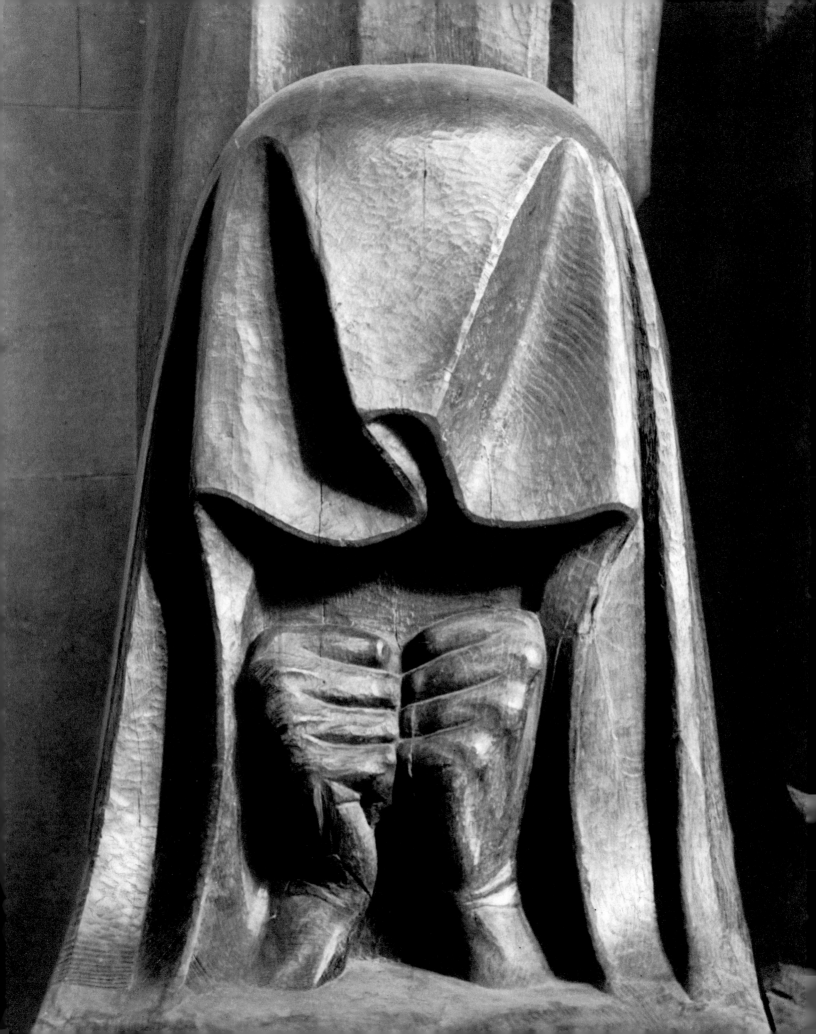

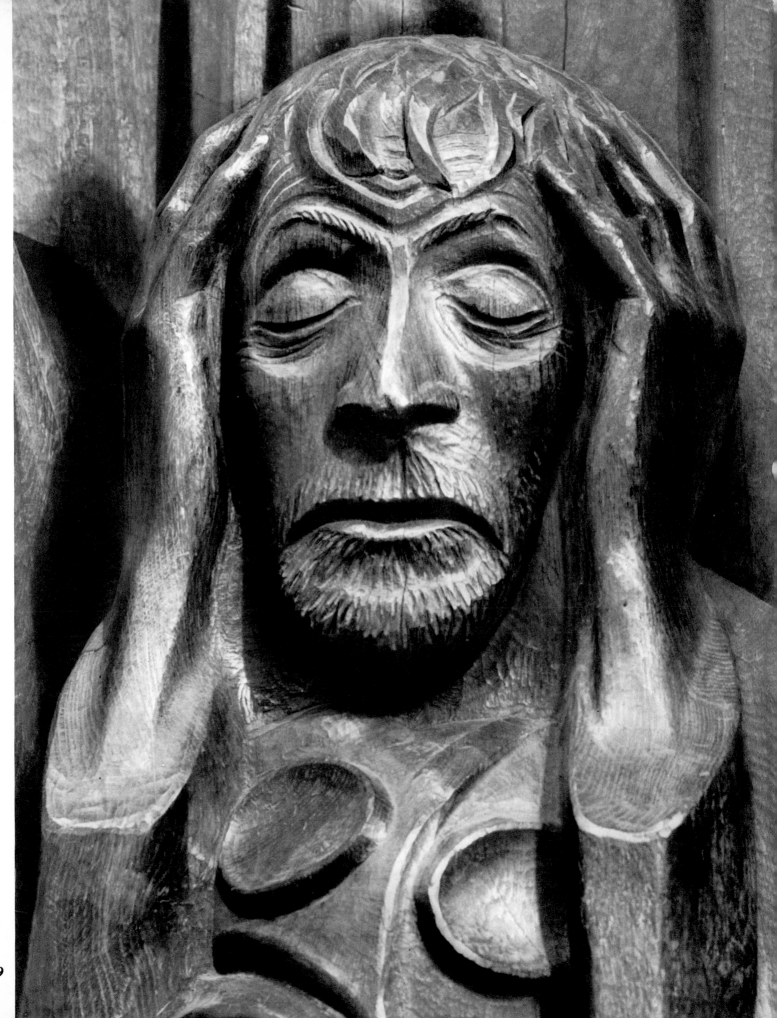

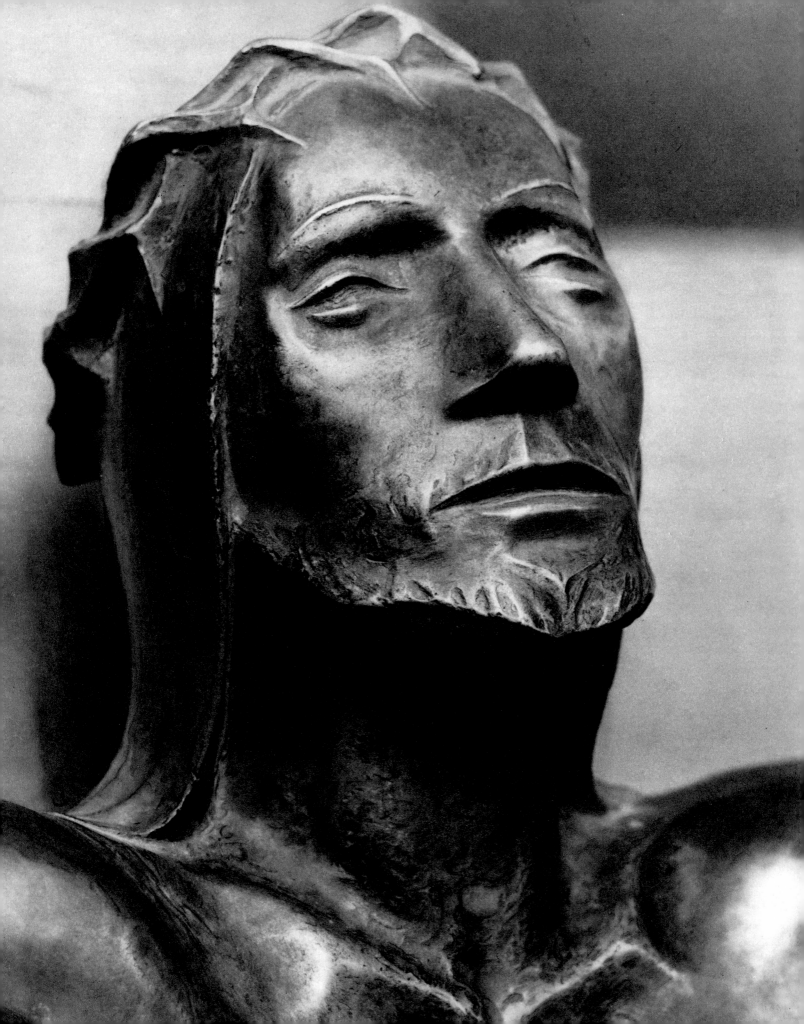

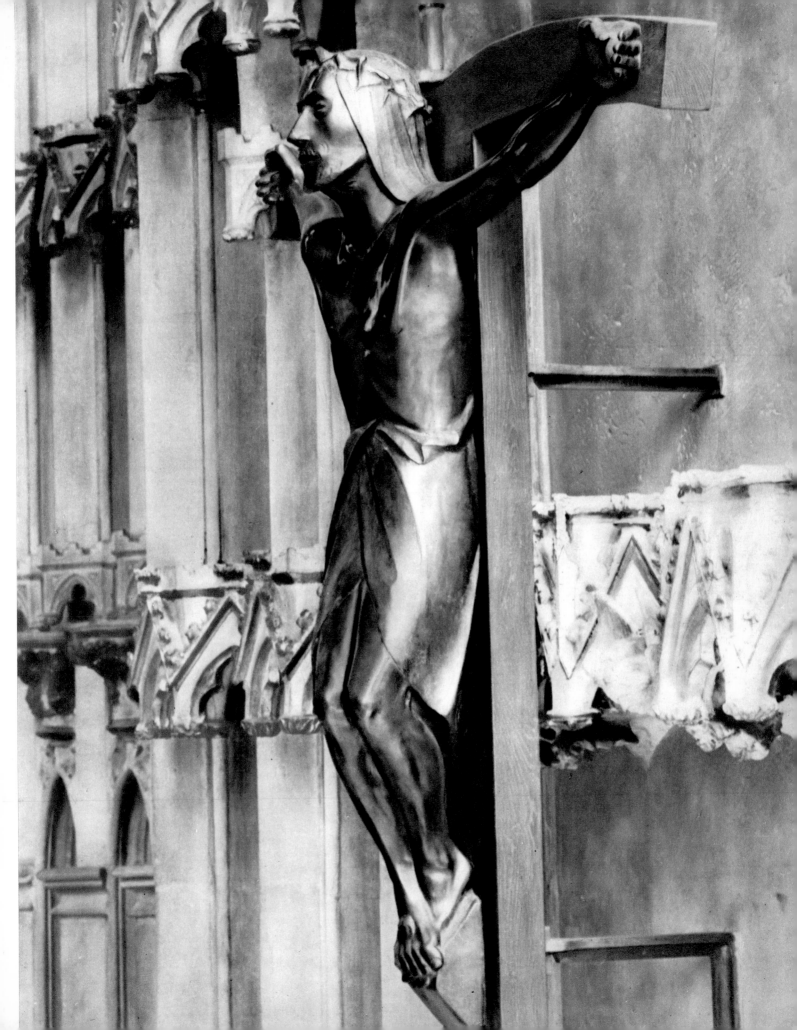

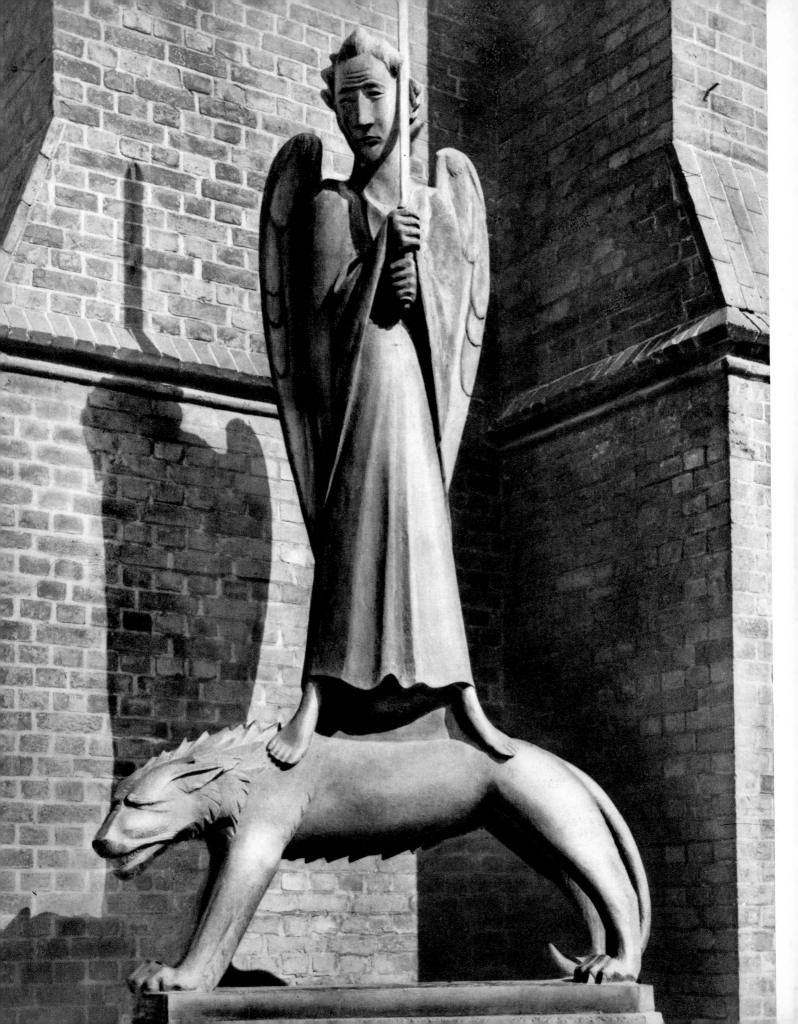

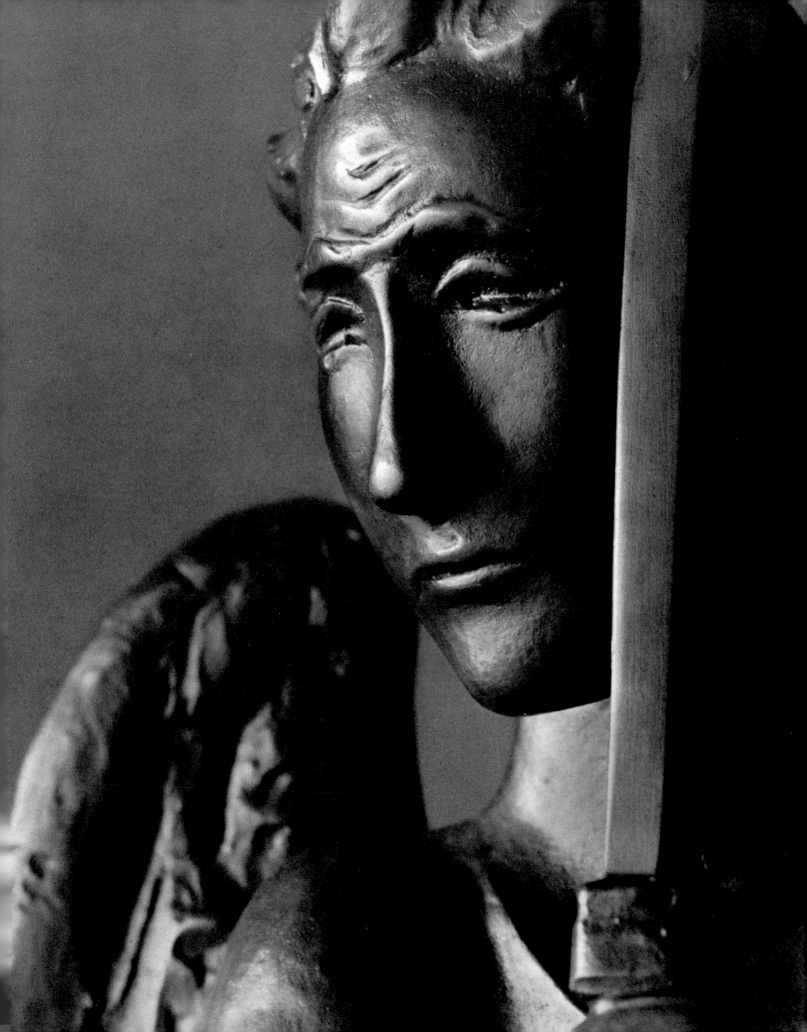

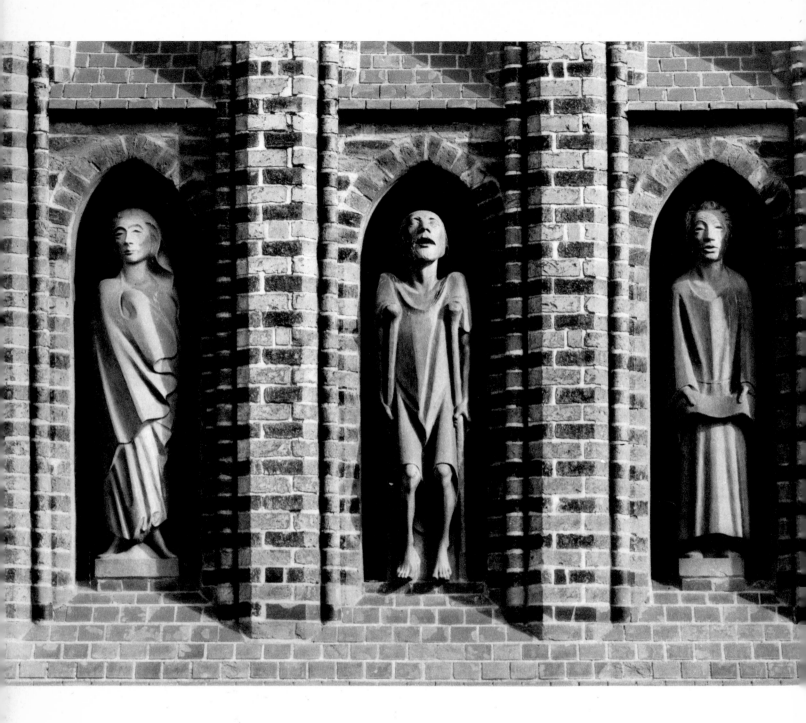

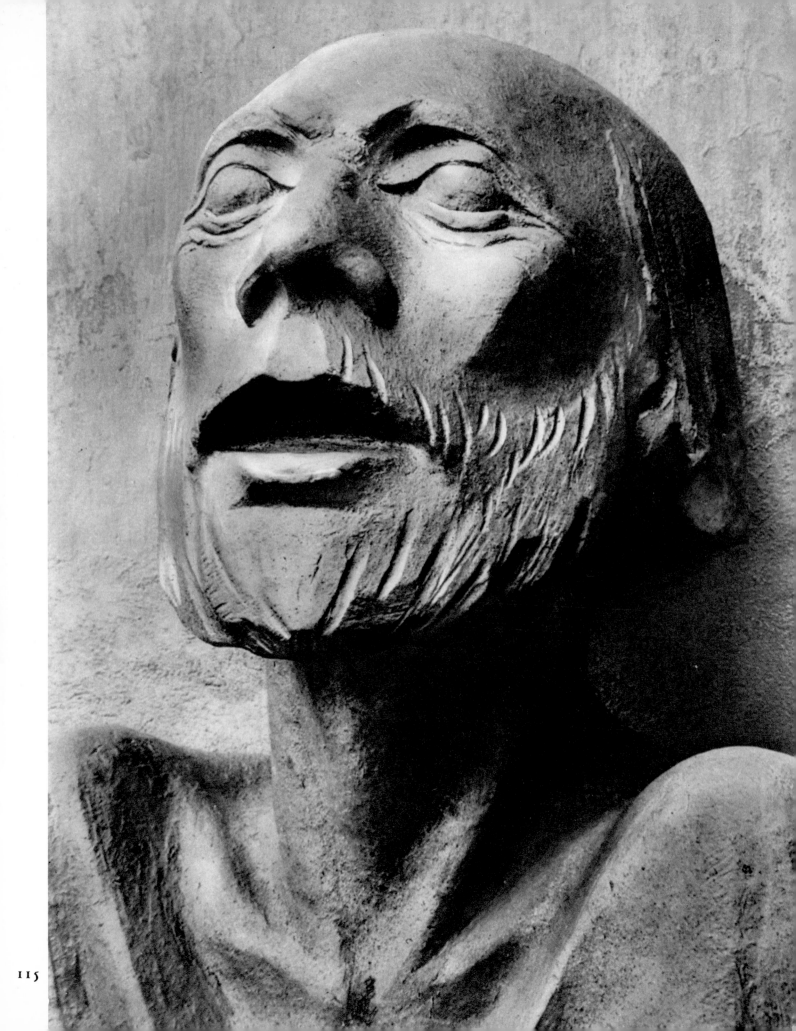

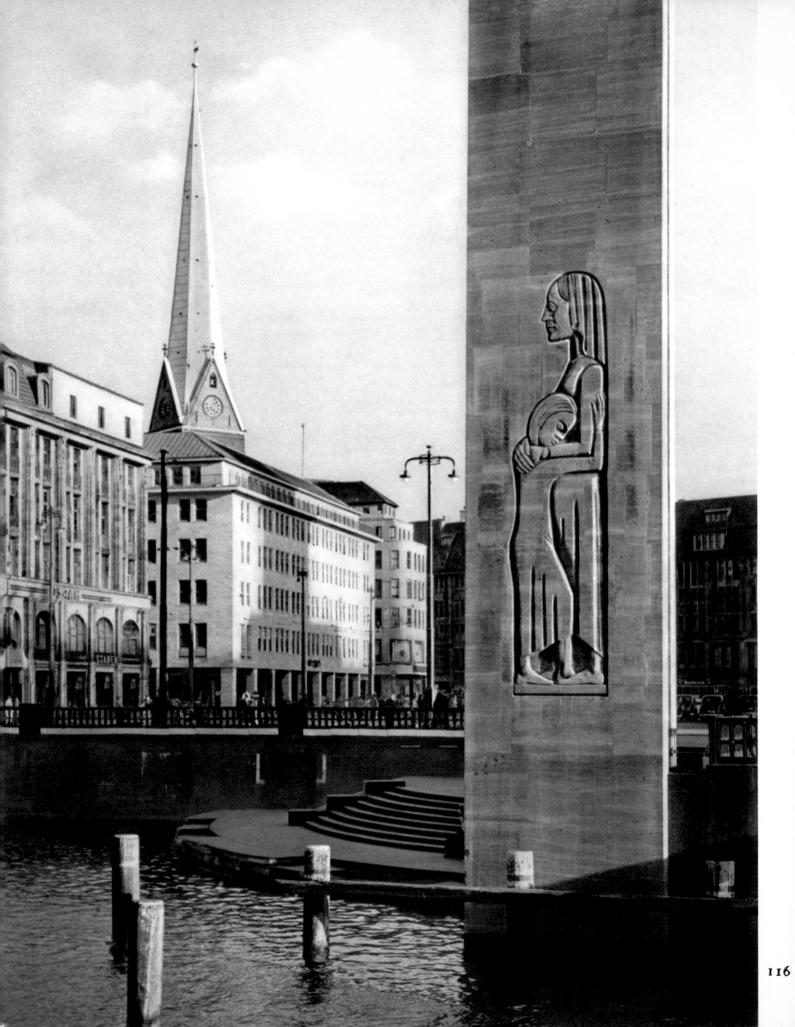

In 1927 Barlach was offered the sort of chance he had wanted for a long time. 'I lack the great opportunities,' he had been telling his close friends. 'I lack the "sacred room" for my sculpture.' Now he was asked to make a memorial sculpture to the dead of World War I for the cathedral at Güstrow, and although the town was small, the sacred room was large. He felt challenged, and the monument he made could have been done only by him.

'That the angel of the Güstrow memorial overwhelmed me is not surprising,' Bertoldt Brecht wrote some twenty-five years later. 'I like such angels.' And he added that the flight of the angel was gloriously rendered, even though no one had ever seen an angel, or for that matter a man, fly.

105, 106 In the *Güstrow Memorial*, the floating human form has been given new emphasis. Severely metallic, it has become a monumental representation of fate, an unforgettable symbol of eternal silence. This messenger from another world does not need wings in order to fly and does not have to open his eyes to see all and know all. He soars and remains mute, powerfully mute, an admonition of iron strength hovering over the tomb of the countless victims of World War I and of later wars. A copy of this angel of death with the rigid body, and stern, dying features hangs in the Antoniterkirche in Cologne, above a tomb inscribed with the dates 1914-18 and 1939-45.

The Güstrow memorial proved that Barlach knew how to utilize the sacred space offered him. But even some of his earlier sculptures

indicated a trend in this direction. In 1918, he had done a *Crucifix* 110, 111
for a war memorial commissioned by the Prussian Ministry of Cul-
ture, but the official in charge said that this modern Christ was not
sufficiently divine. Barlach replied, 'I have never seen a god.' Later
a church in Marburg, St. Elizabeth, acquired a bronze cast, and today
other casts of this Crucifixion are in churches in Bremen and Lübeck.
Barlach also carved a wood-relief for the Church of St. Nicholas in
Kiel of a praying woman threatened by seven swords. This work,
a memorial to the dead of World War I, was destroyed in World
War II.

Heinz Beckmann, the author of a monograph on Barlach, has poin-
ted out that Barlach the sculptor has to be re-examined from the
Christian point of view. 'If the Christian church,' Beckmann main-
tains, 'still had the vision it once had, if it still encompassed life and
brought it into the churches and cathedrals, if it had not become so
lacking in faith as it has in so many ways throughout the world, then
there would be no conflict between Barlach's works and Christianity.
Rather, his works would be found in almost every Christian church,
on all seats and doorsteps of the Almighty, in whose house there
are many rooms. In the era of Gothic fountains and Romanesque
pews, Ernst Barlach's works could not of course have been exhibited,
and Barlach knew this very well. For he, whose attitude toward the
church was so distant, if not refractory, had an ever-growing need for
sacred space for his works, and I believe that however one may dis-
agree about these things, no one can deny that almost everything
Barlach has done belongs in the church.'

Only a few people recognized this in Barlach's life. Traditional
church religiosity had no use for a language of form so unusual, so
different from the traditional. It is therefore to the everlasting credit
of a handful of open-minded churchmen that they accepted his sculp-

112, 113 tures. A year after the Güstrow memorial (in 1928), Barlach completed the *Warrior of the Spirit*, a bronze group about fifteen-foot high for the University Church of Kiel. It shows an angel with sword, in severe dress, wings folded, feet planted on a demon in animal shape. This work, one of the few in which Barlach made use of a popular allegorical theme, may be somewhat mannerist, yet it is undoubtedly highly effective, and with its clear and strong lines and disregard of naturalistic detail, it is ideally suited to its site. The church was destroyed during the war. Today the statue stands in front of the Church of St. Nicholas in Kiel. A copy is in the Minneapolis Institute of Arts.

The *Warrior of the Spirit* was almost two years in the making. One of the problems it posed was one of space. The stable which had served as Barlach's studio was too low, and he was faced with the task of finding new working accommodation. The people who had commissioned the sculptures showed little understanding of his situation and difficulties. 'The progress of such negotiations as they are conducted by officials and their offices,' he wrote, 'is a frightfully costly affair for artists, who have to pay for it by spending their time with plans, sketches, correspondence, and waiting, all the while supporting themselves without receiving a penny for their troubles. The Prussian State or the city of Kiel pays only for finished products. What are designs, drawings, plans, time spent hoping and waiting? These people don't even notice that they are starving you.'

In the meantime a third such commission had come Barlach's way, this one from Magdeburg. He was asked to do a memorial for the cathedral, this time in wood. 'A very different assignment,' he said, 'if only because of the dimensions of the wood needed.' He probably could not have managed by himself, at least not within the ten months he allotted himself, but fortunately he received the help of two young

sculptors, Bernhard and Marga Böhmer, and he was able to catch his breath. Böhmer, a competent young man with business sense, took many burdens off Barlach's shoulders, and with his wife also helped him in preparing the wood, a hard task. 'The centerpiece is now being carved out,' he wrote in June 1929 to his brother Hans. 'The second piece is also being worked on. Mrs. Böhmer has tackled it with the same energy as the first. The only way I can keep her from over-working is by putting my hand under her chisel.'

The *Magdeburg Memorial* is one of the most moving and disturbing 107, 108, 109 evocations of the misery and horror of war imaginable. It consists of three mighty, vertical tree trunks, each representing two figures, one standing and one torso. In the middle of the torso row there is Death, a skeleton wearing a steel helmet. The old man to the left of Death, gas mask strapped around his chest, eyes closed in horror, presses his bony fingers against his temples, a figure of utter despair on the verge of madness. On the other side of Death a woman with clenched fists hides her face in pain, a picture of ineffable sorrow. Above this image of deepest suffering rises a cross bearing the figures 1914, 1915, 1916, 1917, 1918. Crowded around the cross stands a group of men wearing the uniforms put on them by the mighty of this earth. One of them, wrapped in a coat far too big for his boyish frame, with a spiked helmet on his head, is one of those very young men who were pulled into this inhuman war before they knew what was happening. On the other side stands an older, toughened soldier, a picture of unconditional, unquestioning obedience. The middle figure, towering above the others, seems to be the only one to have experienced the monstrous happening consciously and to have arrived at a place where nothing senseless threatens any more. The face of this man also bears traces of suffering, but his eyes are fixed on a better future.

This monument, so unlike the popular notion of a war memorial, aroused a storm of indignation. So-called patriotic and nationalist organizations stirred into action. Barlach was well aware of the forces behind this campaign, and he said so clearly: 'The long and the short of all this is that you want victory monuments, surreptitiously if it can't be done openly and directly, sops to your vanity which can't help the dead . . . It begins with underestimating others and ends with self-delusion. You always bravely accuse others and don't worry about the state of your own house.' He was beginning to sense that a disastrous harvest was being sown, and four years later it ripened. Once again a great German victory was being celebrated—Hitler's coming to power. Barely two months later the Magdeburg church council proposed that Barlach's monument be removed from the cathedral. It would seem that some clerical circles were in an even greater hurry to regiment art than were the Nazis. A year later the Magdeburg monument was crated and shipped to Berlin for storage in the National Gallery. Käthe Kollwitz managed to get to see it. 'It is as good as it looked in the picture; yes, even better,' she wrote in her diary. 'Here the true war experience from 1914 to 1918 has been held fast. Impossible of course for the supporters of the Third Reich; true for me and many others. In looking from one figure to the other: such silence. If mouths generally were made to speak, these here are so tightly closed as though they had never laughed. And he has put a kerchief on the head of the mother. Bravo, Barlach!'

After having lived through the even greater horrors of World War II, one can begin to understand what Barlach was saying here. The man who created this memorial (since returned to its original site) mourns for all victims of war everywhere, regardless of what uniform they are wearing. He is calling on mankind to come to its senses. He shows war for what it is, neither prettifying nor glorifying it.

In 1931 he completed his *Teaching Christ*, a figure certainly meant 82
for a sacred room. But all efforts to place it in a church were in vain.
Today this lovely bronze stands on the top of the tomb of the painter
Christian Rohlfs, in Hagen; one cast is in the Christus Kirche in Hamburg, and another in the museum at Eindhoven. Mention should also
be made of a group of works in shell limestone, a marvelously sensitive tombstone sculpture for the actress Louise Dumont, two mourning female figures for a tomb in Ebersdorf, and the bas-relief for the
Hamburg Memorial (1931). This last work is a profile view of a 116
woman embracing a child. These two figures, by their deep silence,
express the awe felt in the presence of death. The face of the woman,
animated only by a line going from the brow to the mouth, is mournful and closed. Her eyes look out into the distance, where the incomprehensible, the horrible, has taken place. Herself inconsolable, she
seeks to console the apprehensive child by embracing it. The child,
in turn, leans its head against the mother, eyes closed and shyly touching her arm, as if it, too, would like to offer consolation. This theme,
simultaneously harsh and gentle, is part of a composition whose uncompromising vertical and horizontal conception, stripped of all
detail, accords with the relentless severity of the imagery, which does
not wish to soften or gloss over the bitterness of sorrow.

In 1930, a plan by Lübeck's museum director Carl Georg Heise to
commission a major work by Barlach seemed on the verge of realization. Barlach had always felt a special closeness to the medieval architecture and wood sculptures of Lübeck. Heise proposed to let Barlach
do a series of statues for the niches of the Gothic brick façade of St.
Katharine's Church. He and Barlach agreed that ceramic tile would
best harmonize with the red and black brickwork of the building.
Moreover, ceramic tile could be mass-produced and hence help solve

some of the financial problems of this grand plan. Contributions were solicited by offering prospective donors exclusive copies of the statuary. Initially Barlach was hesitant about this project. He had doubts about the suitability of the niches for sculpture, and he told of dreams in which he fought hand-to-hand battles with the architect of the church, from which ultimately he emerged the victor. He wrote to Heise much relieved and in good spirits: 'The old fellow gave in!' The designs he submitted for the statues showed him in top form. He had found a theme which offered him sufficient scope: a community of saints, a fellowship of those who are aware of God's nearness in misfortune as well as in good times, those marked by God and those blessed by Him.

Barlach settled down to work, and Heise began to look for sponsors. Everything turned out to be much more problematical than it had seemed initially. 'Neither the museum administration nor the municipal offices could be moved to underwrite the costs of this undertaking,' Heise reported. 'Although they had been set quite low by the artist, they were not inconsiderable. As so often happens in the case of major art projects, planning was neglected in the enthusiasm for the idea.' Once again, Barlach, as earlier in Kiel and elsewhere, found himself in an intolerable situation. He had invested much work and time, and now the project was faltering. 'The Lübeck affair about which you so kindly ask,' he wrote on November 6, 1930, 'has arrived at a fairly unenjoyable stage. There seem to be problems connected with undertakings of this sort with which I am unable to deal, so much so that work, accomplishment, the essence of the thing, become secondary alongside the unforeseeable developments. It seems to me more important to work than to spend time on misunderstandings and difficulties. In the long run doing something on a small scale is more important to me than the excitement of so-called grand com-

missions. What has become of us artists? Charming little creatures upon whom one calls to show oneself off. I at least feel that everyone seems to know better than we ourselves what we have to do, where in fact we stand. Pleasure in work is the criterion for what is right. He who derives no pleasure must be aware that something has gone wrong. Woe to him who accepts the saying that he who says A must also say B.' But once the first three sponsors had been found Barlach finally did say B, and as time went on, the Lübeck venture became more important to him than anything he had ever done.

Barlach was able to finish only three of the originally planned sixteen (later reduced to eight) figures of the *Community of Saints* when he had to break off work on what might well have been the crowning achievement of his life. After 1933, this project did not fit into the totalitarian scheme of the new rulers of Germany. But the three figures he did complete (they were finally installed in their proper place after 1945) give us an idea of the breadth of his conception. These statues are not the sort of saints we are accustomed to, yet they blend in so harmoniously with the architecture of the old church that one might think they had always been part of it. The middle figure, the *Beggar*, the first one to be completed, is a moving picture of human frailty, a beaten man, the poorest of the poor. With his sunken chest, the hunched shoulders which are supported by crutches framing his thin neck, this ailing creature seems barely able to hold up his head, and yet he raises up his lifeless eyes and opens his slack mouth to call humbly on God. This figure, with its striking treatment of legs, feet, and hands, has the sort of cohesiveness that one expects of architectural sculpture. This is true also of the two other figures, the serene, devoted *Singing Seminarian* and the gently swaying *Woman in the Wind*. They, too, are taut in form, powerful and characteristic in expression — true architectural sculptures and true Barlach, a sculptural

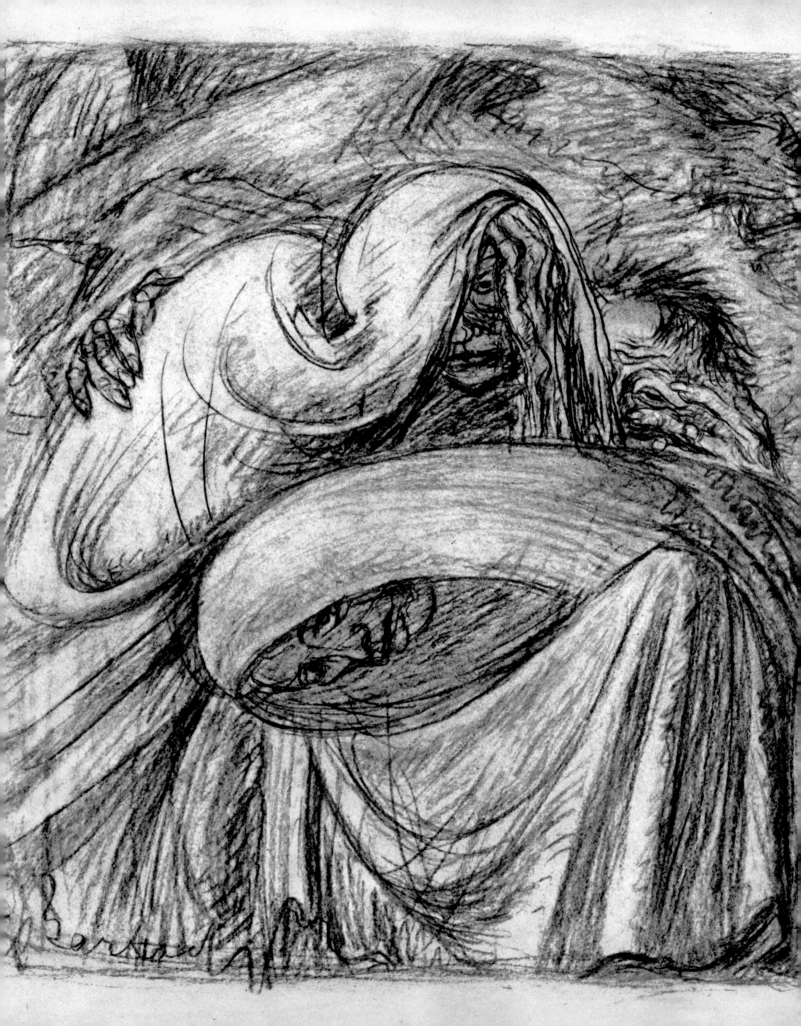

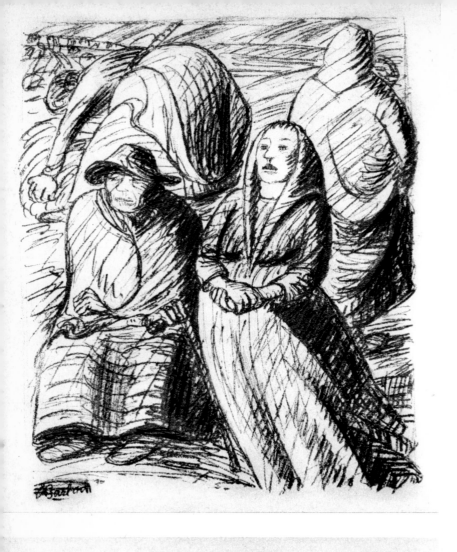

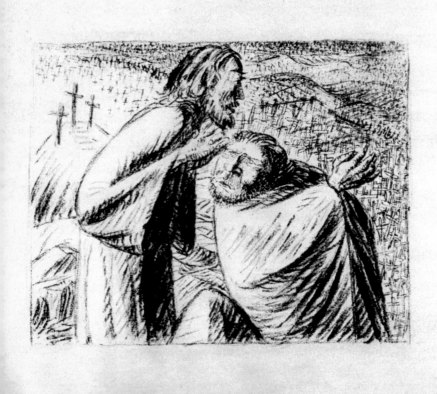

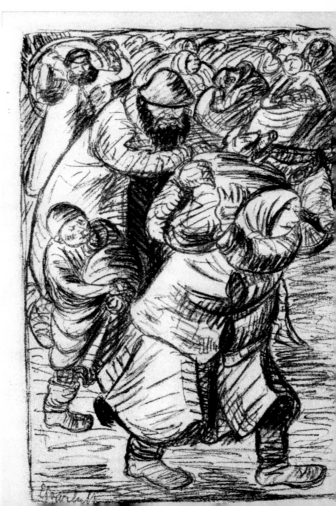

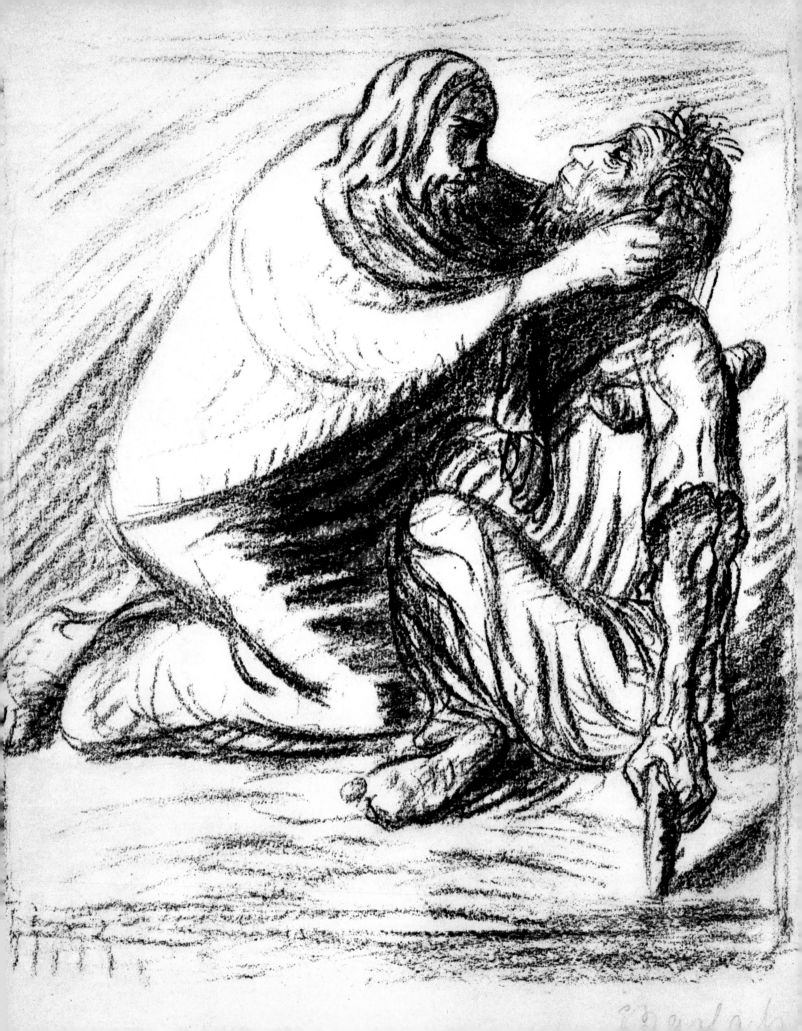

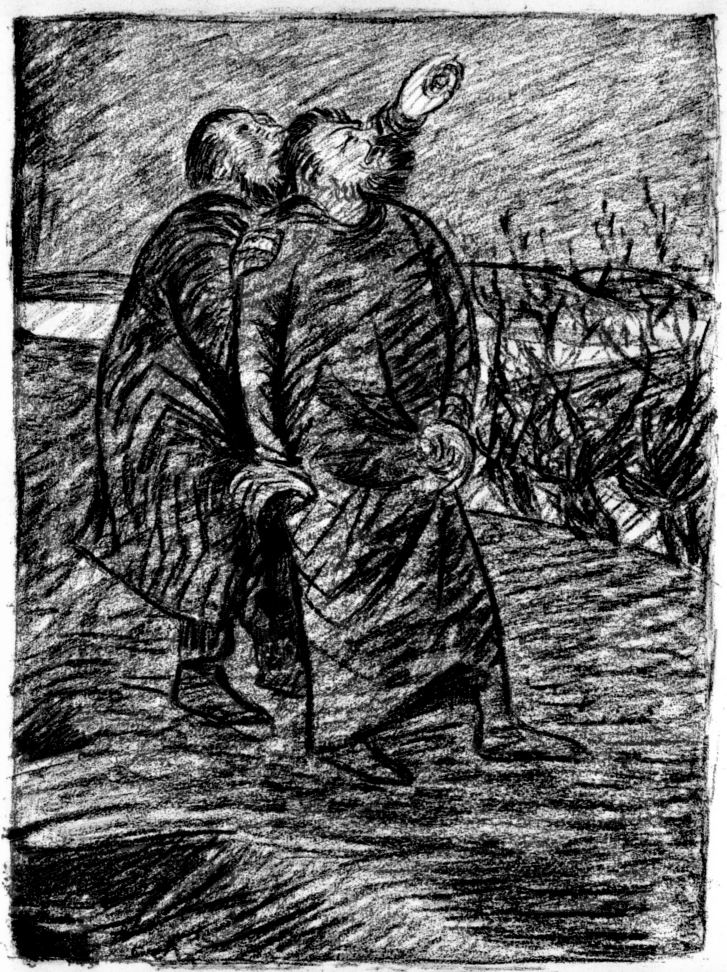

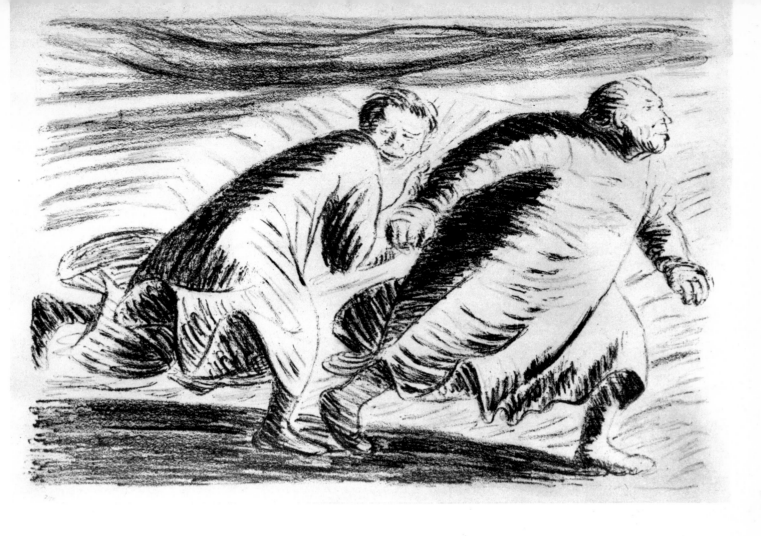

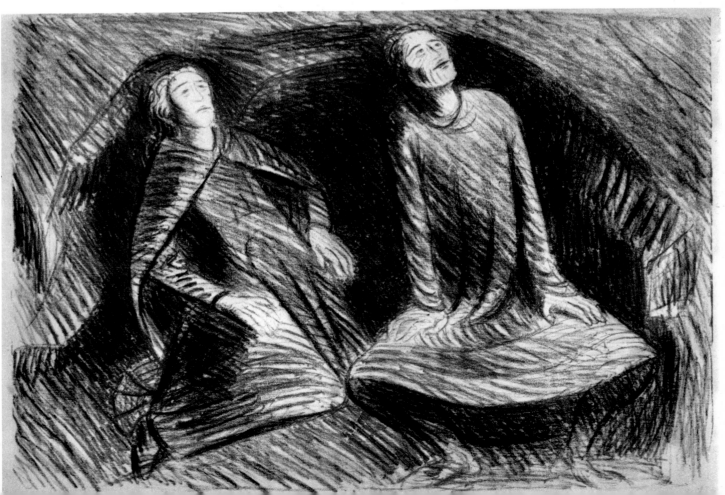

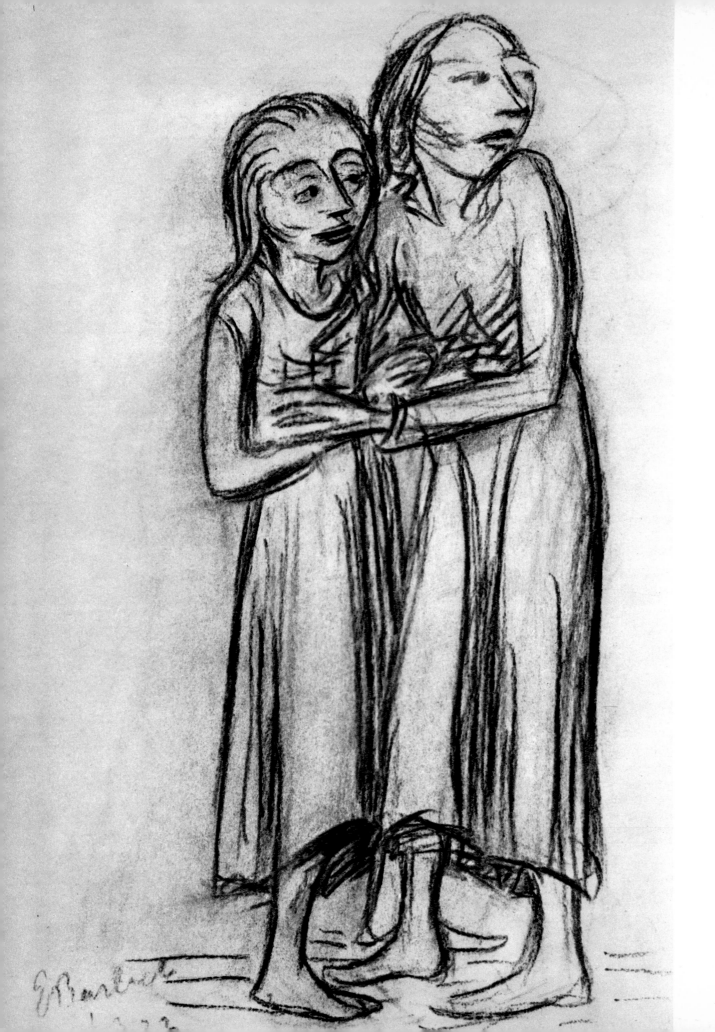

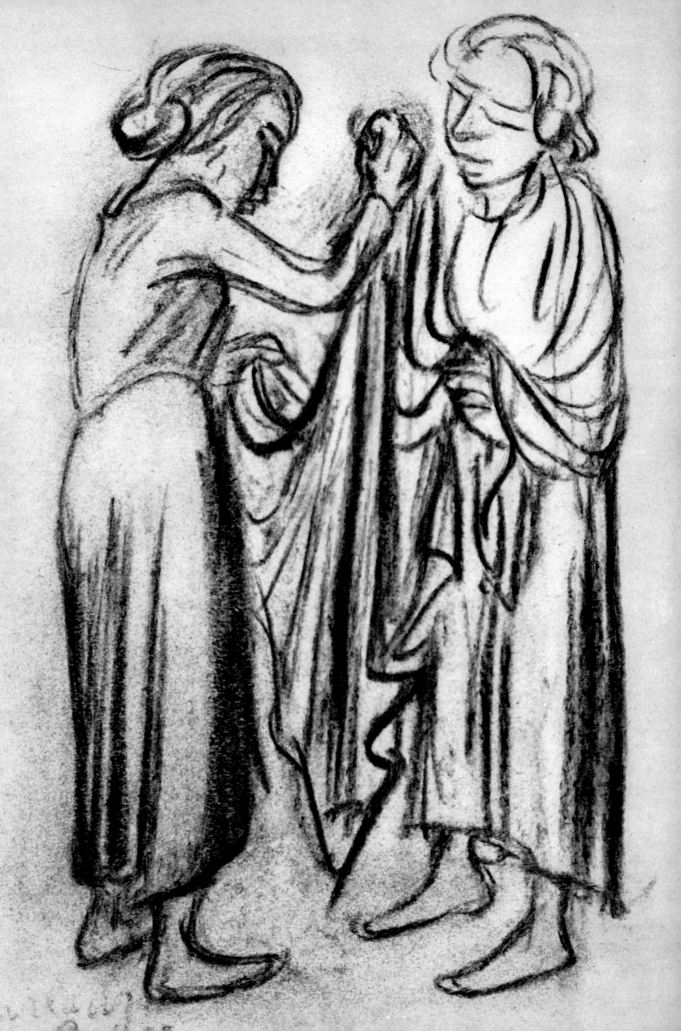

131

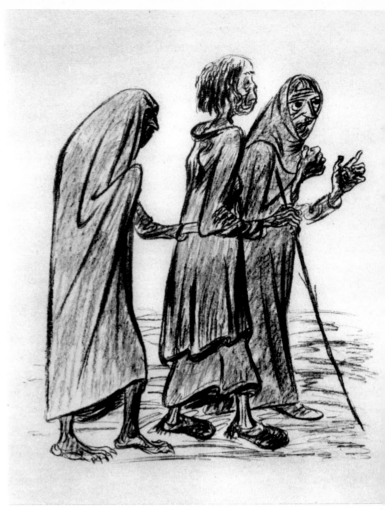

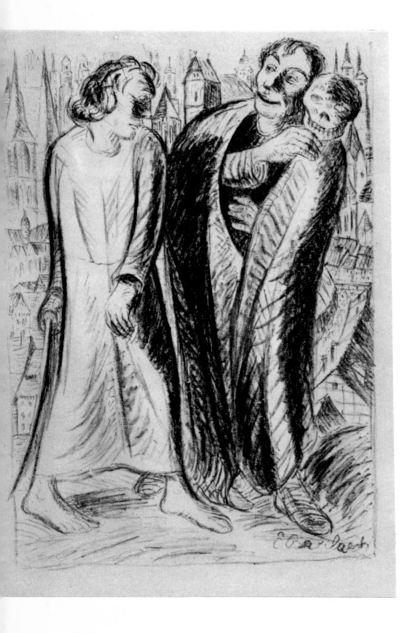

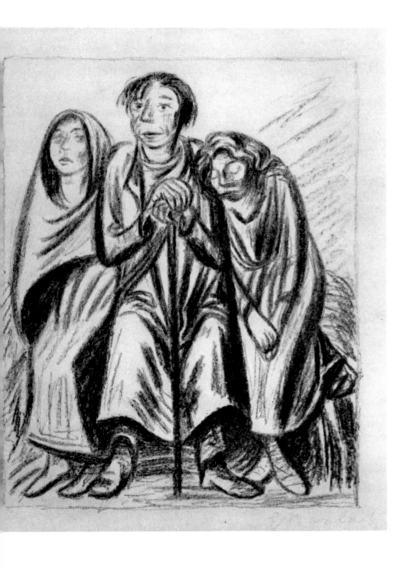

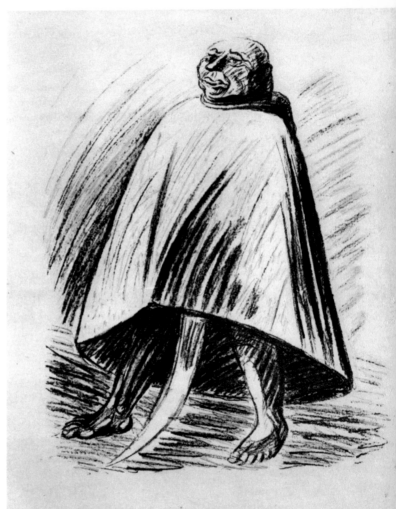

133

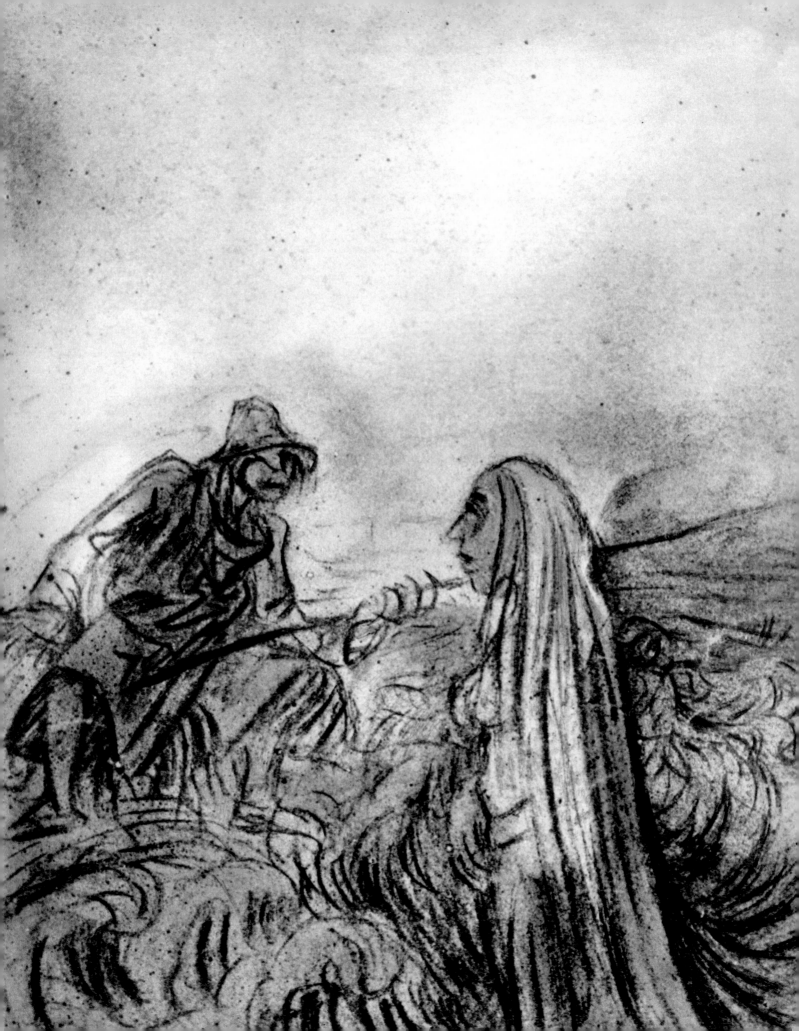

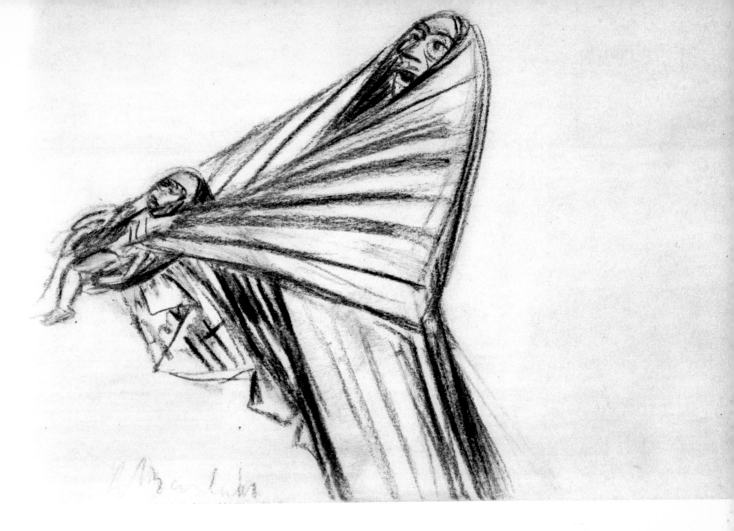

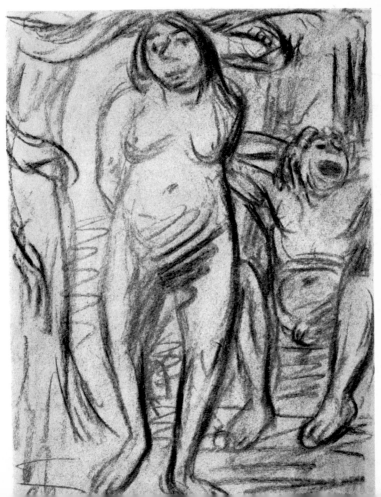

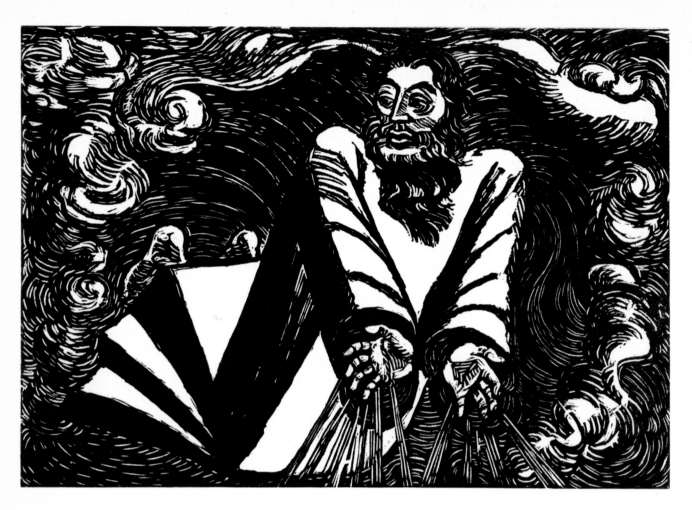

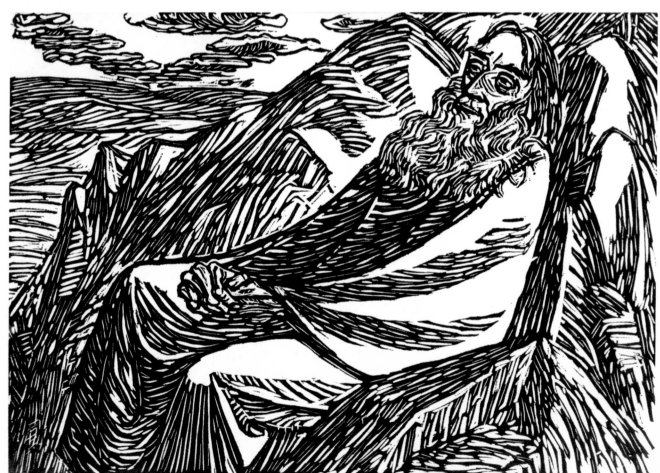

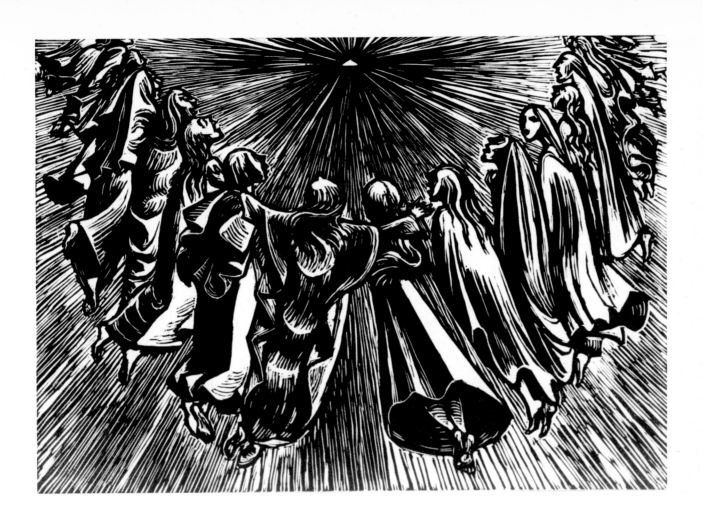

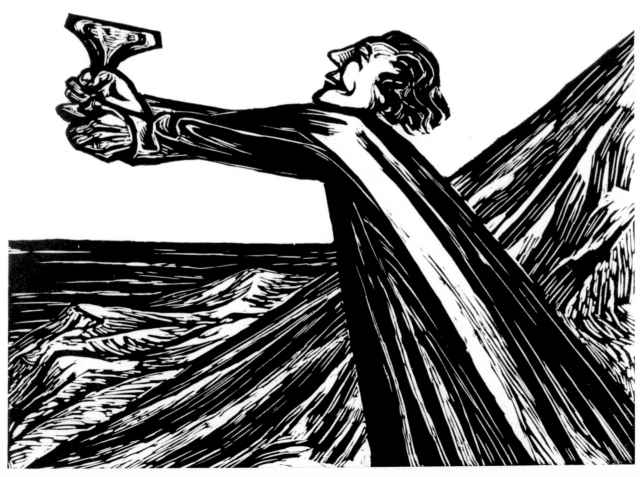

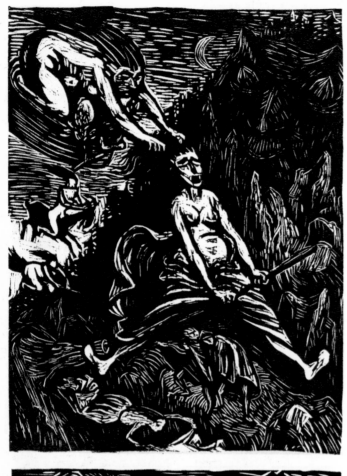
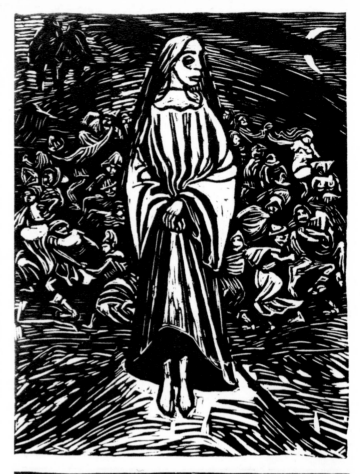
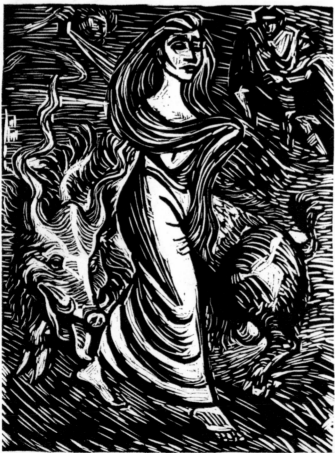
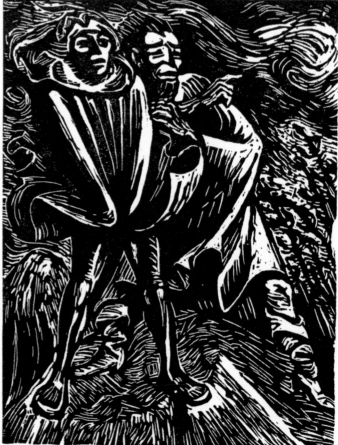

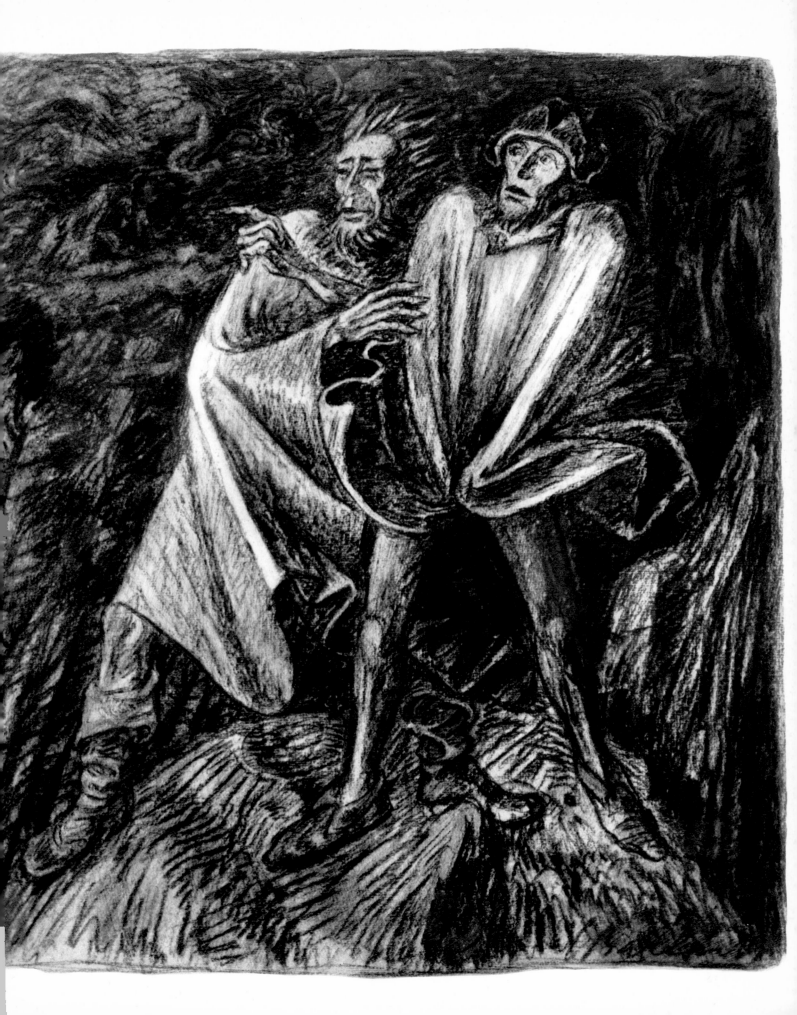

symphony which remained unfinished and, precisely because of its fragmentary nature, stimulates the imagination. The *Community of Saints* succeeds in something which is rarely successful, namely in building a bridge to an epoch long past. Barlach, without falling into the trap of imitation, obeyed the spirit of the Gothic simply by obeying himself. After the war, the sculptor Gerhard Marcks completed the cycle in Barlach's spirit, partly carrying out Barlach's designs and partly his own.

With the Lübeck figures, the sixty-year-old Barlach found the way back to simpler and more serene forms, having traveled the long road from the severity of his early wood sculptures to that explosive dynamism whose highest potential is typified by such figures as *The Refugee* and *The Avenger*. Having tested himself in various media, he had gained enough confidence in his skill to become more restrained, without relinquishing an iota of his individuality and intensity. Barlach's late works combine undiminished expressiveness with a greater balance.

58 top left, 60 The *Reading Seminarian* (1930), a figure of solitary contemplation, has an almost dreamy quality amid an atmosphere of truly monastic peace. He emanates a calm and serenity missing in earlier Barlach. In contrast to the symmetry resulting from the solitude, the form of

184, 185 the later *Reading Monks* (1932) is determined by its duality. The relationship of the two figures, the reading monk holding the book and his companion who reads along with him, makes for a more animated, richer rhythm which lends it inner cohesion.

192 top left The *Wanderer in the Wind* (1934) is an example of how sculpture can make the intangible tangible. The wind shapes this figure, determines its rhythm, is in it and around it. Everything relates to this invisible antagonist, from the stance, the tilt of the head, and the

141

movement of the arms, to the hands, one of which holds the wrap closed while the other reaches for the hat. There is not a superfluous fold in the garment. Here Barlach, with intensity and great spiritual force, has captured the natural phenomenon.

He took the opposite approach in his *Flame* (1934). Here he did cf. 188 not capture nature externally but turned a human form into a natural element. The flame-like grain of the wood is made part of the shape. It rises up along the figure, compresses its shoulders, draws flickering veins on its face, and licks the wreath of hair. A figure outside of reality, a dream figure, a flame seeking to become man or a man becoming a flame. It may be 'borderline' sculpture, an attempt to give shape to that which almost cannot be shaped, but that is precisely where its appeal lies. The persuasiveness of mature power of expression makes the impossible appear almost possible.

The *Old Woman Sitting*, a bronze of 1933, is a picture of decaying, 190 top left burned-out life beyond the reach of either joy or pain. The tired, work-worn hands resting in the lap and the lined face contrast sharply with the motionless, smooth dress. Barlach did the figure because of the hands, and he concentrated on them and on nothing else. He himself characterized this figure in these words: 'An old woman who has learned nothing and knows everything.'

To extract the core, the essence, without embellishment and flattery, remained Barlach's guiding principle throughout. His portrait busts, of which there are more than a dozen, are examples of this searching, penetrating approach. His bust of Theodor Däubler, done in 1916 in wood, deserves special mention: 'A beautiful model, but heavy,' Barlach wrote while working on it. 'So much flesh, one thinks, so much hair, such cheeks, but never mind, all this flesh and bone should and must be mastered, must disappear and be forgotten.' His friend Däubler was to him 'an inhabitant of another world, of another planet,

who for some impenetrable reason has found his way to us,' and that is how he depicted him, surrounded by an aura which from a distance is reminiscent of Pan, the impetuous flute-player of the woods.

Barlach also did portrait busts of Tilla Durieux, the actress, and the actor Paul Wegener, both bronzes. Wegener's unique features, that broad, unforgettable Buddha-like face, could not fail to interest him. Tilla Durieux had sat for Barlach in 1912; at the time she was married to Paul Cassirer. In her reminiscences she relates that in the course of their acquaintance, her apartment slowly became filled with Barlach sculptures. One day, unable to find the right approach to one of her roles, that of a peasant woman, she turned for help to his *Troubled Woman*. The role, she says, became one of her greatest successes. 66 bottom The *Bust of Tilla Durieux*, a lovely and expressive work, now stands in the Schlosspark Theater in Berlin.

It is not in itself unusual for a sculptor to draw . But Barlach's drawings are much more than simply sculptor's sketches. His prints alone, about three hundred of them, reveal a highly personal and unique command of the medium. That is most true perhaps of the many sketches which he kept secret for a long time and which did not come to light until after his death. Most of them have no direct connection with his sculptures; in concept and execution they are independent entities, and they prove beyond the shadow of a doubt that Barlach's graphic work was of the same caliber as his sculpture. It was Paul Cassirer who encouraged Barlach to try his hand at prints. 'When he asked me to contribute a lithograph for the Pan Press,' Barlach wrote, 'I mentioned a "drama" which might possibly serve as a framework for a series of prints. He did not hesitate for a moment with his answer: 'Well, then draw.' I did, and produced a rectangular, full-sized, and for the time being unsalable album, together with a text volume to *Dead Day* which looked as if it had been found somewhere and the finder had given it a temporary haven in the big album. Cassirer, without sharing responsibility for the play, since he had not read it, began a widespread distribution in town and country, and the text volume, having become cozy in its nesting place, went along with it.' One can understand Barlach's satisfaction at getting his play distributed in this way. But he was mistaken on one point: Cassirer had indeed read it but had not said anything about it since he felt that the chances of getting it performed

144

at the time—1912—were not good, and he was right. *Dead Day* was first performed on November 22, 1919, a year after the end of the war. The *de luxe* first edition of the twenty-seven lithographs and text volume, a drug on the market when published, has become a collector's item. Here for the first time Barlach the graphic artist is completely himself, having drawn for years and years, 'indiscriminately firing his gun,' as he put it, or, in order to make money, adapting his style to various periodicals. Now suddenly his graphic style blossomed forth and everything foreign to it was discarded. While working on his first play shortly after his return from Russia, he had done a series of drawings of a somewhat mythical cast. They were not really conceived as illustrations to *Dead Day*. The relationship of the characters to each other, the mother and the son, the mysterious stranger and the mythical domestic spirits, the entire twilight atmosphere of this unreal world are summed up in the treatment of the basic

150, 151 theme, the father-son relationship. These illustrations have an almost oppressive immediacy if one recalls the dominant question of the play: 'If my father is invisible, how come I am visible? If I can call out, how can my father keep silent? Can one say "mother" without meaning "father"?'

152, 153 The thirty-four lithographs to his second play, *The Poor Cousin*, published in 1919, are of a completely different order. Here Barlach sticks more closely to the text and is more illustrative, almost as if he were plotting the entire production of the play—scenery, staging, and acting. Barlach may not have been a man of the theater, but whoever stages *The Poor Cousin* or wants to study it would do well to look at these illustrations.

His contributions to *Kriegszeit* and *Bildermann* have already been mentioned. What remains to be noted here is a small jewel of the year 1912, a series of thirty charming, fresh lithographs, illustrations for

his book about his travels through the steppes. Barlach consulted his Russian sketchbook again in 1919, when he did his first series of woodcuts. Because of his familiarity with the peculiarities of wood, he had no difficulty in perfecting his technique and made good use of the compact, bold blacks and whites. He also did a series about the misery of the war and early postwar years.

In the *Metamorphosis of God*, a woodcut series done in 1922, Barlach exploits all the possibilities of that medium in a treatment of Genesis. The *First Day of the Creation* again has the floating figure 136 top which so preoccupied him; here it is God the Creator, who with a benevolent gesture hovers over the waters, powerful in black and white, surrounded by swirling clouds which seem to be on the verge of an explosion. *The Seventh Day* shows the seated figure of the 136 bottom Creator leaning against a rock, the tired hands resting in His lap, looking out into space. The work of six days has been done, the tension between black and white has been subdued, the strong contrasts have given way to a soft evening light. This lovely woodcut was originally entitled *Moses looking into the Promised Land*, an interpretation which perhaps is more acceptable in this day and age, when a great German philosopher has stood out for the principle of hope and a great prophet of non-violence has spoken the unforgettable words 'I have a dream.' Moses, too, has a dream. This figure seems enveloped in an aura of peaceful promise.

The Foundling, written immediately after the war, was published in 1922 with twenty woodcut illustrations. One of these, the *Quarrel-* 149 *ing Couple in the Rain*, is a fine example of Barlach's subdued yet 149 top right convincing utilization of this medium. The oblique crosshatching, which covers the entire upper portion of the page and runs over into the lower, hints at driving rain, but only the stooped posture of the man, his attempt to hold his coat closed, and the concern of the

146

sitting woman to keep the child in her lap covered with her cloak convey the bitterness of these homeless people abandoned to wind and weather. Others in this series also wander through the streets exhausted, starved, unkempt, at the mercy of a pitiless nature. Barlach has captured here an anguished vision of a world out of joint.

Goethe and Schiller furnished the idea for two other series of woodcuts. Barlach was pleased to be asked to do the illustrations to 138 Goethe's *Walpurgis Night*, for it gave him the opportunity to indulge his secret love for the fantastic and grotesque. It is a very spooky and eerie world which he drew. All the inhabitants of the witches' realm are noisily gathered together; the wind puffs up the garments and sets everything in motion. Only at one point does everything suddenly become extremely still, as a young woman in a long gown, pale and slender, hair untied, hands resting on her body, moves through the 138 top right night. It is Margarethe, on whose neck Faust sees a thin red string, 138 top left 'no wider than the edge of a knife.' Another drawing, typical of the noisy and agitated mood, shows a witch riding across the sky in a washtub, chasing another witch riding on a broomstick. Below, between their legs, we can see Faust and Mephistopheles, shrinking back from the noise that fills the air. Even the landscape seems bewitched; a mountain peak has become transformed into a devil's mask. The twenty illustrations to the *Walpurgis Night* appeared in 1923. Four 137 years later he did nine large woodcuts to Schiller's *Ode to Joy*. 'Joy as content, purpose, meaning of the world, an idea which has occupied my thoughts beyond time and space,' was Barlach's comment on 137 bottom this venture. The very first woodcut of the series, a composition of only a few lines and planes, testifies to a passionate desire to match the expressiveness of the poem, resulting in a stark, almost poster-like simplification. The horizon, the line of a dark sea, dissects the picture, which is also divided diagonally from lower left to upper

right by a mountain slope. Into this landscape, whose sky is white, and cutting obliquely across the horizon from the right, a mighty figure moves forward, head thrown back, arms outstretched, a wine glass in hand, a gesture that proclaims: 'This drink is to the entire world.' It is an exaggerated, unforgettably powerful symbol of the beautiful, world-embracing exuberance of the poem. Its basic theme, joy, is treated like a musical motif, in part freely interpreted, in part in literal illustration of the text. The cycle closes with an image of the Judge of the Heavens, a seated Godfather with arms outstretched, palms down, the bearded head surrounded by a halo which sheds its light all around, filling the page and gathering everything up into a radial order. What Barlach intended and accomplished here is the utmost simplification and condensing of the graphic technique.

Barlach's prints, catalogued with great care in Friedrich Schult's index of works, are much in demand today, but being widely scattered are not easily assembled. The most representative collection is that of the Reuttie Foundation in the Bremen museum — almost three hundred prints, the bequest of a collector. Among these are thirty-one lithographs to a volume of Goethe poems published in 1924, and four self-portraits done in 1928.

I would like to mention once more Barlach's vast output of drawings, of which only a few hundred have as yet been shown to the public. Nearly a thousand are still at Güstrow. Some are familiar to us from the sketchbooks of the years 1891 to 1914, which show how deeply affected Barlach was by everything he had seen in Dresden and Paris, in Russia, Florence, and Güstrow. Some of the sketches are probably studies for sculptures, others designs for prints; occasionally one and the same theme was executed both as sculpture and as prints, while others, suited to neither medium, remained simply sketch-

cf. 34, 73 top 74, 86

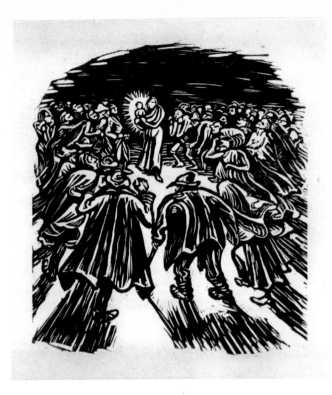

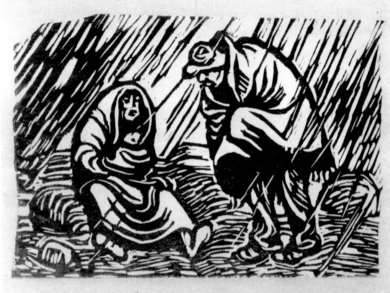

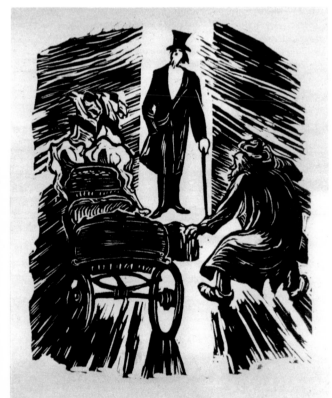

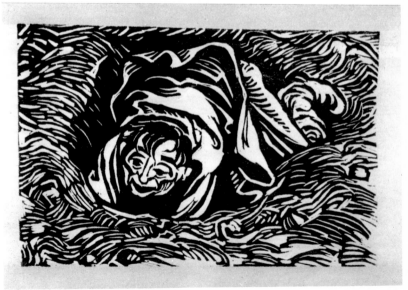

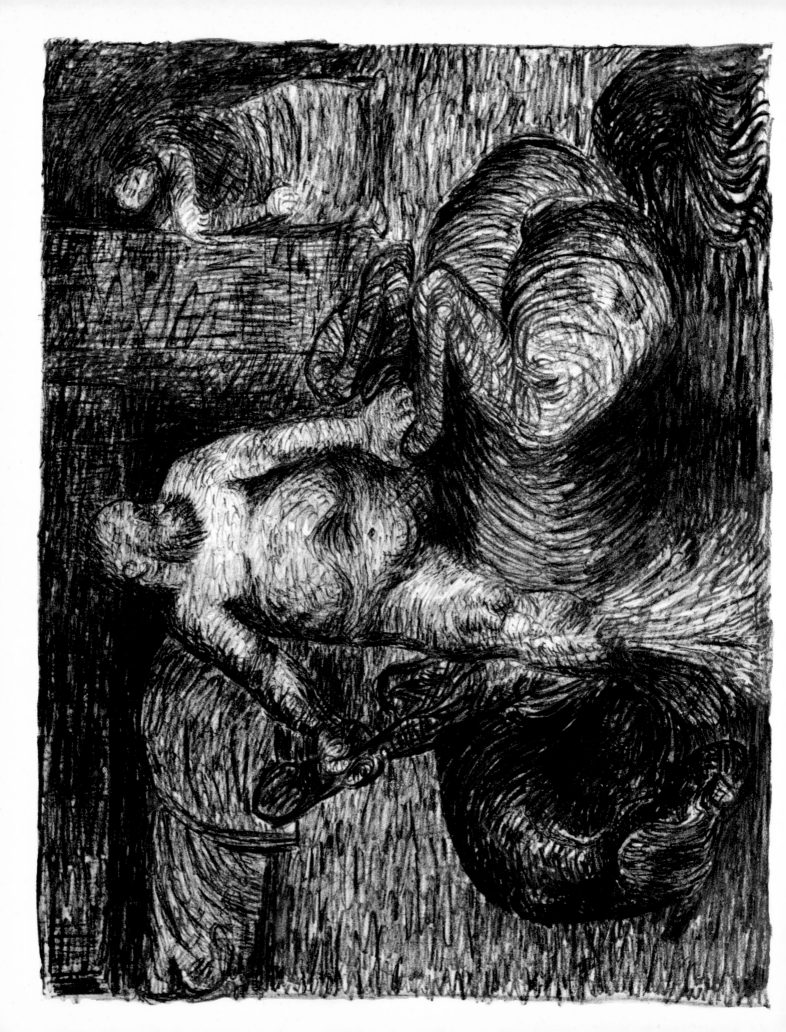

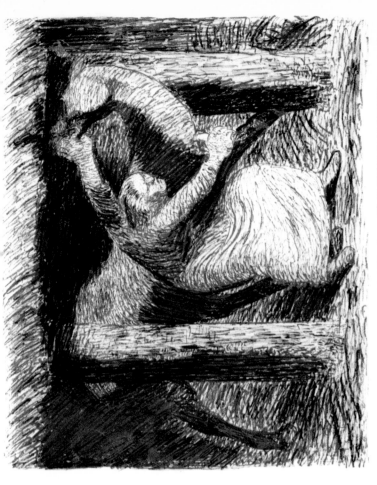
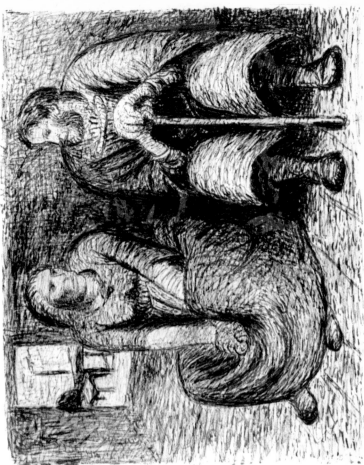

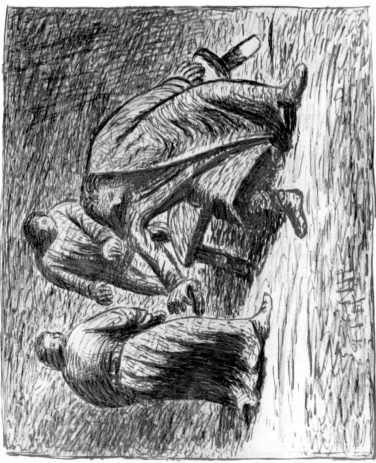

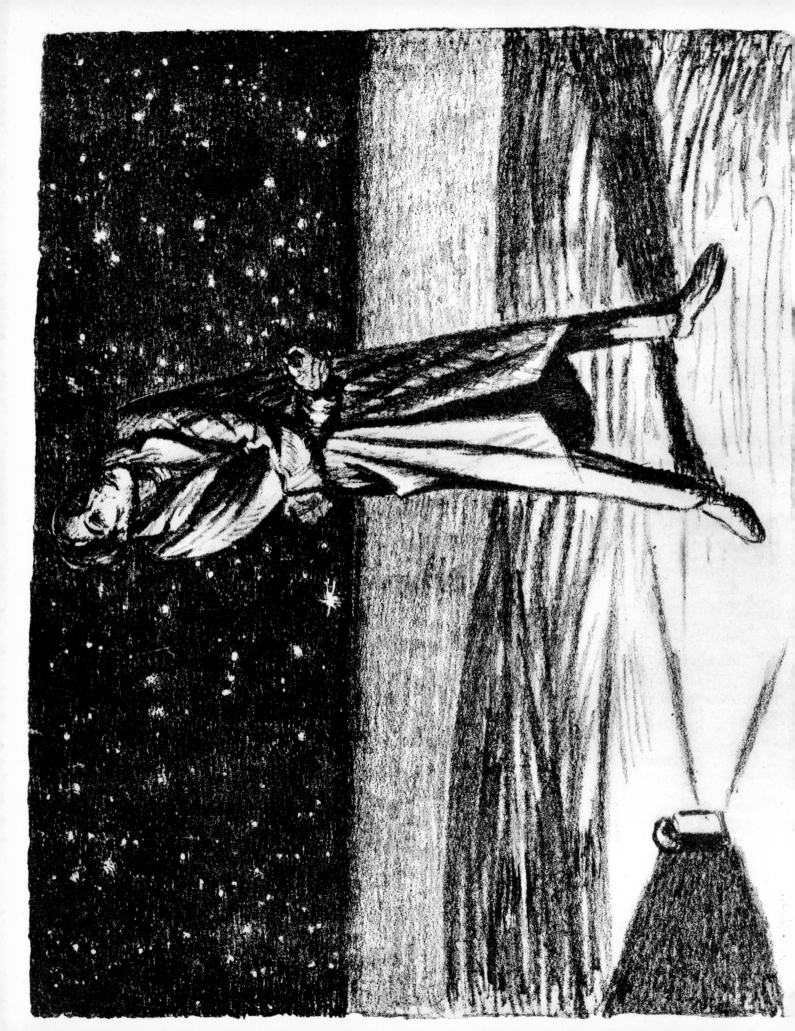

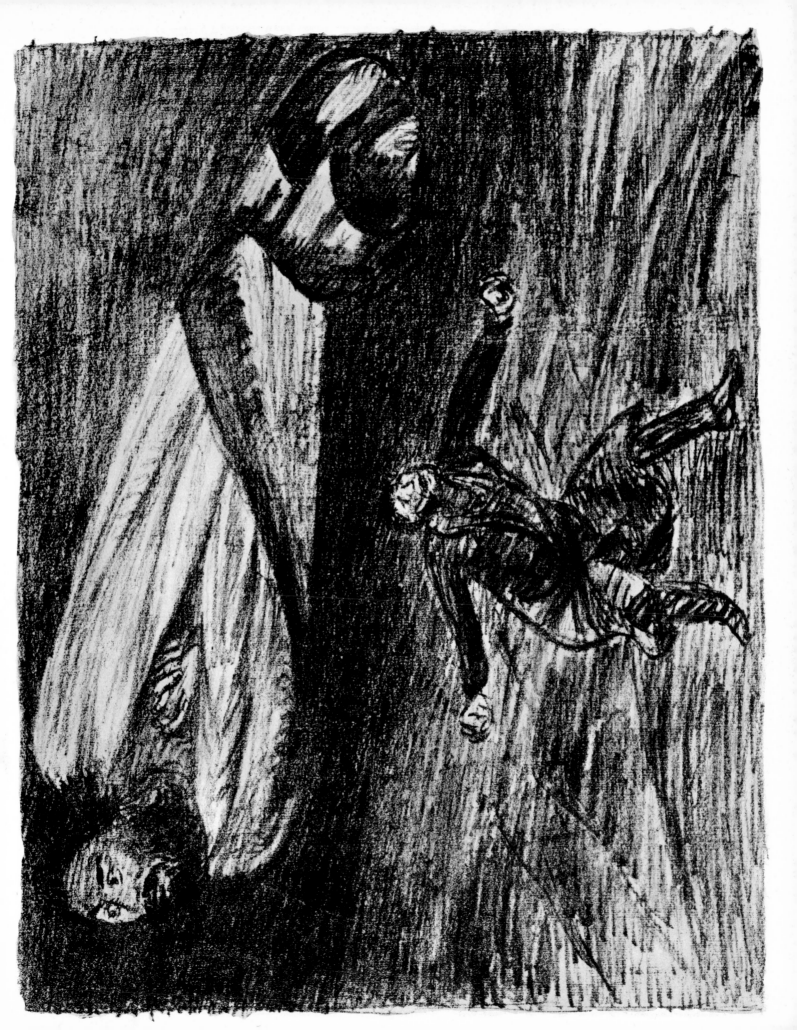

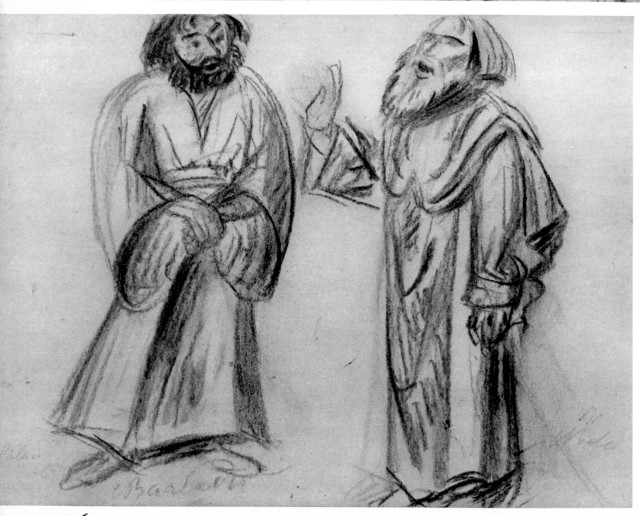

es. At any rate, Barlach's search for form always concentrated on drawing, whatever the final goal he had in mind, and hence the drawings can with some justification be looked on as the directive center of his entire work. As a draftsman he mastered reality and by drawing it he transformed, simplified, and tightened it, extracting the inner shape of his artistic vision from the outer form. To follow this process from a quick sketch, from the original idea to the final products, is as enjoyable as it is exciting.

In leafing through Barlach's notebooks one is often surprised to find hitherto unfamiliar characteristics. Still greater is the surprise in seeing a drawing he contributed to *Jugend* around the turn of the century. It seems almost unbelievable that the creator of this conventional, decorative pastel is the same Barlach of the *Russian Beggars* and *The Reader*. Looking through these books, one can follow the road traveled by Barlach the draftsman between 1900 and 1925, the vast distance he covered from his early beginnings to the skill of his maturity. At first he used a variety of techniques and materials—lead, chalk, charcoal, and india ink. Later he used charcoal almost exclusively, accepting its limitations and renouncing certain nuances, but at the same time achieving a concentration on essentials, a linear control in harmony with the subject.

Among his drawings there is a particularly striking series of furies and witches. Here something breaks through which does not show up nearly so clearly in his sculptures and prints: a trace of the scurrilous, a tendency to see the grotesque even in the eerie. For the rest the themes of his drawings range widely, from the simple *Lovers* to the *Desert Preacher*, from childish terror to Biblical miracles, for example *Elijah Being Fed by the Ravens*, and again and again his floating figures appear singly or in pairs. The dividing line between his drawings, sculptures, and prints was and remained fluid. There

can be no doubt that a major portion of his drawings not only show cf. 130, 131 astonishing skill, but in content and form are works of art which can stand on their own merit and which could have been done only thus and in no other way. 134, 135 upper
135 lower

Among his sketches there is a *Nibelungen Saga*, which he did in 1922, and which was supposed to become a woodcut series. Even though he had done a great deal of work on this, he ultimately decided against finishing it, because, according to Friedrich Schult, 'he did not want to subject himself to the suspicion of having given in to the noisy demands of nationalism in a rapidly worsening world.' How right he was. The *Nibelungen Saga* had, only a few years after the end of the war, again become a nationalist symbol.

Asked about his plays, Barlach reputedly said that in them he gave the people who were always round him a chance to do a little talking every now and then. This sounds like a casual remark about a minor fancy which does not warrant further mention. But the people who were always round him were the products of his imagination to whom he held fast in his drawings and sculptures. Yet it would seem that what he learned by eavesdropping on them in this manner was not enough. His dialogue with them continued, and he had to write down that which he was unable to depict graphically. An inner compulsion drove him to exorcise the people of his imagination threefold: in sculpture, drawings, and plays. A remarkable phenonemon, this triple gift, the more astonishing in a man who said of himself that he at no time possessed that which is generally referred to as talent. And he meant it sincerely. What he wanted to say was that he lacked that light which one generally associates with the word 'talent'. However, he possessed another gift: a drive which did not let him rest until he had found the appropriate means of expression. The world has known many men of multiple gifts—poets who painted and drew, painters and sculptors who wrote—but only few artists were also major playwrights.

In Barlach's plays the phrase which he used to describe his sculptures, 'nostalgic intermediaries between the whence and the whither,' takes on a very special meaning. In the plays the inner mechanism which the sculptor could only touch externally, so to speak, is revealed; what

Barlach has to say about man now is there for all to see and hear. The question about the meaning of life is the theme that dominates all his work. The human situation as Barlach experienced it is that of the poor cousin who can never quite forget his more exalted origins and who longs to become the equal of his better-off relatives.

What matters, Barlach said, was to give voice to one's innermost thoughts and feelings. Barlach for years had felt that man was superfluous, and through his plays he hoped to exorcise this troublesome idea. But he never fully succeeded. He always saw man as only 'half of something else,' an exile, a beggar, a prisoner. 'I for my part cannot rid myself of the thought,' he confessed late in life, 'that we are sitting in hell or in a penitentiary, a very cunning penitentiary in which there are many different punishments, but in which everyone more or less tends towards rebellion, since we are kept ignorant of our situation. 'Ignorant' refers to the fact that man is denied even the consolation of being able to return home after having served his sentence. Elsewhere he said that even though he himself hungers for life as much as the next man—thus has nature decreed—the 'affair as a whole' strikes him as being like a poorly-ventilated, badly organized passageway, making sense and having a purpose only as a transitional stage, a phase. 'You know,' says Hans Iver, the poor cousin, 'I got lost or ended up here in the hole because of some stupidity.' And by the hole, the prison, he means life. He does not reject the idea of original sin as nonsensical, because 'one doesn't get into this mess, be disowned by one's relatives, ignored by people for no reason at all.' He is plagued by disgust with the world and with himself; he can no longer stand the smell of his own body once he has become aware of the questionable nature of life. One Easter morning he wanders in despair through the heath of the Lower Elbe, where a deeply-troubled Barlach had walked in his Wedel days. The other

holiday strollers are in a festive mood, but the dejected Iver has decided to do away with himself. But his suicide attempt fails, and wounded, he is taken into a boathouse where there is a crowd waiting to return to Hamburg. Iver shamefacedly tries to hide his injury, and becomes the object of public ridicule. But among the noisy crowd there is a kind soul, Miss Isenbarn. This young woman is deeply upset by Iver's attempted suicide and defends him with spirit against the coarse jokes of the others. She even gets into an argument with her fiancé, Mr. Siebenmark, a proper and self-satisfied traveler through life who fears nothing so much as scandal. Now the seemingly impossible comes to pass: Iver is victorious over the unimaginative Siebenmark. Miss Isenbarn cannot save Iver, who slinks away to die, but because of her encounter with him she breaks off her engagement. Iver has kindled a flame in her which cannot be extinguished. In a letter in which he discusses *The Poor Cousin*, Barlach says that he is satisfied with having brought out something which is only too easily forgotten. 'Children, remember that things being as they are, everything looks pretty desperate, and therefore since you can't all kill yourselves, at least try to entertain the idea of a more dignified existence.'

cf. 208 middle left In *The True Sedemunds*, which appeared in 1920, two years after *The Poor Cousin*, Barlach is concerned with the tragi-comic aspects of life. The idea came to him some years earlier, as he noted in his diary on June 17, 1917: 'I have an idea for a play which might take place in a fairground: a funeral, church music, shooting gallery noises, carrousels, menagerie noises, everything all together. The mood of Judgment Day. The meaning behind it: how God who, as the symbol of life has created this confusion, must have suffered as this ferment, this duality, this shredding of feeling is the reflection of a process. Happiness, harmony, are sought after convulsively,

wildly, desperately, and the harvest is only disappointment, suffering, and pain. The carnival of life presented here by Barlach is set in motion by the somewhat peculiar Mr. Gude, who acts with the stubborn persistence of a man who has always believed that either he or all others are mad. He has carried this belief to its logical conclusion and has voluntarily spent some time in a mental institution. At the fairground he gets hold of a lion's skin after having spread the rumor that a lion has escaped. At first no one believes him, but then someone sees the escaped lion (Grude dressed in the lion's skin) in the bushes, and the fair turns into a bizarre lion-hunt, which ends at the church yard. There the young Sedemund, his father, and his Uncle Waldemar, in front of their family vault, are having an argument. In the course of this family dispute a number of things which would better have remained unspoken, some unsavory deals inside and outside the Sedemund family, are brought to light. After all the excitement has died down, the old Sedemund takes his son aside and tells him: 'Well, what does the son say about a father who has erred? . . . I should think that you have fully avenged your mother. . . . But, son, if I were to tell you the whole truth in appropriate words, both of us standing here in the dark would blush before each other. . . . She was a good mother, Gerhard, but a miserable woman.' The son is indignant, but old Sedemund goes on talking, trying to cleanse himself of guilt. 'Learn to see that closeness, dependence on other people, is a dangerous thing. A gulf opens up between people when they fail to keep a proper distance. . . . You don't know how beautiful the world is; neither did she. Call me sinful; God Himself loved sinfully when He created the world with its horrors and its beauty.' Young Sedemund ultimately realizes that his rebellion, a more or less blind gesture, has brought him into an embarrassing situation. In order to give things a chance to simmer down, this

162

moral radical, partly out of disgust and partly as a favor to his father, agrees to enter the same institution from which Grude, his spiritual brother, has just been released. Uncle Waldemar, deeply touched by his nephew's action, calls him a 'true Sedemund,' an absurd praise considering everything that has gone before. Grude for his part has achieved what he set out to do; he has shaken up the whole petty, bourgeois, lying society. Putting his arms around his wife, filled with fresh confidence, he dances with her over the graves: 'The old have had their time and have died; now it is our turn, and after us our children's; everything from the bottom up will be changed. Long live the new era and the true Grudes.' One leaves the mental home, the other enters it; this, Barlach said, reflects 'the unease about everything,' the kind of upheaval found in all his sculptures and plays until *The Deluge*. There the whole world reverberates with the majestic, relentless battle between belief and unbelief, between good and evil.

But this intellectual debate never deteriorates into a mere game. Barlach did not lose touch with reality even when he presented it in an exaggerated form. That which moves the people in his plays is frequently put into the simple idiom of the German North. Barlach is a modeler of languages in whose hands the everyday speech of the people takes on a special luminosity, changing its meaning, veering between real and unreal, between the metaphorical and the allegorical, between seriousness and humor. His use of language permits him to endow his characters with two sets of characteristics, an everyday and a special one.

cf. 154, 155 207 bottom, 208 top and middle In *Boll*, a Mecklenburg landowner and his wife, a decent, not very astute woman by the name of Martha, come to town to do some shopping, talk with the mayor, and have dinner with a cousin, Prunkhorst, at an inn. When he gets to town, Boll feels that there is some-

thing in the air. He alludes to it in the opening lines: 'Still a light fog, not completely unattractive, eh, Martha?' he says to his wife as they walk across the market square and look up at the church. 'Look at this blurred perspective. I like it. There might be more to it than one might think. Things can turn out differently from what one assumes.' Mrs. Boll does not like to hear such talk. It bothers her. She finds that her husband has changed lately. She does not know what has come over him, and, annoyed when her husband fails to keep the dinner appointment, she talks things over with Prunkhorst. 'Do you believe,' she asks in her touching simplicity, 'that people can change, I mean become completely different? I am more frightened about Kurt than I can tell you.' Prunkhorst, conservative to the core and under the influence of wine, laughingly answers: 'If Kurt feels like acting the way he does, let him. But if he should become a nuisance, I'll deal with him. We need him just the way he is. Change, I'm against all change. It can't get better and therefore it's best to leave things as they are.'

In the meantime Boll, who has not felt comfortable in his own skin for some time, is determined to change. His meeting with an unhappy young woman has stirred him deeply. It was an accidental encounter, but for Boll it became purgatory. He had met her as she was walking aimlessly through the town, in flight from her husband. In the bell-tower of the church where she has decided to hide, Boll, who calls her the Witch Grete, has a macabre talk with her about three poor children whom she feels compelled to liberate from their earthly existence. Moved by her insistence, torn between responsibility and desire, he had half promised to get her some poison. But now he stands before her empty-handed, and she wants nothing more to do with him. She disappears into a disreputable tavern, and half willingly, half reluctantly, accepts the innkeeper's offer of lodgings in his 'Devil's caul-

dron,' as he himself calls his cavern, which promptly turns into purgatory. While Grete is roasting there, Boll spends the rest of the evening with his wife and his cousin Prunkhorst, as well as two peculiar characters, one the devout Holtfreter, a local cobbler, and the other a mysterious stranger who, Holtfreter says, 'is the Almighty Himself, a simple pilgrim.' While talking to them, Boll is thinking about Grete, 'who wants to set fire to the houses in which these children live, Grete whom I have promised to help instead of the opposite.' He tries to make up for his failure by getting her out of the Devil's cauldron and taking her back to the church where it all began. There in the church, among its pillars and bay windows and statues, he is finally overcome by the feeling of complete change, of inner transformation, and pitilessly takes stock of himself. With the help of the mysterious stranger, he pledges himself to shoulder responsibility and follow the dictates of a newly acquired conscience.

It is a play about change and transformation, growth, free will, and compulsion, in effect about the origin and purpose of man. 'My interests and my creative drive again and again center on the problems of the meaning of life,' Barlach said, and he added that it was not for him to preach, to offer solutions, to hand out grades, to define good and evil. He was an artist who had to create, not speculate; he wanted to give voice to his feeling about the universe and nothing more. That he did do, honestly and fearlessly, unhampered by dogma.

If Barlach the playwright climbed the 'high mountains in the spiritual realm,' he nonetheless knew that 'the true and final knowledge is and must remain hidden.' The word, he believed, was only a miserable expedient, a shabby tool, 'an earthen pot of earthly life which wants to tap eternity.' Man may want to believe, but because he is human he is unable to express his beliefs. This is an insoluble contradiction, because 'God is—thank God—certainly not man.

. . . Men will never be able to see God. To man He will always remain an idealized picture of man.' The same Barlach who said this also said that he has been reluctant to speak about God, but that the word kept coming back. 'I am ashamed to talk about God,' says a young shepherd in *The Deluge*. 'The word is too big for my mouth. I know that He cannot be known, and that is all I know about Him'. Noah believes in God; Calan does not. They are in conflict with each other, the man of unconditional nonviolence in the Christian sense and the man of action and violence. But here too the final question remains unanswered, namely whether this bitter contest which tears apart this world can be settled on earth. Pure and undefiled, Noah wanders through this sinful vale. He relinquishes his will because he is guided by God's will, and he can do no other because he loves his God. But just as Noah acts out of an inner need, so does Calan. He is impelled by the same overflowing hatred which Barlach had in mind when in his novel *The Stolen Moon* the fallen angel Harut says that this cf. 156 hatred fulfills the function of love because evil is needed to bring about good. Barlach refused to pass judgment on Calan. If evil is needed to bring about good, then Calan is merely a tool, then it is his fate to heap guilt on himself, just as every living being becomes guilty to the degree in which it acts under compulsion. The deluge, the great cleansing, separates good from evil and devours Calan and all like him. But is it true in fact that only the good survive? One of Noah's sons takes a girl who had been a subject of Calan as his wife. She is admitted into the circle of grace, and along with her a seed of evil, because she has been violated and impregnated by Calan. Life, Barlach tells us, continues, and so do good and evil, even after the deluge.

In order to understand this work one must look at the tormented Calan in defeat, when his hatred of God turns into praise, when the nihilist is overwhelmed by a God 'without shape or voice,' very differ-

166

ent from Noah's picture of his God, the just and benevolent ruler of whom he can say: 'The Lord is my shepherd; I shall not want. He makes me lie down in green pastures; He leads me beside the still waters.' What Calan experiences in his hour of death is the meeting with a God who is only a glow, an ember, less than nothing, yet everything emanates from Him and everything returns to Him, He creates and is re-created by His creation. Noah, for whom such a creed is incomprehensible, asks Calan: 'How can this apply to God, who is unchanging from eternity to eternity?' But for Calan these are nothing but empty words; he sees the other God, the eternally changing, in whom everything begins and to whom everything returns: 'I, too, am going to whence I came forth, in me God also grows and changes with me to something new. . . . How beautiful, Noah, that I, too, am no longer a shape but only a glow in God. . . . I am already sinking into Him. . . . He has become me, and I, He. . . . He with my baseness and I with His glory . . . a single entity.'

The pious Noah and the godless Calan — a clear-cut, unambiguous confrontation it would seem at first, but it turns out that the play has a double meaning after all. True, Calan has no God. But God in the end has Calan — all of him. Does He, however, have all of Noah, who had so relied on his God that he did not raise a finger to prevent the terrible human sacrifice by which Calan had wanted to prove the impotence of Noah's God? Was Calan not right to scoff at Noah's dull piety and to accuse him of cowardice? 'Noah relied on God, and God perhaps relied on Noah. . . . In the face of so much confidence and reliance, I became a murderer and violator, through God's failure, through your failure, Noah.' The pious Noah admittedly has his weaknesses. He is not an ideal figure. Barlach saw him as a landowner grown too comfortable, tending toward corpulence, rather self-indulgent and patronizing despite all his kindness,

at times even slightly comic in his fearfulness as well as his naive selfishness, and at any rate not very eager to assume responsibility. But even though he was slightly ironic about this type of man and this type of piety, it was not his intention to make Calan, who in his argument with Noah has the last word, his spokesman in the sense 'as if the world now finally is to be told the truth.' He himself had this to say: 'What I as an individual and a man of my time believe and think does of course have a bearing on my characters, or else I could not feel them come to life within me. Thus I am part of all of them and certainly make a poor commentator, for the sympathetic and unpleasant characters are equally close to me. As for me, I try to be honest with myself, and as a result I passionately take the part of a "noble" or "exalted" character without forgetting that all of us have a common heritage and that I do not have the right to judge or evaluate.' In *The Deluge* he sided with an elegant traveler and a beggar, both incarnations of the Old Testament God, the Creator who mingles among his creatures and sees that: 'They are not as they ought to be . . . They think what I do not think. . . . They want that which I do not want.' Barlach endowed this exalted figure with great stature, but he never shed his conviction that man is able to visualize God only as the idealized image of man. 'The Noahs,' Barlach wrote in a commentary on *The Deluge*, 'need a Godfather Jehovah who is their Creator as much as they are His.' But to Barlach, Calan, who scoffs at God and who in the end is overwhelmed by God, personified his view of the dual nature of man. Here the 'poor cousin who never could quite forget his more exalted past,' has become a rebel, an angry challenger, who says of himself that he is a very special being, 'dispossessed, lost, unliked, and abandoned, but a god.' Calan is made to pay for his audacity, but his fall becomes his liberation, he is released from the 'affliction with himself,' an affliction which

the pious Noah in the well-tempered and rather naive self-satisfaction of his devoted life has never experienced. 'In my best hours,' Barlach said, 'I am overcome by the idea of depersonalization, by the absorbtion in something higher. I call it the happiness of self-conquest. . . . Impersonality, that is, infinity, must be the essence of that which reluctantly I call "God".' That is also how he wanted us to see Calan's fall, a transcending of the self, as a dissolution in something higher, infinite, as a redemption of the self and the personality, as a turn to a God without shape.

In *The Deluge* Barlach the dramatist reveals his innermost beliefs. Here the spiritual framework and metaphysics of his writings, its many-faceted quality and its ambivalence, emerge more clearly than ever before. Barlach has been called a God-seeker. 'But what really is a God-seeker?' he asked. 'I would consider it presumptious to make such a claim.' He also reacted strongly — and rightly so — to having the label 'mystical' pinned on his plays. His art is visionary, but it is not mystical. 'The priests and teachers are holding readings of my *Deluge*,' he said in 1932, 'while I had nothing more in mind than to show that the old tale is simply absurd.' That may be so, but this is certainly too modest an appraisal, an ironic understatement, the great thunderer poking fun at his own thunderstorm. What remains to be asked is why the priests and teachers should not have held readings of *The Deluge*. It could not have done them any harm to deal with a new version of the old tale.

Barlach began his last play, *The Count of Ratzeburg*, in 1927, resumed work on it in 1934, and finished it in 1936. It was not published until 1951, thirteen years after his death, and was performed that same year. It is a historical legend, a parable of an odyssey with a large cast of characters. The main character, Count Heinrich, is a powerful man, 'a ruler and possessor,' as he says of himself, 'a

possessor and keeper, administrator and repository.' Count Heinrich has taken a restless, irksome character named Offerus into his employ, who is engaged in a constant search for the most glorious and powerful employer there is. Although he soon leaves the Count, their paths continue to cross. Count Heinrich makes a pilgrimage to the Holy Land, having grown tired of his possessions and status, stirred up by Offerus' words that what matters is not status but being. After a long journey, in which he is imprisoned by the Turks, chained and made a galley slave, he is taken prisoner by a robber band and brought to Mount Sinai. There he witnesses a battle between Hilarion and the spirit of Moses, who defends the rigid commandments of the law, the unconditional demand of the Lord for service and obedience, 'in fear and trembling,' while Hilarion the Christian ascetic defends free choice. Count Heinrich and Offerus, who again meet here, are persuaded by Hilarion's arguments. Returning home, they bring back with them a 'knowledge without fear, the knowledge about all knowledge.' In fearless freedom, Count Heinrich accepts the responsibility for his illegitimate favorite son, who in his absence has become a thief and brigand. He sacrifices himself for his son and is killed. Offerus, however, who has served so many brutal masters, including the fallen angel Marut, Satan's deputy on earth, has come to the end of his wanderings. He becomes a Christopher, a 'servant of the child which has power over violence.'

Barlach's plays were not allowed to be performed in Germany until after the end of the war. Between 1956 and 1961, however, the Schiller Theater in Berlin produced four of his plays.

208 top
208 middle
right, 208
bottom left
and right

In November 1930, Barlach's new living quarters in Güstrow were ready. The arrangements had been carried out by the energetic Böhmer, almost against the wishes of Barlach, who did not want to be bothered with building a new house. But finally he agreed, having become persuaded that his old studio was simply inadequate. And once he moved into the attractive, spacious new studio on the shores of a small lake, all his former misgivings went. This was no longer a makeshift barn but a real sculptor's workshop with everything he needed. In addition, his beloved woods were practically on his doorstep. He could not have wanted anything better. The building also contained an apartment, but he gave that to the Böhmers. Barlach felt more at home in a simple old house next to the studio, a 'quiet corner for contemplation.'

This was a good period in Barlach's life. He was finding growing acceptance both as a sculptor and playwright, he was working on the *Community of Saints*, he had an idea for a new play, and, having reached the peak of his creativity, he could look hopefully into the future. And then, in 1933, Hitler came to power.

On January 23, 1933, a week before Hitler's takeover, Barlach delivered a radio address, his first and last, and spoke out publicly on things which had preoccupied him for some time. It was a political speech, and though given by an apolitical man and clothed in somewhat obscure, baroque language, its point was clear and unequivocal. He spoke of the 'blessing of rejecting all that one is asked to take

on faith without question because reputedly it is universally valid.'
The essence of his speech, however, was this: 'Hidden behind the
mask of dogma, behind questions of belief and national and economic
demands as behind law and acceptance of moral values lies the secret
death of mankind, the lurking destroyer of others.'

Barlach was soon to experience the vengefulness of the regime
personally. He was called 'eastern' and 'alien' because in 1906, more
than a quarter of a century earlier, he had traveled through Russia
and been impressed by the country and its people. A rumor was given
currency that Barlach was of Slavic or Jewish descent. They of course
made much of the fact that the art dealers who had championed and
helped him, Paul Cassirer and Alfred Flechtheim, were both Jewish.
Barlach voiced his feelings in a letter written to Reinhard Piper on
April 11, 1933: 'The new epoch does not agree with me; my boat
is sinking rapidly; the time is near when I'll drown; these times do not
suit me, I don't fit, I am not nationally decked out, not properly
combed; noise alarms me; instead of cheering as the shouts of 'Heil'
grow louder, instead of making Roman arm gestures, I push my hat
down more deeply on my forehead.' His situation gradually deterio-
rated. In February 1933, he had been awarded the Order of Merit for
Science and Art, but despite this high award the Lübeck project was
quietly dropped after the completion of three statues, and no further
orders came his way. Nothing, however, was done about his plays
at that point. But then suddenly the blows began to rain down on
him: the Magdeburg memorial was removed from the cathedral in
1934; in 1935, *The True Sedemunds* was banned in Altona; soon
after, one of his sculptures, the famous *Reunion*, was confiscated in
Schwerin, and in his very own Güstrow the cathedral angel came
under attack. Barlach took everything with outer calm, continued
working and kept his sense of humor, even though it had become a

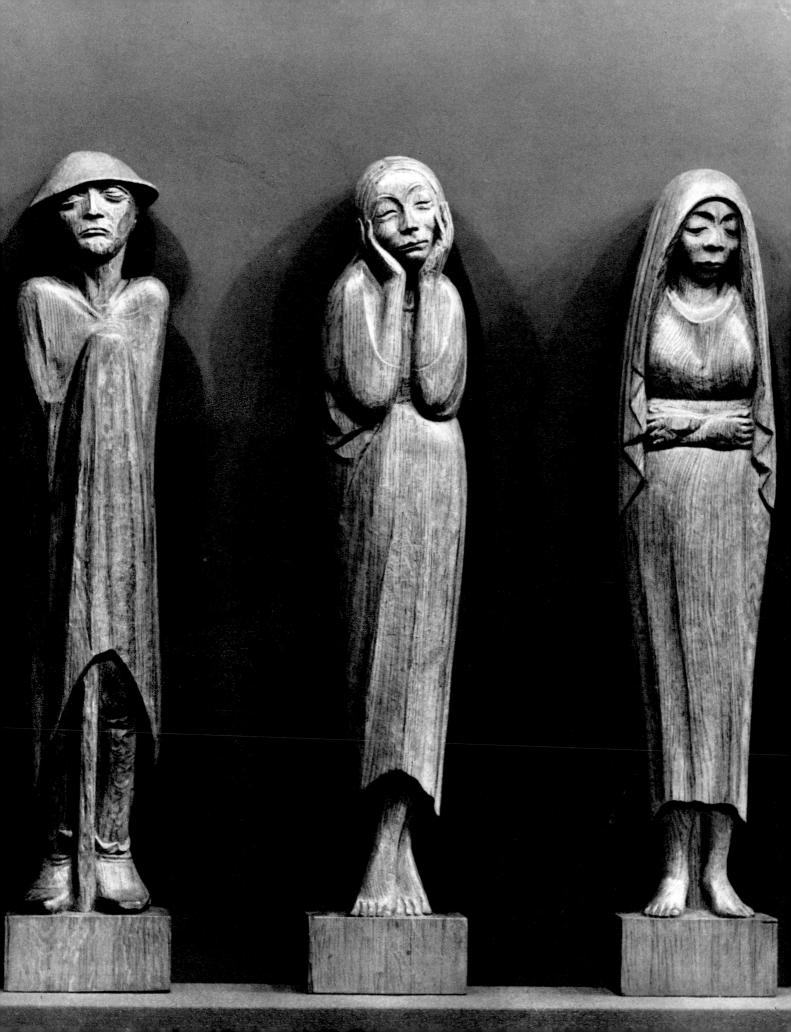

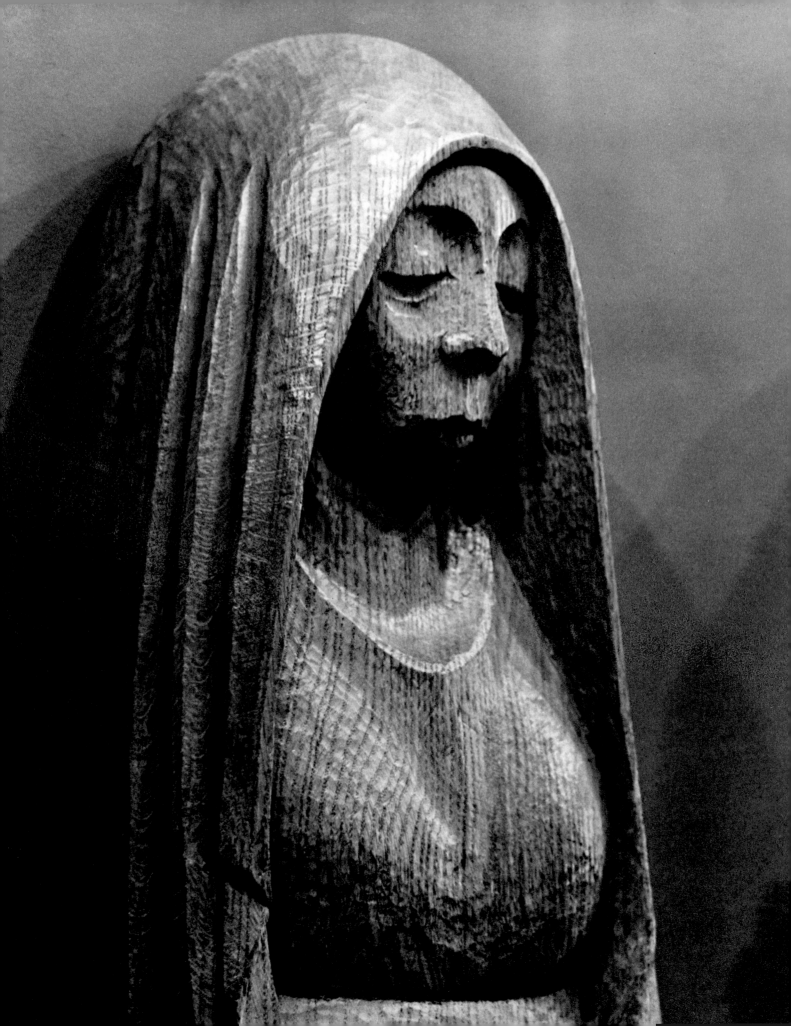

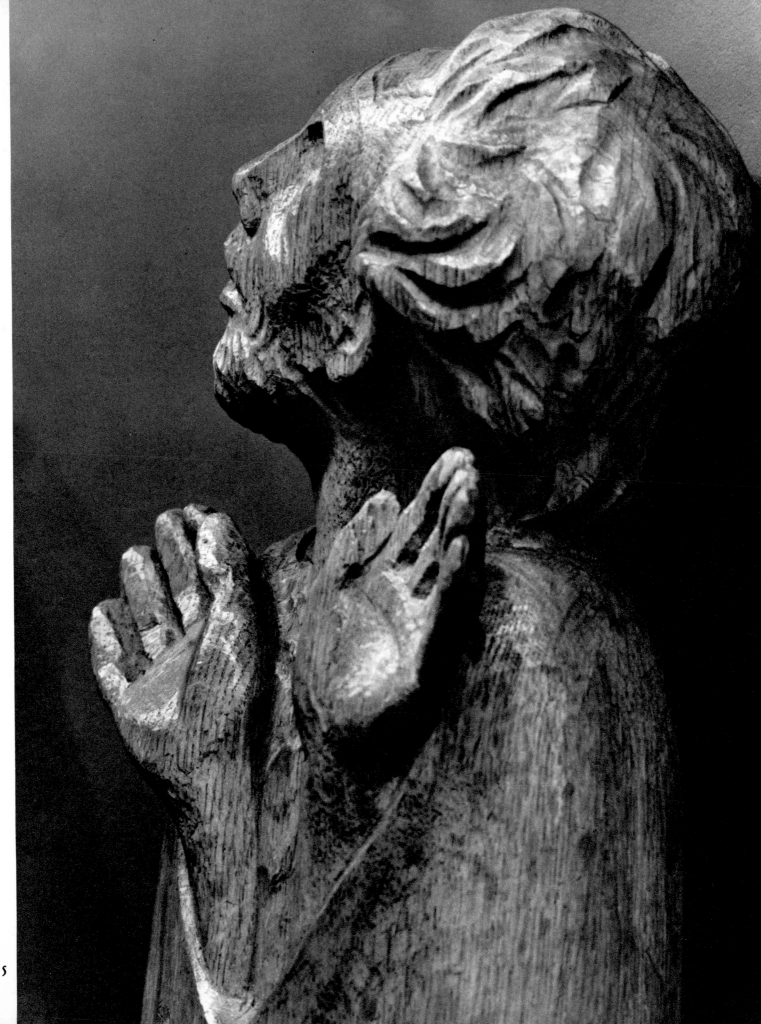

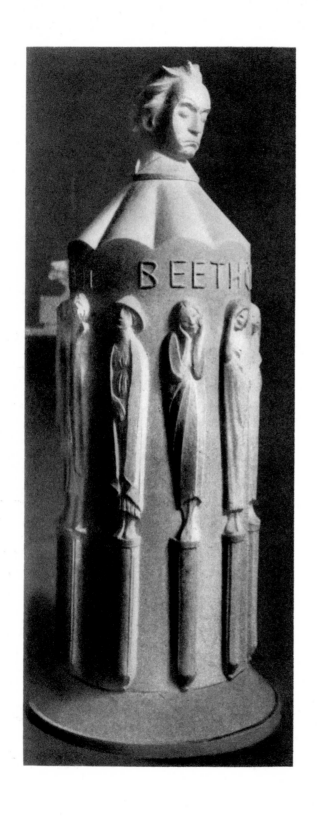

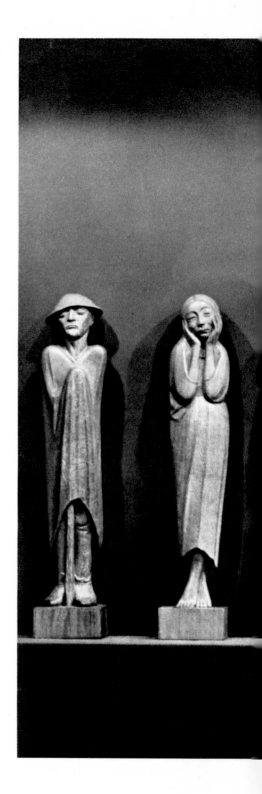

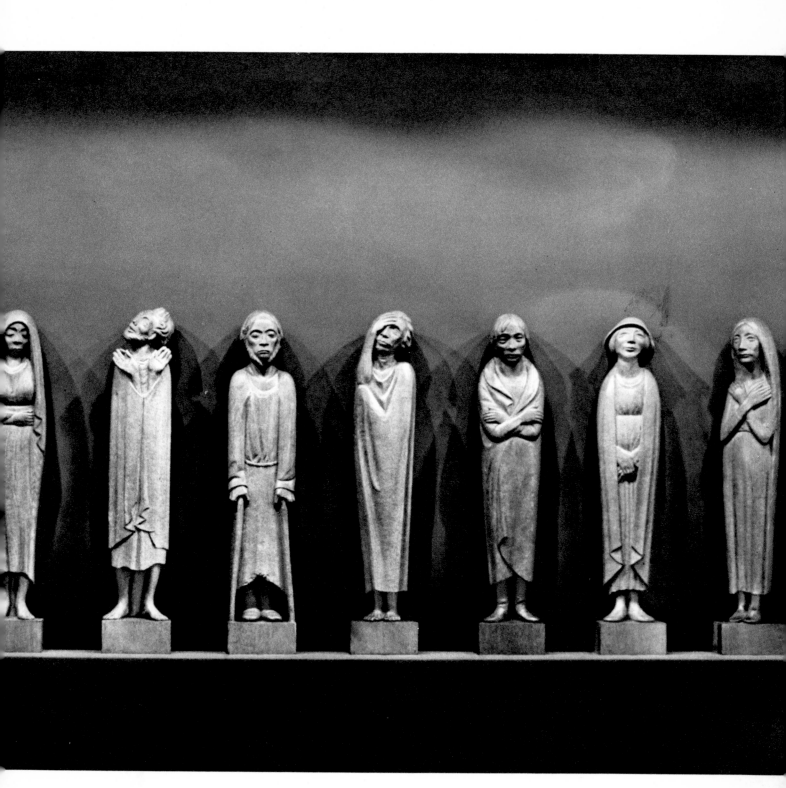

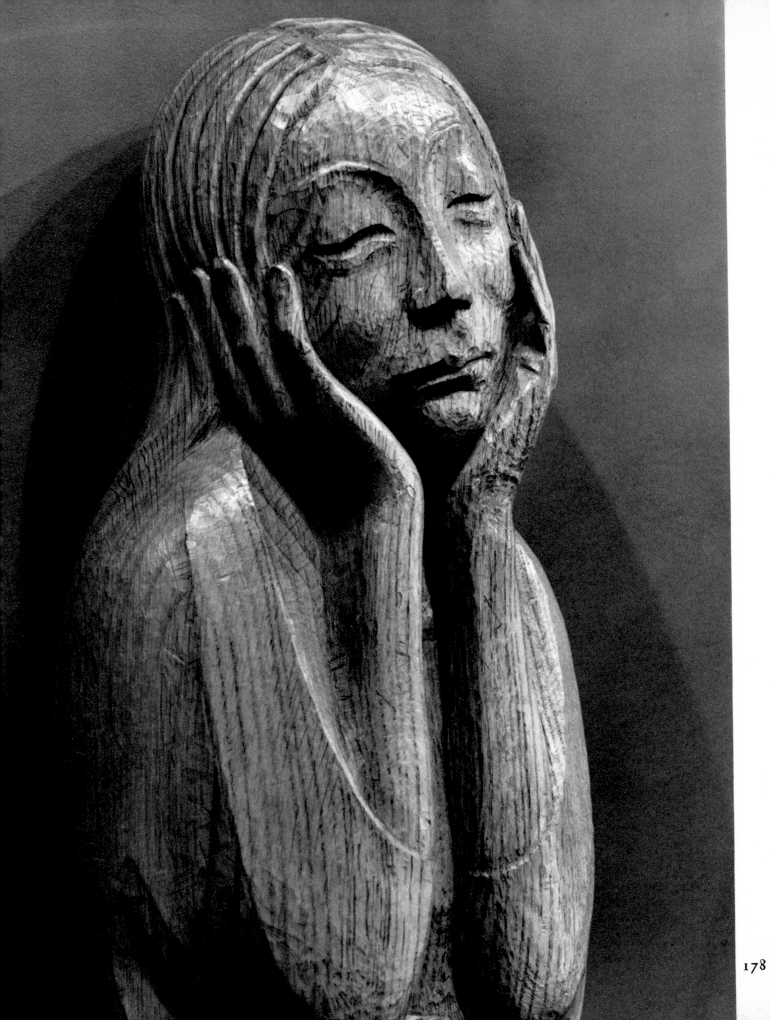

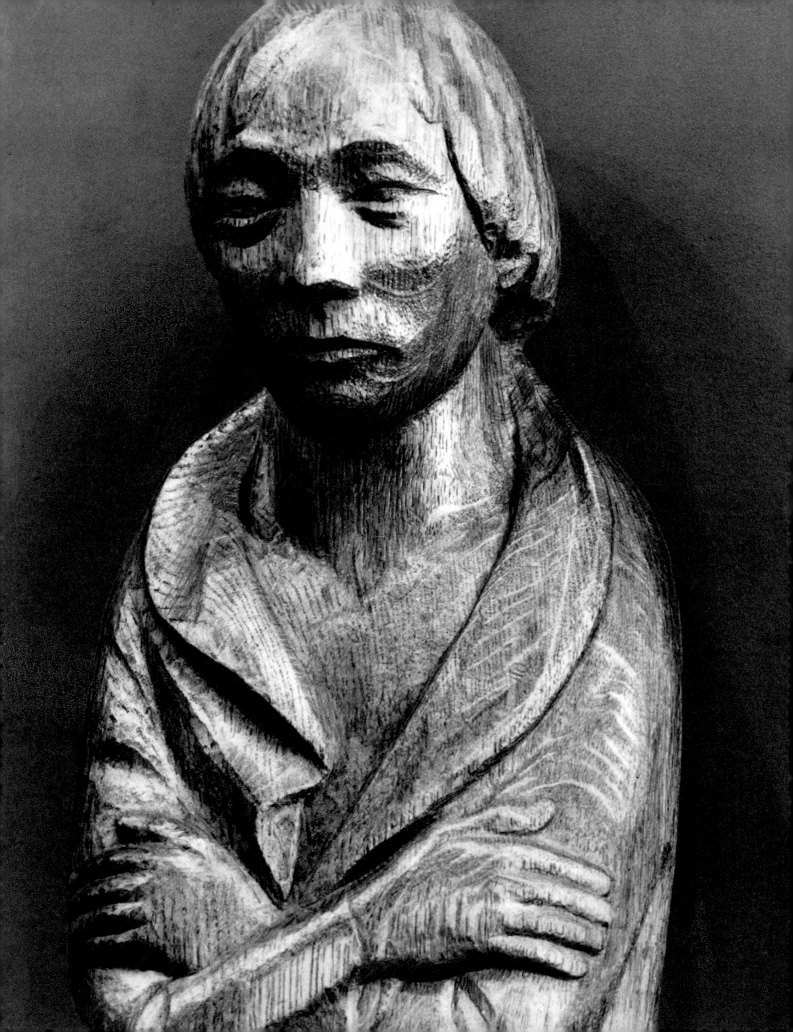

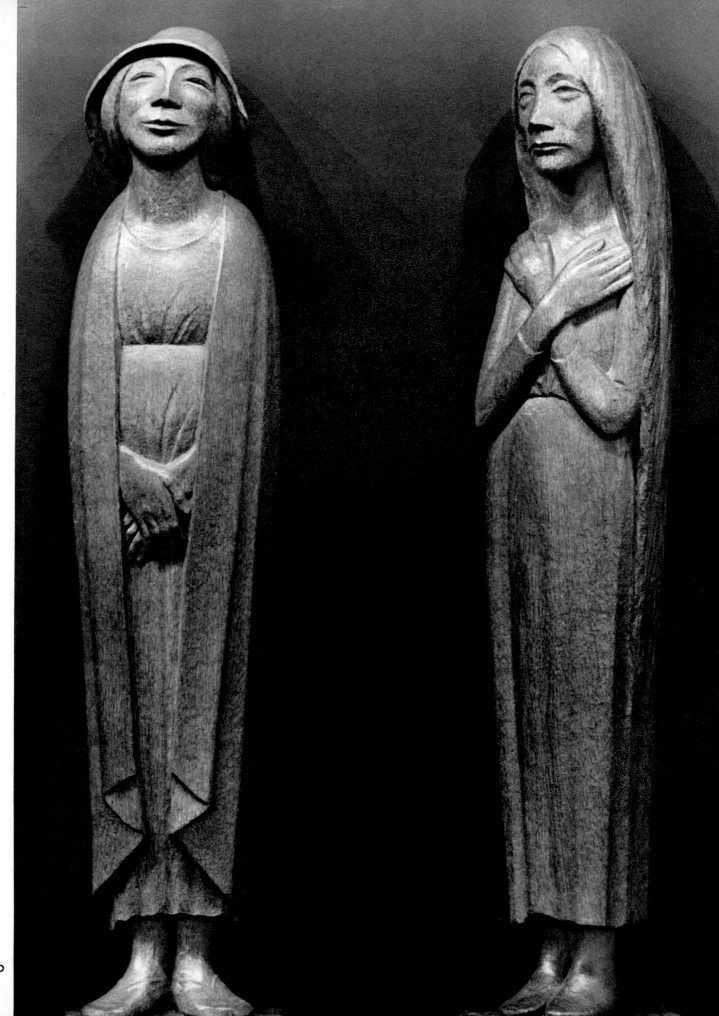

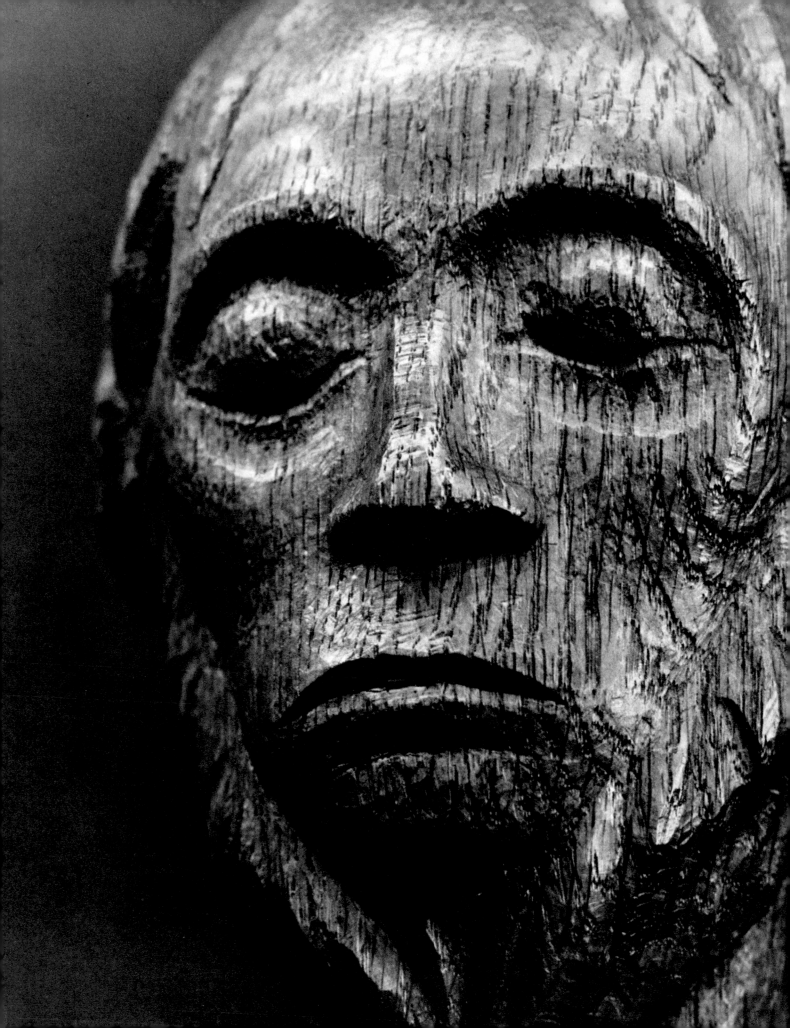

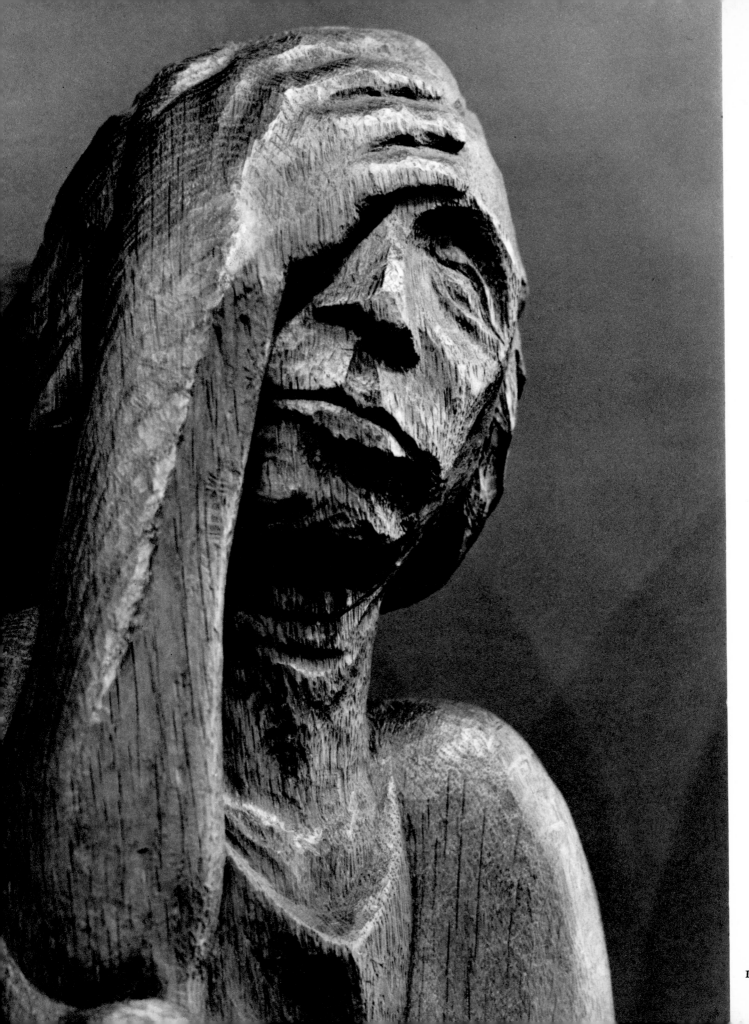

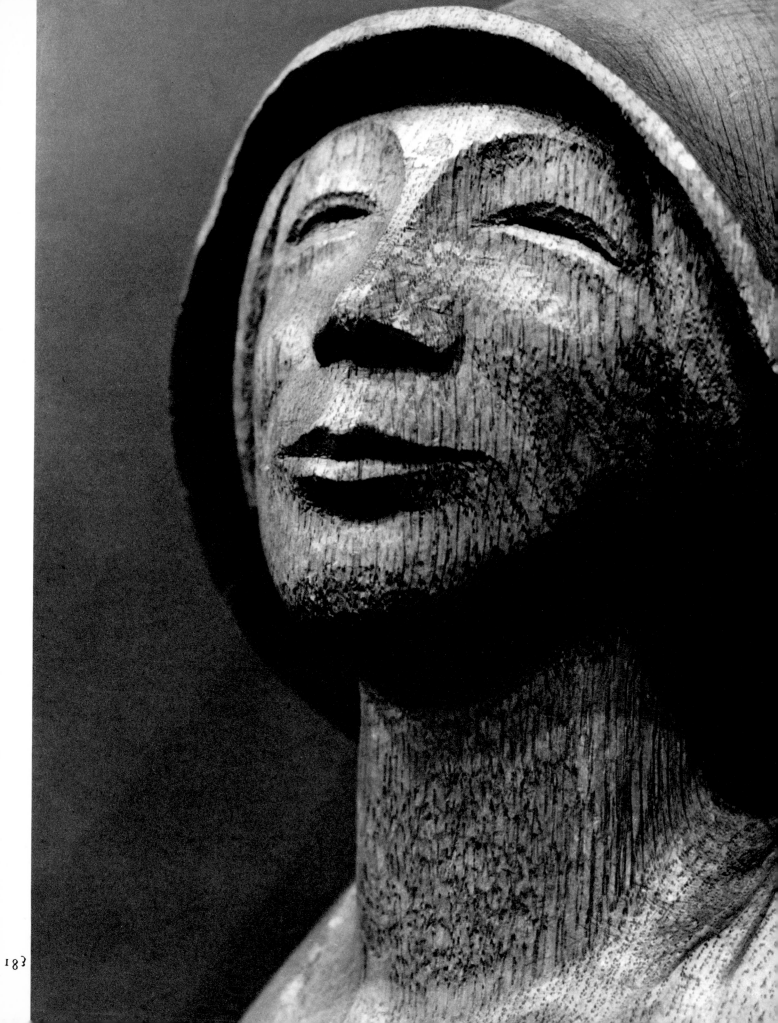

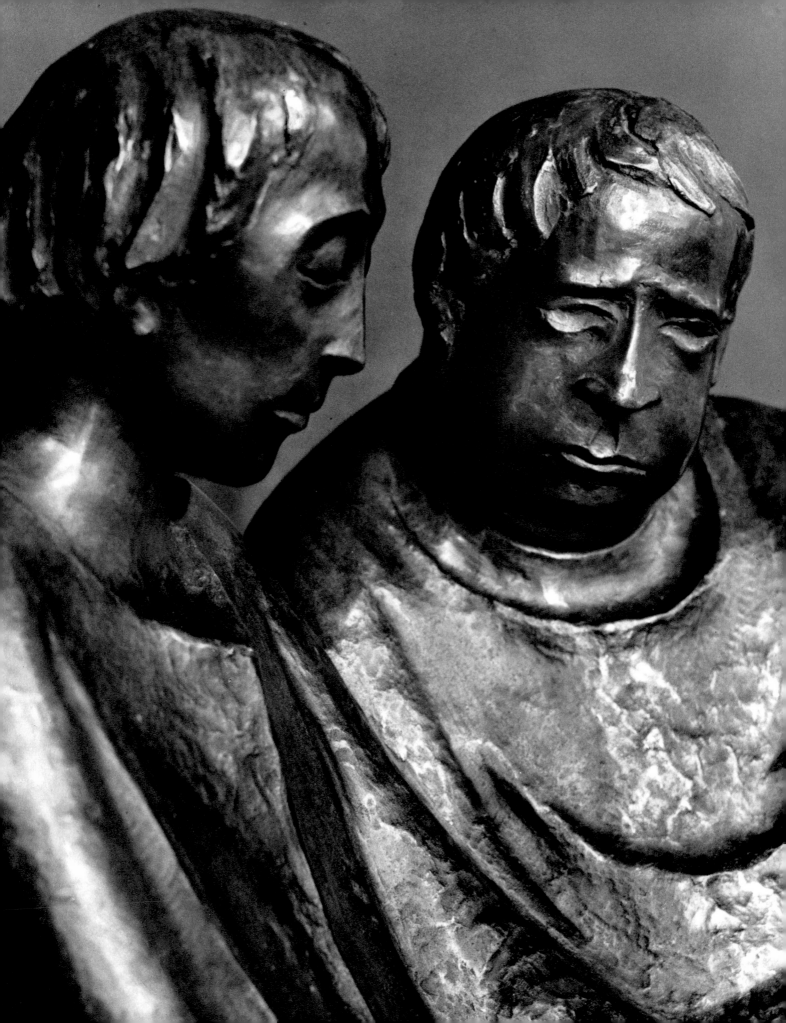

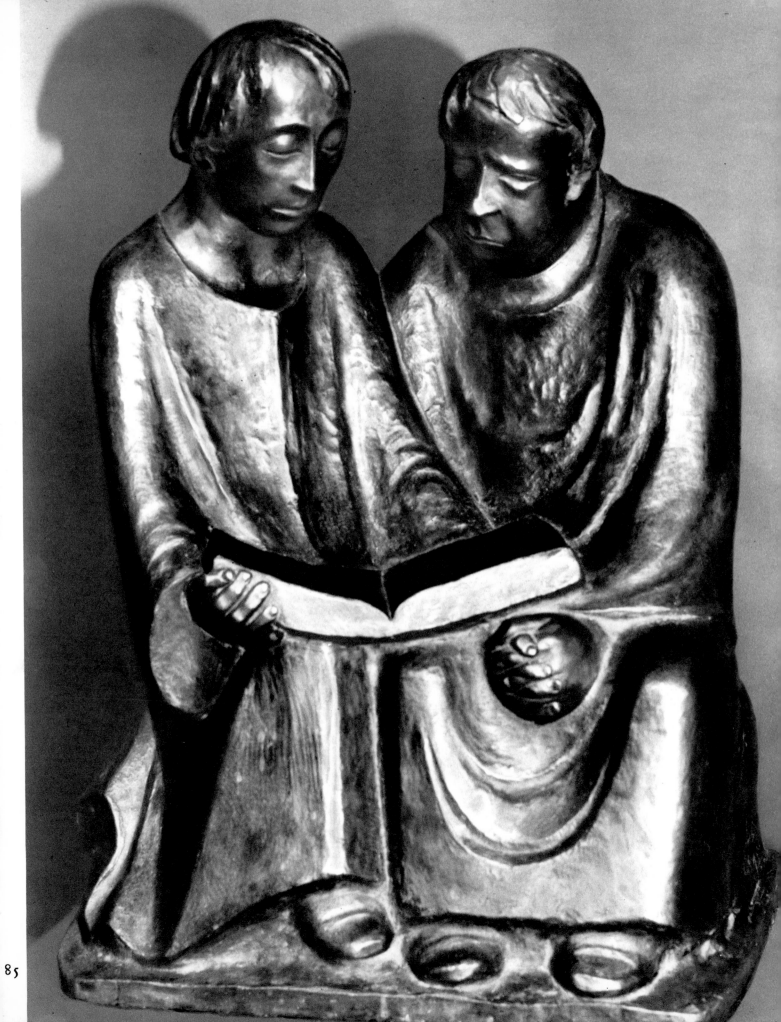

85

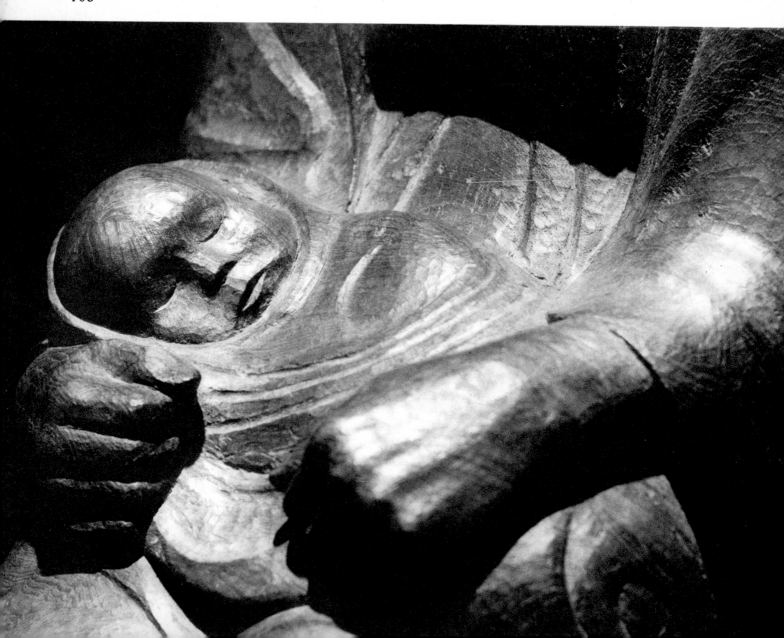

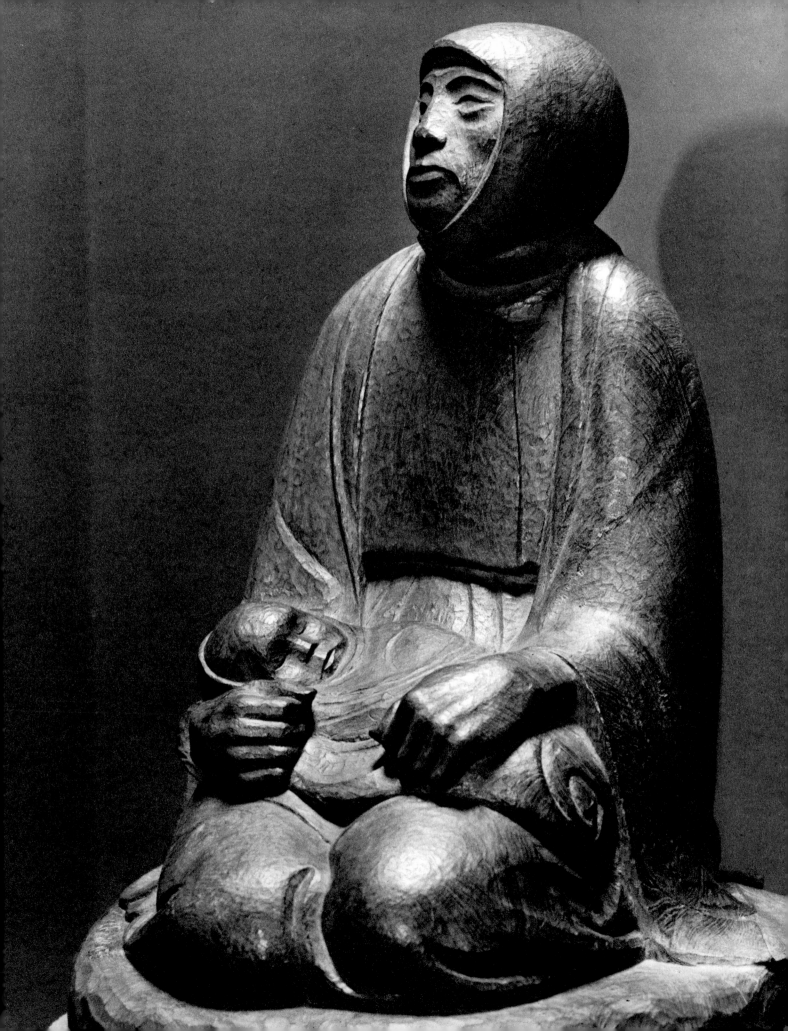

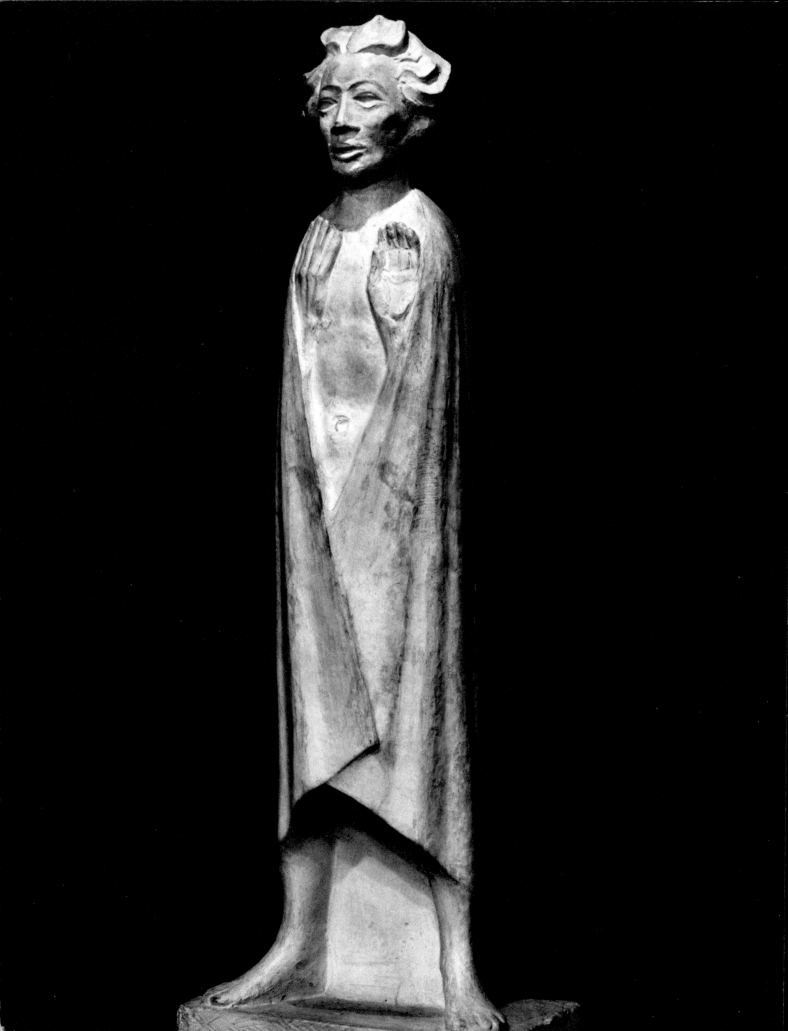

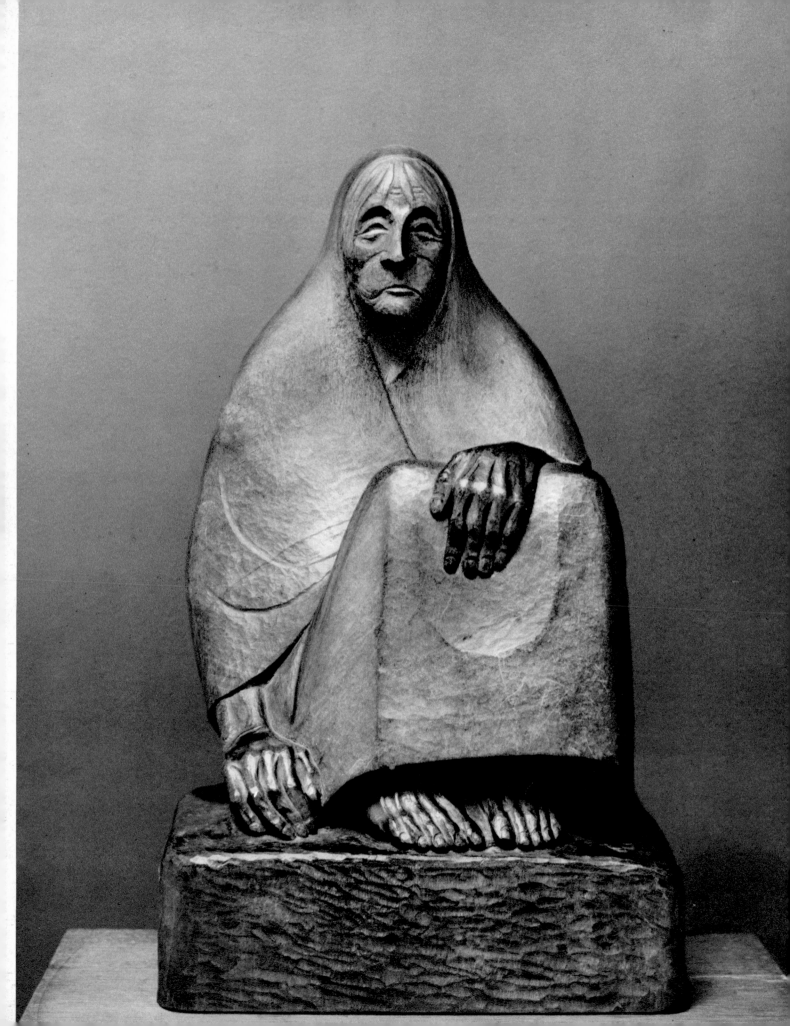

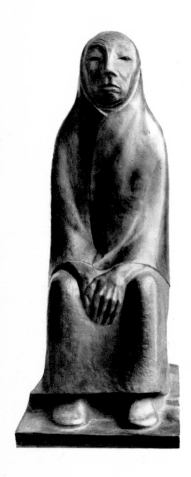

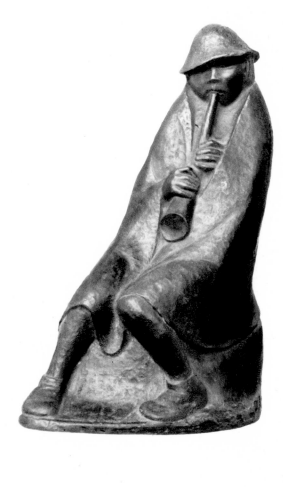

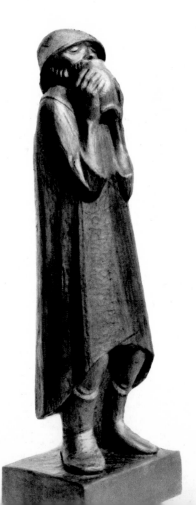

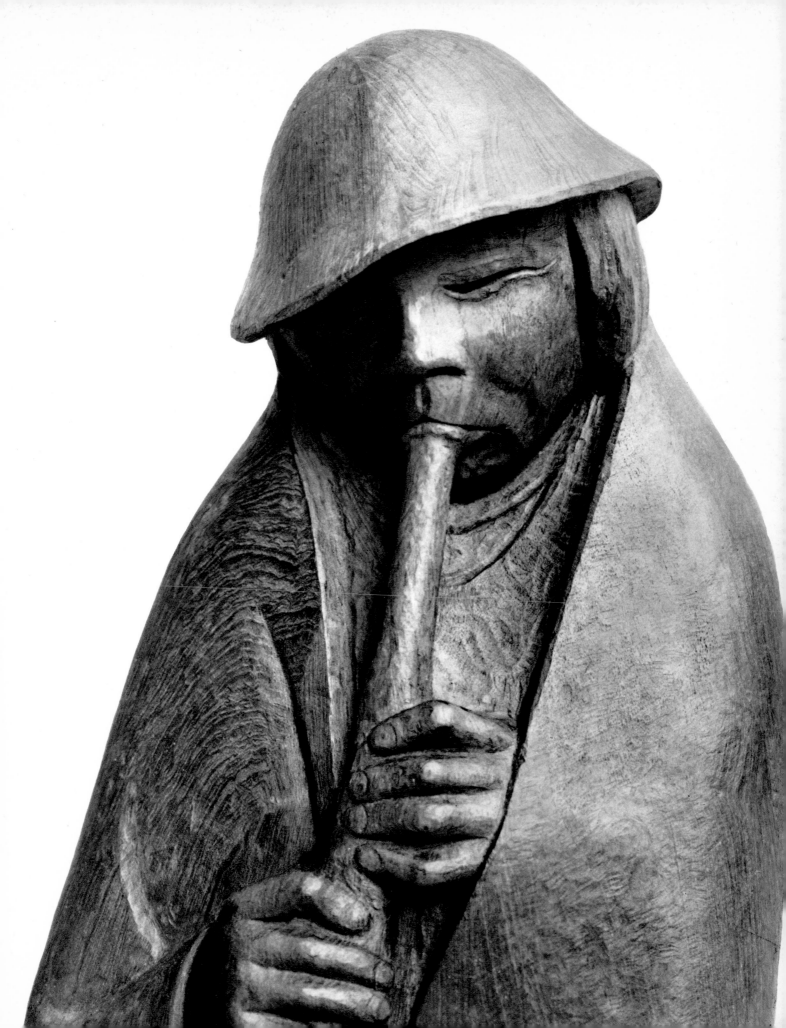

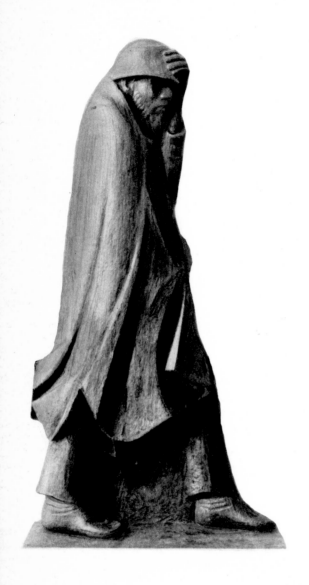

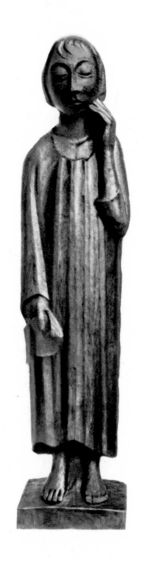

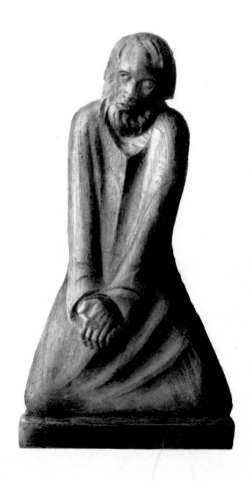

192

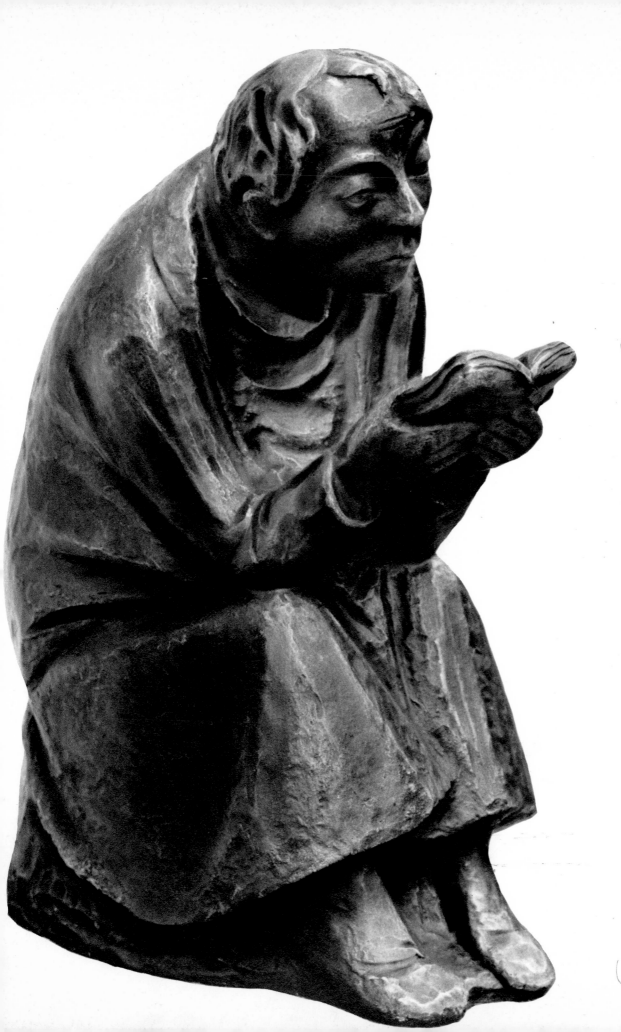

193

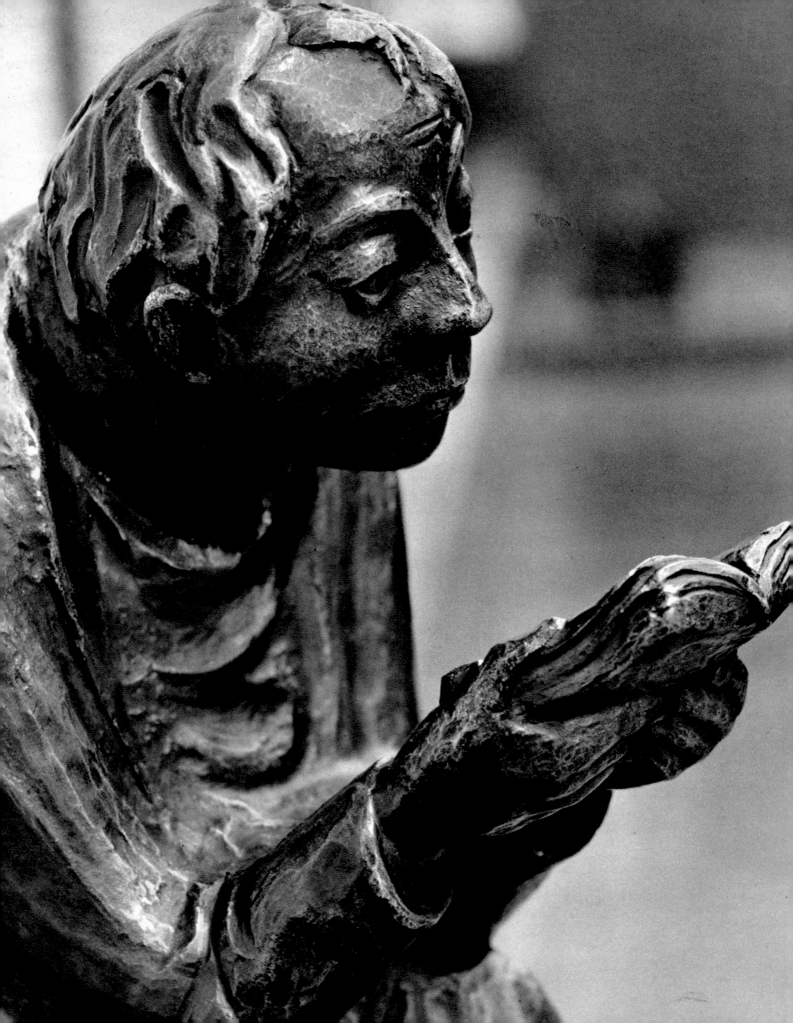

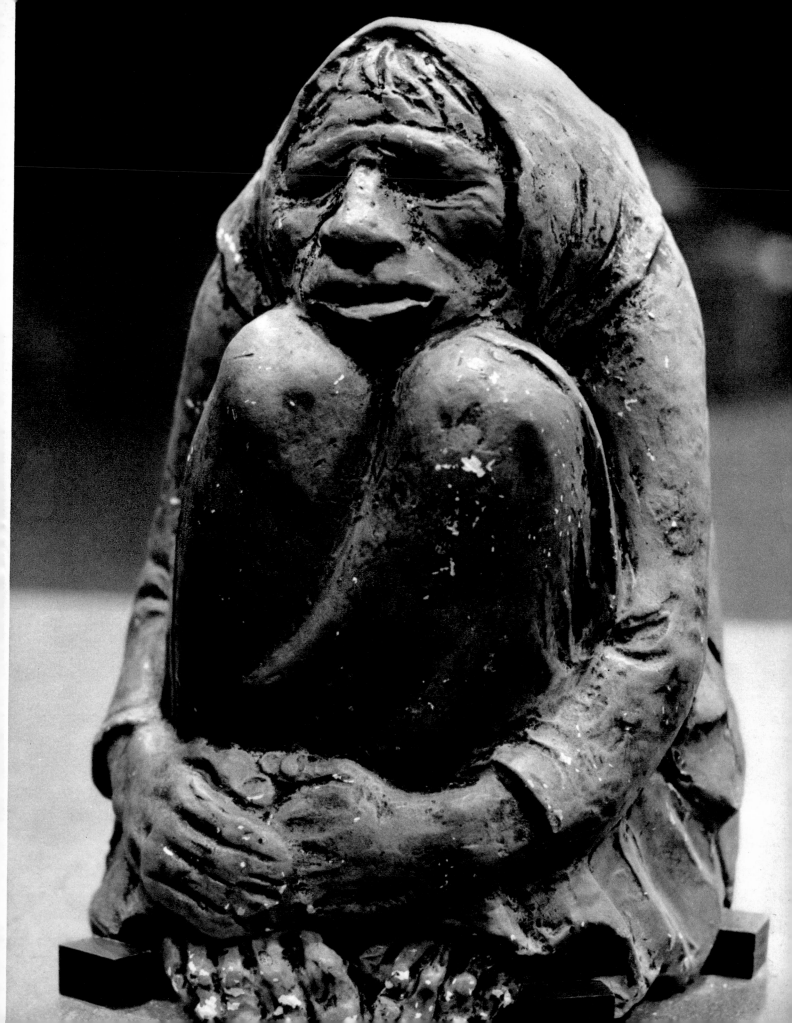

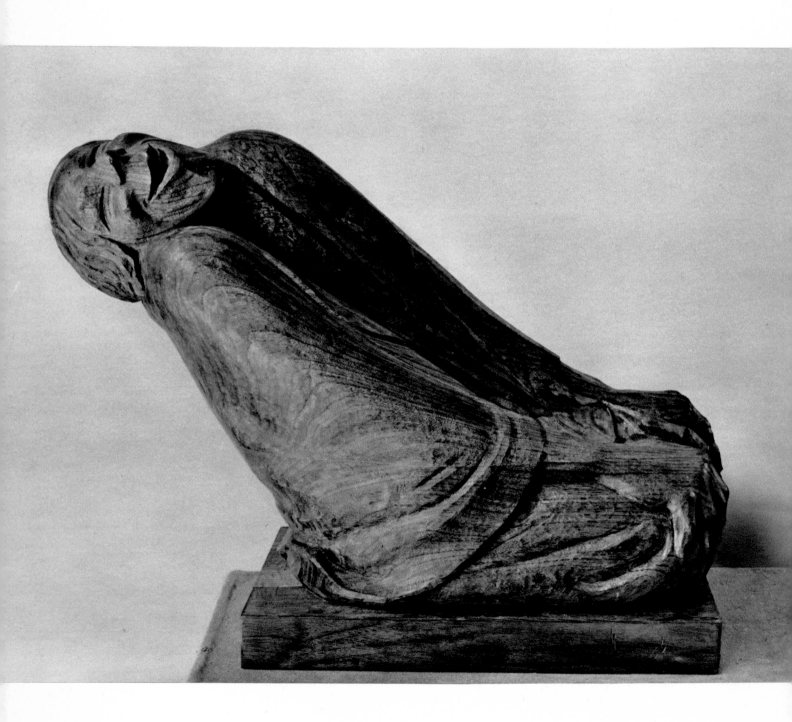

little bitter. But now the storm drew closer and threatened the peace of his retreat. He did not want to stay in Güstrow if his angel was removed from the cathedral and he toyed with the idea of moving to Berlin. However, for the time being the angel remained, and there were even some bright spots, such as the publication by Piper of a volume of his drawings. For a while it almost seemed as if the tide was beginning to turn.

cf. 206 bottom

It was during this period, in the fall of 1935, that I first met Barlach. I arrived at his studio one evening and found him still at work, wearing his white smock and standing at his work-table in front of an almost finished wood sculpture, one of the figures for the *Listeners*. He was a man of slight, almost delicate build, gray-haired, with a firm mouth and large, deep-set eyes.

After sitting down with him I had trouble finding the right words. 'Perhaps you find it embarrassing if no one says anything,' Barlach said after a while, 'but silence no longer bothers me.' He said this casually, with a smile, but I, many years his junior, was deeply impressed. To me these words were indicative of a maturity free of all petty concerns. Now that the ice was broken we spoke of many things — about the most advantageous way of showing and lighting sculptures, about people he had known, about the problems he was having, the intrigues against him, and his fear that he might have to leave Güstrow. Quite obviously he was deeply troubled.

To get away from this disturbing subject, I tried to steer our conversation to the theater and his plays. I knew that he had almost completed two new plays, and I suggested that he try to have them produced. I still then thought this possible. But he skirted this and mentioned some of his other plays which were running into difficulties. Anyway, he said, he had the feeling that the theater was not for him. He must have noticed my surprise, for he told me of his first

and only direct contact with the theater. This was in 1921, when he was approached by a director who wanted to stage *The True Sedemunds* in Berlin. Barlach found it 'decidedly interesting' to be dealing with a theater man who was going through all the emotional stages which he himself had gone through in the writing. Barlach had the greatest respect for the gentleman, but when he saw the performance he was utterly bewildered. What he himself had considered to be quiet had become loud, what he had thought of as violent and uncontrolled had become tamed, and what he had imagined as a small-town setting had turned into a highly stylized stage. This was no longer his play, it was the director's. He left the theater and never again attended a performance of any of his plays.

I stayed in the studio for some time after Barlach had retired, moving among his figures, works of every period, plaster casts and finished products, from the *Russian Beggar-Woman* of his early years to the *Frieze of the Listeners*, then still unfinished, a babble of voices and a sea of faces, unmistakably Barlach. When I went out into the night I continued to hear Barlach's voice, the native idiom in which he took such touching pride.

Some months later there came the news that the memorial in Güstrow was under renewed attack, this time by a petition drive which, as Böhmer wrote me, 'was started by the newly appointed superintendent Kestmann.' A new broom, a theologically trained one, apparently wanted to prove that he was able to sweep well. The petition drive sought to mobilize popular feeling against what Kestmann called the 'alleged' memorial. To have a man of the church believe that to loosen the pack against a member of his community was his Christian duty was a particularly bitter pill for Barlach to swallow.

The *Frieze of the Listeners*, the major work of his maturity, was begun in 1931, but was not completed until 1935, when Hermann Reemtsma made it possible for the artist to resume his work. Tilla Durieux had originally wanted the frieze, and it was commissioned by Ludwig Katzenellenbogen, a Berlin financier whom she had married after Cassirer's death. But Katzenellenbogen suffered financial reverses and in the end had to withdraw his support. In 1934, Reemtsma made it possible for Barlach to resume the project. The conception of the frieze is cheerful and musical. It had originally been designed in 1927 for a Beethoven Monument. The music to which the eight figures of his frieze are listening is nameless; no musician is to be seen; the source of their transport is from another world, an echo in the air, a breath from on high. These slender wooden columns, each of which personified a human emotion, listen intently to voices outside and within themselves, and each hears the one voice which speaks to all differently, but all are captivated by its beauty, by the same joyous, lovely tune. Only one, which Barlach added to the original eight figures of his design because the work seemed to him almost too lyrical, disrupts the harmony of the group with a harsher accent. This is the *Blind Man*, leaning on two canes, completely self-absorbed. This man, who bears Barlach's features, is the counterpoint in this choir of rapturous listening, the only sufferer among the group, completely unlike the rest even in his proportions. Yet even he still has a conciliatory quality, seems infected by the joyous looseness of

181

199

this group whose fervor is underscored by his seriousness. 'I won joy and serenity during my work on these figures, and for that I am most grateful to them,' Barlach wrote after he had finished them. 'They played the role of patrons and saviours.'

Once more, in his superb *Flutist* of 1936, he succeeded in creating a similarly airborne and happy composition, as untouched by the misery of the times as *The Listeners*. In the *Carefree Peg Leg* (1934) and *The Drinker* (1933-34) his humor came through once more. The first is uninhibitedly droll, the other is caught in the act of stilling a gigantic thirst. Very severe and deeply serious, on the other hand, is the *Mother and Child* (1935), a kneeling figure holding a child, with pleading expression and clenched fist, as if ready to defend her dearest treasure against any hostile force. Then there is a very quiet figure, *The Doubter* (1937), who, kneeling, wrings his hands in painful uncertainty, glancing shyly upward, almost hopefully. This work, which also bears traces of self-portraiture, goes back to a bronze of 1931. One can almost see Barlach himself, the man always sorely tested, wring his hands like his doubter, and just like the mother he might have clenched his fists while sitting in his studio and thinking about the fate that might still await his creations.

The campaign against Barlach continued to gain in intensity. In 1936, the Gestapo confiscated the volume of his drawings published by Piper on the grounds that this completely non-political work 'endangered public safety, peace, and order.' That same year all of his sculptures were removed from the anniversary exhibition of the Berlin Academy of Art, as were the works of Lehmbruck and Käthe Kollwitz, and in Kiel the *Warrior of the Spirit* was removed. A Barlach exhibition held in a private gallery in Berlin was closed in June 1937, and in July he was included in the exhibition of 'Degenerate Art' held in Munich. Now his works had to be

190 top right, 191

87

190 bottom

187, 186

192 bottom right

200

removed from every museum. And as if that were not enough he was threatened with a work ban. 'Things haven't gone this far yet,' he wrote in a letter of December 29, 1937, 'but no exhibitions of my works are possible. In Spain this is called garroting, asphyxiation. What can one say?' Nothing. He had to accept every blow that fell on him. Of course, he might have emigrated and spared himself much suffering, but he was too deeply rooted in his native soil to be able to start anew at his age. He did not leave, even though he had long before begun to feel like an emigrant in his own country. 'And even worse than a true one,' he wrote, 'because the wolves are howling against and after me. But at the same time one should and must guard against becoming embittered.' He fought desperately against a growing feeling of resignation and sought refuge in work, but as time went on he was able to work only spasmodically; sometimes he found himself unable to do anything at all for weeks on end.

In August 1937, his angel was removed from the Güstrow cathedral, yet another, very painful blow. Also his health continued to deteriorate, and his doctor advised him to go to the mountains. He went to the Harz, where no one knew him or anything about him. The change agreed with him, and he even seemed to accept the news that the last of his four memorials, the relief in Hamburg, was put on the list of proscribed works with comparative equanimity. But when he returned to Güstrow it became obvious that he could no longer do any real work in his old surroundings. He lacked everything he needed—peace, quiet, and good health. He was at the end of his tether, sick in body and soul.

In his reminiscences about Barlach, Paul Schurek tells of his last meeting with him in the summer of 1938, when he found him 'still thinner, his face waxen, deeply lined, bags under his eyes. He was now also in physical pain.' He wanted to leave Güstrow, where life

had become intolerable for him, and move to an isolated barn, preferably near the sea. That was his last hope, to find a small retreat next to to the open sea. But this plan came to naught, for his doctor again prescribed mountain air, this time for good. But before he could make the move to the mountains he was hospitalized with a heart and lung ailment. Perhaps he could have recovered if he had not lost his desire to live. 'Whether I still do a few small woods is not so important,' he allegedly said, 'since I am not permitted to finish the Lübeck project.' Life had defeated him; he was tired of the unequal struggle. He did not tell his friends of the seriousness of his condition and barred all visitors, all letters, and all flowers. Only Marga Böhmer, the companion of his last years, was at his side.

Barlach died on October 24, 1938. A memorial service was held for him in his studio amidst his figures, attended by all those who had stood by him. He was buried in Ratzeburg, where he had spent the happiest years of his youth. Away from Güstrow, away from Mecklenburg—that was what he wanted.

Thus the life of a great artist who after years of struggle achieved a measure of happiness ended in tragic loneliness. Barlach lived as he had to, a man of the plains whose eyes and imagination roamed the vastness of space, a brooder of the North who retreated into his quiet hut so as to be able to do his work free from interruption. He worked as he had to, whether as sculptor, graphic artist, or dramatist; everything he did was the product of an inner compulsion, it grew out of the center of his being. He was admired by all who had watched his development and were aware of the scope of his talent and disliked by all who were unable or unwilling to understand him. They are the ones who in his lifetime had the final say, for might was on their side. He was unable to draw a line through the past and emigrate, even though it was impossible for him to live in the same house with these false prophets. The lot he chose was inner emigration, and he died from it.

Barlach felt a kinship with the Gothic wood carvers of North Germany, but he knew that his ideas were not the same as theirs and that he could not take up where they had left off. He was awed by them, but it would be a gross oversimplification to call him a 'Gothic' artist, as has sometimes been done. Barlach was far removed from any traditionalism. His craving for honesty could not be held in check by any convention; his creativity was governed by an inner law which would accept no halfway measures. Whatever he did was painfully won, completely his own, both in form and content. He was

a trailblazer, not a follower of some current mode, and he shouldered the burden to express that which he himself had called the 'experience of a creative and irresistible restlessness.' This creative restlessness, this self-sacrificing dedication to his work, is the mark of his humanity. In the center of everything Barlach did, stood man, a vessel containing the most profound secret which he never tired of exploring. As stated earlier, he had said that 'my mother tongue is the human body or the *milieu* . . . through which or in which man lives, suffers, enjoys himself, feels, thinks.' His vast compassion with all living beings was what inspired him in his art. Everything he created was the product of a true humanity, of the awareness of the oneness of all mankind, of a deep involvement. He never thought in terms of 'human material', and he saw even the sorriest creature as the 'half of something else,' the glowing divine spark. The question about the purpose of life, the whence and whither, never ceased to occupy him, whether in his plays, his sculptures, or his drawings. He had the courage to proclaim this basic feeling, and this absolute, trailblazing declaration made for the uniqueness of his artistic achievement. 'Two are needed for every art,' he said, 'one who makes it and one who needs it.' He admitted that he hoped to create something which could be understood not only by the elite of his time but also by the simplest person. Occasionally he asked himself what would become of his work in the future. 'In doing my sculptures,' he told friends, 'I am really working blindly. I don't know where they will ultimately stand. They'll probably be scattered. But it is no little thing that I have been permitted to express myself in my fashion.'

He turned out to be right. His sculptures are scattered. They are to be found in Berlin and New York, San Francisco and Toronto, Hamburg and Copenhagen, Zürich and Tel Aviv. What Barlach wanted to say today is understood far beyond the borders of Germany.

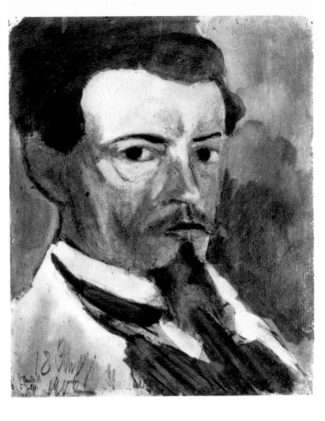

205

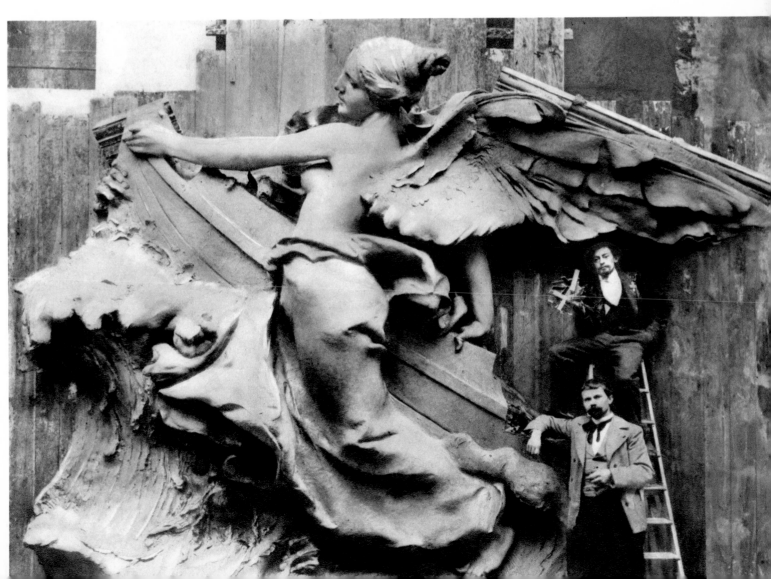

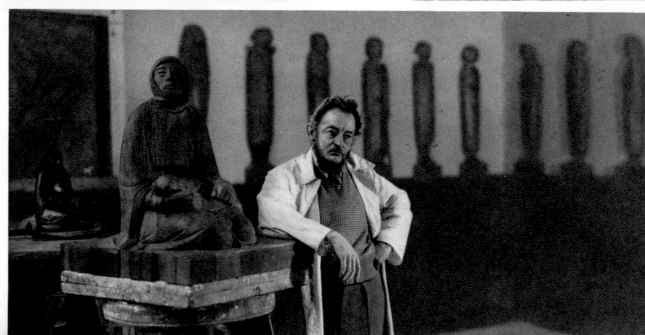

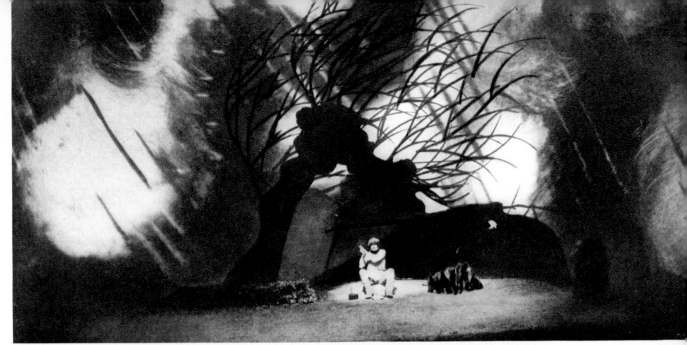

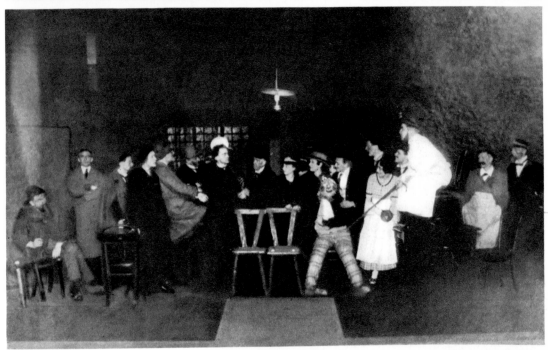

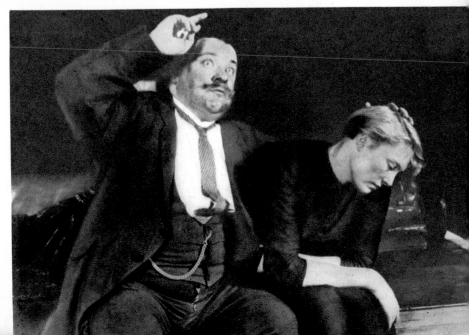

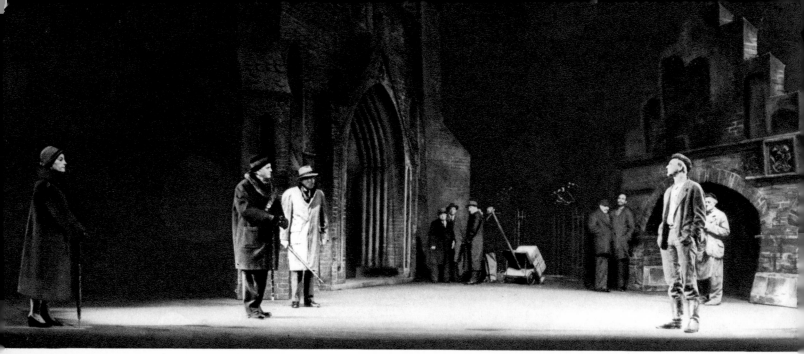

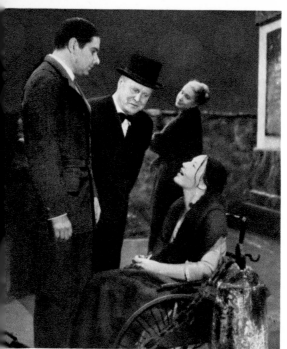

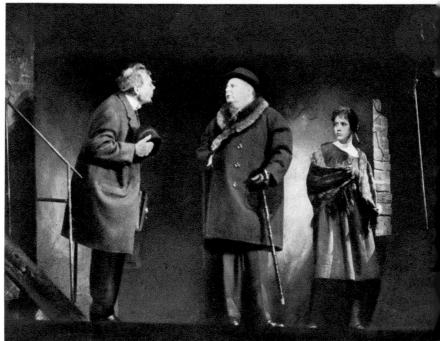

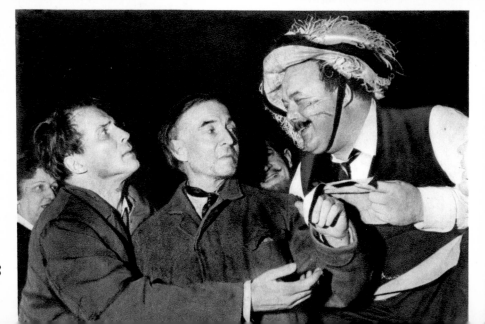

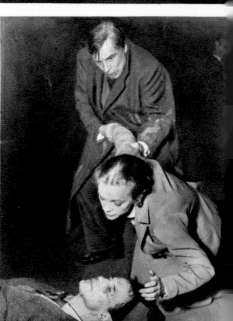

List of Illustrations

LIST OF ILLUSTRATIONS (Dimensions given in order of height, breadth, depth)

212

213

214

The author and publisher wish to express their gratitude to Mr. Friedrich Schult for furnishing pertinent data, particularly in connection with current holdings of Barlach's works. Mr. Nikolaus Barlach was most helpful in supplying photographic material. We are indebted to him, as well as to all private collectors, museums, and galleries who furnished information and photographs.

Picture credits: Bayer. Staatsgemäldesammlung 73 bottom l. — Beyer 106, 107, 108, 109 — Castelli 114 — Claasen 105 — Cordes 22, 23, 28, 33, 73 top, 86, 125, 127, 128, 135 (2) — Eidenbenz 75 — Flugel 26, 27, 29, 31, 32, 35, 37, 39, 40, 59, 61, 62, 64, 70, 80, 81, 84, 85, 88, 113, 173, 174, 175, 177, 178, 179, 180, 181, 182, 183, 184, 185, 186, 187, 188, 193, 194, 195 — Galerie des 20. Jahrhunderts 63 — Hamburg-American Line 25 — Staatl. Landesbildstelle Hamburg 116 — Heise 115 — Hewicker 19, 30 bottom, 69, 87 — Kegebein 36 top, 38 (2), 58 (2), 65 (3), 66 (2), 67, 72 (2), 73 bottom r., 83 (4), 110, 130, 131, 176, 190 (3), 191, 192 (3), 205 top, 206 (4) — Kindermann 208 — Kleinhempel 18 bottom — Institut für Theaterwissenschaften, Cologne 207 (3) — Köster 208 (4) — Kraschawski 205 bottom — Kraushaar 60 — Foto Marburg 57, 111 — Münchow 79 — Niedersächsisches Landesmuseum 76 — Reutti 34 — Rheinisches Bildarchiv 189 — Schöning 112 — Schuch 68, 72 r., 196 — Spindler 82, 126 (4), 132 r., 133 (2), 156 top — Stickelmann 132 l. — Witzel 78 — Wohlfahrt 71 — Kunsthaus Zürich 65 bottom r.

216